Ann Hartley
from
Aunt Ida Meranda 1976

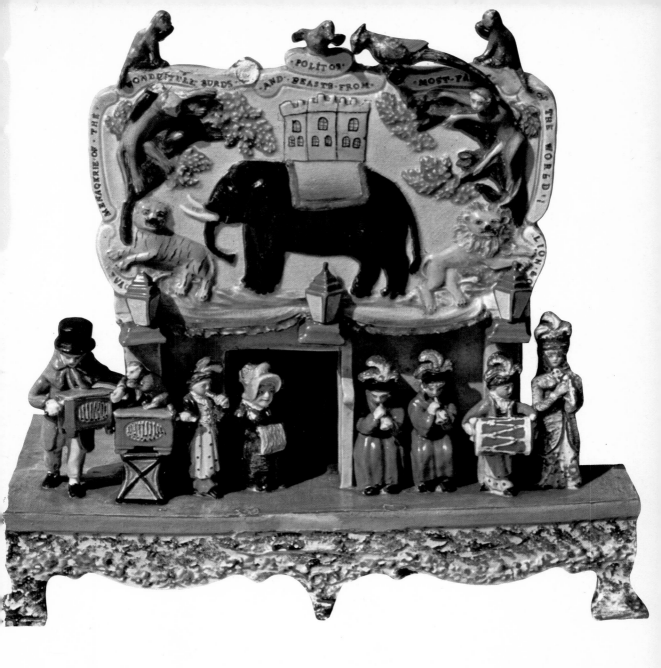

Animals in Pottery
and Porcelain

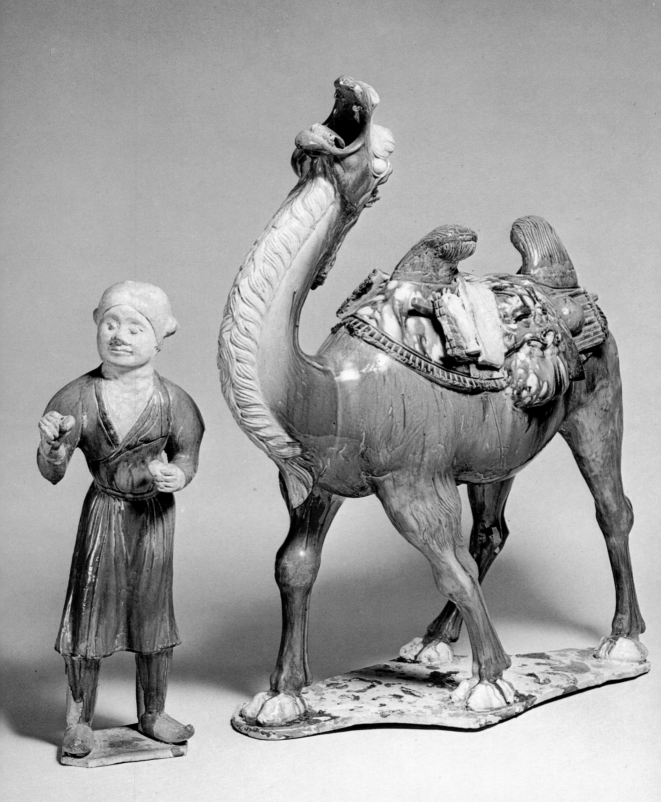

Animals in Pottery and Porcelain

John P Cushion

CROWN PUBLISHERS, Inc. New York

Library of Congress Catalog Card No. 74–75736
ISBN 0–517–515644

© John P Cushion 1974

First published in the USA 1974
by Crown Publishers, Inc.

Produced by Walter Parrish International Limited
London, England

Printed and bound in Spain by Roner S.A., Madrid
Dep. Legal: M. 23.684-1974

half-title
1 Group depicting Polito's Menagerie in earthenware, painted in enamel
colours. ENGLISH (Staffordshire) attributed to Obadiah Sherratt, about
1815; height 31.8 cm/12½ in. (p 128)
Courtesy The Newcastle-under-Lyme Borough Museum

frontispiece
2 Camel and groom in lead-glazed earthenware, decorated in high-tem-
perature colours. CHINESE (T'ang dynasty), AD 618–906; height 89 cm/35 in.
(p 36)
Courtesy The Asian Art Museum of San Francisco, Avery Brundage Collection

to Debbie and Cleo

Contents

Introduction

As primitive man became aware of the properties of clay for producing his cooking-pots and bricks, he soon realized the ornamental possibilities offered by this versatile substance. Throughout the centuries from the time of ancient Egypt (when bricks were merely strengthened with straw and dried in the sun) the various ceramic materials that were available were employed to create a type of sculpture, sometimes in human form but more often in that of a familiar, or fictitious, animal.

A wealth of material is encountered from early China: fine vigorously formed animals made for tomb furnishing, such as camels and horses to carry the deceased on his long journey, monsters with frightening features to ward off any evil spirits and small reproductions of the various livestock known at that date. Many such simple farmyard pieces were probably made as playthings for the potter's children. With the discovery of glazes, and the use of coloured slips, these figures became more satisfying to both the touch and the eye, and during the T'ang dynasty (AD 618–906) many large and naturalistic horses and camels were produced, a number of which still survive.

During the ninth century AD true or hard-paste porcelain was first introduced and its tight-fitting glaze was found to be advantageous for use on figures; then the fine modelling was no longer obscured under a heavy lead-glaze, and figures and wares were made in imitation of the more precious materials of jade and nephrite. Up to 1710 when Augustus the Strong, Elector of Saxony and King of Poland, started his hard-paste porcelain manufactory at Meissen, near Dresden, any true porcelain required in the courts of Europe or the Near East had to be imported from China, or later, Japan. Augustus was directly responsible for the manufacture of more porcelain animals and birds than any other man. He made endless demands upon the skill of his factory modellers, moulders and kiln-masters. J J Kändler, the most prolific of all modellers for porcelain, worked endlessly to fulfil his king's mania for large figures of animals and birds to furnish his *Japanische Palais*.

When Augustus died in 1733 this palace already housed 439 models of animals and birds, created from 16 different moulds. The records go on to tell that 35,798 pieces were produced from a variety of moulds during 1744. Thus it is not difficult to understand why constant reference must be made to Meissen as the source of so many models.

The figures produced in the soft-paste porcelain factories of France, England and other European countries were often modelled after Meissen originals. At one time they were probably regarded as poor substitutes, but today's collectors have learned to appreciate the beauty of these imitations, which have a naïve but sensuous charm of their own. It was to such creations that the late W B Honey was especially referring when he

suggested that to be at their best, porcelain figures should not be larger than about 18 centimetres (7 inches), enabling them to be fully appreciated as something precious; beyond this size, many figures take on the appearance of dolls or puppets.

From the early eighteenth century onwards, the potters of Staffordshire found that there was an increasing demand for figures of animals and birds, in addition to the mass of useful wares they produced. Astbury, Whieldon and the Wood family have all given their names to types of figures that were in many cases made by contemporary but lesser-known potters. Later, in the nineteenth century, came the wares of Walton, Sherratt, Salt and countless other Staffordshire 'image' makers. It was from Victorian times that the mass of flat-back chimney-piece ornaments was so cheaply produced for sale at markets and fairs.

Today figures of animals and birds are among the most sought-after of all ceramic antiques. In addition, many creative studio potters and foremost industrial pottery and porcelain concerns feature entrancing lifelike or highly stylized figures of this type, which often become coveted collectors' pieces as soon as they go on the market.

It is the purpose of this book to acquaint collectors with the materials, techniques, localities and factories that have, through the ages, been concerned with the production of ceramic animals and birds – from the hand of the early primitive potter to those ceramic modellers who are comparatively new in the field and whose work is being shown at the present time. It is also hoped that this book will inspire those animal lovers who are not as yet pottery or porcelain collectors to appreciate the beauty of such pieces and to seek out for collection models of their favourite animals.

Author's note

A few of the black and white illustrations are included in the history section, but most are grouped according to animal kind between pages 147 and 212. This allows the various animals within each group to be easily compared and contrasted. Page numbers are given at the end of the captions so that the reader can find the relevant text reference for each example. In the text, the colour illustrations are differentiated from the black and white ones by the use of bold numbers.

The craft
of animal sculpture

1 Materials and techniques

Earthenware, stoneware, and porcelain (both true or soft-paste) all require as part of their make-up the essential material of clay, and nearly all need certain preparation, with possible chemical additions, in order to obtain the body and finish desired. The amount of vitreous material contained within clay varies, so kiln temperatures are adjusted accordingly to produce finished materials of differing appearance and properties. Clayware has been appreciated by mankind for many centuries, with primitive man quick to realize that clay could be shaped into almost any form and then made rigid and durable by subjecting it to the heat of the sun or of fire. He also quickly learned that such material when formed could be decorated to give visual pleasure, either by painting or incising into the unfired clay, and so he began to use it to create quaint figures, sometimes for ritual use or worship, sometimes merely to satisfy his own whim.

The most common example of earthenware known today is the simple red earthenware flower-pot. Clay of this type was used in the early days to make either bricks or utensils which were hardened by being placed in the heat of the sun; these vessels could only be used for dry materials or storage purposes or, in the case of bricks, for building. Some of the earliest writings known to present-day man tell of the making and use of them by the ancient Egyptians and the peoples of Babylonia, Phoenicia and Persia, all of whom boasted of great cities filled with structures built of brick. An early Egyptian tomb painting shows the various stages in the technique used at that time for making them: the cutting of clay, the moulding and drying of the shaped bricks and the stacking of the finished wares, all under the watchful eye of a typical foreman.

Earthenware clays vary widely in composition and appearance, according to their locality. They are found in a variety of colours from very dark reds to creamy whites. These clays contain very little vitreous material, and consequently even after firing at temperatures ranging between 1000 and 1200 °C, they remain partially porous. Often the term used for earthenware clay is terracotta (Italian for burned earth). The chemical study of the formation of clay is very complex but, in brief, we can all understand and appreciate how the original rocks and minerals of which our earth is made were created from a molten or gaseous state, which gradually cooled and hardened into a solid mass of rock, forming what we now refer to as the earth's crust, and how it has over countless years been subjected to an extreme range of varying weather conditions, bringing about the formation of 'dirt', sand, silt and clay, either on or near the surface. Most of the rocks of the earth's crust contain silica (silicon dioxide) and alumina (aluminium oxide), which are found in feldspar, a mineral which in turn is found in rocks that have been broken down by the winds and rains of countless centuries to form clay.

In relation to the content of feldspar in a clay, the firing temperatures can be adjusted to result in bodies of varying hardness. If a clay body can withstand temperatures of between 1200 and 1400 °C, it can then be fired to a point of vitrification, which renders it impervious to liquids without the addition of a protective glaze. This stoneware is much akin to true porcelain, except that it lacks both the whiteness and the translucency. There are, however, certain exceptions, such as the fine high-fired stonewares produced by John Dwight of Fulham, whose small cups of Chinese form were so thinly potted that a slight orange-tinted translucency can at times be observed with the aid of a strong light.

Another particularly attractive form of red stoneware was that made at Yi-hsing in China, a type of ware from which the many exported teapots were produced in order that the European tea-drinker could enjoy the beverage to the full; the pleasing red tone was due to the high content of iron in the clay.

There are only very few materials or techniques concerned with the manufacture of ceramic wares that were not initially introduced and used by the Chinese potter. It is thought that even prior to the Han dynasty (206 BC to AD 220) the oriental potter was aware of the value of china-clay, or kaolin, a clay most probably found in the region of Mount Kao-ling (meaning 'high hill') in the Kiangsi province. High-fired stonewares of porcellaineous nature were being produced throughout the first eight centuries AD, prior to the production of the true porcelain such as that excavated on the site of the Abbasid capital, Samarra, on the Tigris (a city that had been abandoned by AD 883).

Two materials are essential for the manufacture of true or hard-paste porcelain, two ingredients aptly described by the Chinese as the skeleton and flesh of porcelain. The first ingredient, china-clay or kaolin, just discussed, forms the 'skeleton' of the finished material, while the 'flesh' is composed of china-stone or *petuntse* (from the Chinese *pai-tun-tzu* meaning 'little white bricks', the form in which the china-stone was processed in readiness for the potter). Both these basic materials come from the same type of feldspathic rocks, which are in varying stages of decomposition. When these two basic materials are blended together in approximately equal proportions and fired to a temperature of between 1300 and 1400 °C, they fuse together to form a hard, white, vitrified body. As pure silica is difficult to melt, the impurities of soda ash, feldspar or lead are sometimes added as fluxes to aid the melting process.

This method of manufacturing hard-paste porcelain remained a secret of the Chinese, and later the Japanese and Korean potter, up to the time of the establishment of the Saxon factory at Meissen in 1710. The first porcelain produced at this factory was not a true porcelain in the Chinese sense but contained alabaster, which was used as an alternative to china-stone until information about the correct material was discovered around 1718. By the middle of the eighteenth century, many other European factories had also learned of the materials and firing techniques but it was 1768 before the English factory of William Cookworthy was established at Plymouth, in Devon, for the production of a hard-paste porcelain made from materials found on the estate of Lord Camelford, near Truro. This material was further modified by Josiah Spode in about 1794 and resulted in the material with which we are so well acquainted today – bone china. This is composed of approximately 25 per cent china-

stone, 25 per cent china-clay and 50 per cent calcined animal bone, resulting in a pleasing and highly popular ware of a creamy hue with extreme translucency, softer than hard-paste porcelain, but very durable. Bone china remains the standard body of the majority of English translucent wares manufactured at the present time.

The potters who were unable to gain knowledge of the ingredients of true porcelain, or who did not know where they could be located, as was sometimes the case, were forced to produce a ware that imitated the finer material. The first and most famous of these soft-pastes was made at Florence in about 1575 under the patronage of Francesco Maria de' Medici, Grand Duke of Tuscany. A pleasing and practical ware was produced by firing a mixture of about 80 per cent white clay, a type of kaolin, together with 20 per cent frit, the materials for glass, which were fused then ground to a powder as a substitute for china-stone.

In France experiments took place at Rouen and Saint-Cloud from about 1673, experiments which by the end of the century resulted in the production of a fine creamy soft-paste porcelain, much like some of the porcelain later produced at the early English factories. There is no documentary evidence, however, to suggest that the English porcelain manufacturers arrived at their formulas by any means other than their own experiments. The varying proportions of the white firing clays, and the use of calcined animal bone or steatite, resulted in a wide range of soft-paste porcelains being produced and these differences help the collector to attribute a piece of porcelain to the factory where it was made.

The glossy coating seen on the majority of ceramic wares is referred to as glaze and was introduced originally to render a porous clay body impervious to liquids, making possible a whole range of new vessels and forms in a material that previously had had very restricted use.

The earliest glazes used in ancient Egypt and the Near East were of the nature of soda-glass, known as alkaline siliceous glaze, which consisted of sand fused with nitre (natron) or some other form of soda. To make this glaze more attractive, copper was added, producing tones of rich blue and turquoise of extreme translucency. Such glazes were inclined to flake away from the clay body and were really only suitable for very porous, sandy materials.

The type of glaze more commonly used on earthenwares by both the Chinese and European potters is known as lead-glaze. Lead-glaze consists of sand, or other forms of silica, fused with the aid of natural sulphide or an oxide of lead. Potash was also often used; it was sometimes obtained from the lees of wine. (A full description of how this form of potash was obtained is given by Cavaliere Cipriano Piccolpasso in his mid-sixteenth-century treatise *Li Tre Libri dell'Arte del Vasaio*.) Lead-glazing was certainly known to the ancient Romans and the Chinese potters of the Han dynasty (206 BC to AD 220); its use was continued throughout medieval times, and it is still used by many present-day potters. In the case of the early primitive wares, the powdered sulphide of lead (galena) was dusted onto the surface of the clay prior to the initial firing; during the firing this united with the silica in the clay to form a transparent glaze or layer of lead-glass. The normal colour of glazes of this type was a rich honey or syrupy tone but if the clay contained other oxides, such as iron, different tints were often evident. The earliest use of lead-glaze in England was apparently in about the ninth century and it was applied in a powdered

form until late medieval times. Unfortunately, the powdered galena was injurious to the potters, who often suffered from what was then called potters' rot, a form of lead-poisoning.

These same lead-glazes could be stained to a limited range of colours with the use of various oxides: iron produced yellows and browns, cobalt produced a blue, copper gave a green, and manganese a wide range of purples and reddish-browns. Mixtures of these same oxides were at times used to acquire less common tones, for example, manganese and iron together gave a near-black metallic-looking glaze. The full range of such coloured glazes is best seen on the work of Bernard Palissy, the sixteenth-century French potter who so successfully stained his lead-glazes before applying them, a process seen later on the beautiful figures of animals attributed to the earlier years of the eighteenth-century Wood family of Burslem, Staffordshire.

The discovery of early fragments of Chinese porcelain on the site of the city of Samarra has already been mentioned: the Near Eastern potter was obviously acquainted with this precious new material but lacked the knowledge necessary to produce it, and therefore a form of lead-glaze was introduced called tin-glaze. This was used to dress up an earthenware body so that it vaguely resembled the ware known only to the Far Eastern potter. Tin-glaze was apparently introduced in the Mesopotamian region as early as the ninth century, seemingly within years of the discovery of hard-paste porcelain. The process was very simple: it consisted of rendering a normally translucent lead-glaze to a white and opaque appearance by the addition of oxide (ashes) of tin. Knowledge of this type of glazing spread along the shores of the Mediterranean, and from the twelfth century we read of 'the golden pottery of Aragon', known today as Hispano-Moresque wares, but merely one of several names for what is basically a tin-glazed earthenware. In Italy these wares were referred to as maiolica; the term faience was used in France; *fayence* in Germany; and Delftware in Holland. The term delftware (without the capital) is used today for the tin-glazed earthenwares made in England from as early as the mid-sixteenth century, though this is rather unfair to the potters of England in view of the fact that their earliest wares pre-date those of Delft in Holland by at least fifty years.

Some of the animals and birds illustrated in this volume are of stoneware, a material most readers will be familiar with, if only in the form of many contemporary marmalade pots, old-type ginger-beer bottles, or underground drainage pipes. Stoneware differs from earthenware in that the clay from which it is made contains sufficient natural fluxes to enable it, when fired at a temperature between 1200 and 1400 °C to reach a point of vitrification, becoming a glassy mass that is completely impervious to liquids. Most unglazed stoneware is an unpleasant material to handle or drink from, although ideal for many forms of ceramic sculpture. From as early as 1300 the German potters learned how to glaze their stonewares in a very effective and cheap manner known as salt-glaze. The process consists of throwing common salt (sodium chloride) into the kiln at the peak firing temperature. The heat causes the salt to volatilize and the sodium in the salt combines with the natural silicates in the clay to form a thin, hard film with a slightly pitted surface, usually referred to by collectors as an orange-peel texture, although this is not at all times apparent.

The glaze applied to hard-paste porcelain is called a feldspathic glaze, and is made from one of the two materials used to produce the porcelain (china-stone) mixed with a little lime, potash, sand or quartz. This glaze can be applied to the body of the ware before it is fired, enabling fine porcelain, sometimes decorated with underglaze-blue or copper-red, to be finished in a single firing. Hard-paste porcelain has the same advantages as stoneware and can be used without a glaze; such bodies without the covering of a glaze are said to be 'in the biscuit'. Feldspathic glazes can be stained before application by using one or both of the high-temperature oxides already mentioned, cobalt and copper.

Because of the composition of soft-paste porcelain, the glaze cannot be fired at the initial firing of the body. Although the temperature required to fire soft-paste porcelains rarely exceeded 1100 °C, this was too high for the glaze used, and the fine layer of lead-glaze was fused to the fired porcelain at a second firing, in the glost kiln. The glaze on soft-paste porcelain never matches the porcelain to the same extent as the feldspathic glaze used on the harder ware of true porcelain; one is always more aware of the glaze and it is often possible to arrive at a conclusion as to whether porcelain is hard- or soft-paste by looking for signs of glaze gathered up in the detailed modelling, especially between features such as fingers.

The major defect so often encountered on soft-paste glazes is known as crazing. This network of fine cracks is produced as a result of the ill-matching glaze shrinking at a different rate to that of the body and it usually occurs when the ware is cooling in the glost kiln, rather than at a later time. However, crazing can be produced on the various hybrid wares by exposure to extreme temperatures, such as plunging into extremely hot washing-up water.

Ceramic wares can be decorated in many ways. The early potter usually considered the varying colours of the natural clays sufficient for his needs, especially when covered with a thick lead-glaze, but use was often made of metallic oxides, chiefly copper, manganese, iron or antimony, producing moss-green, purple, browns or yellows. These same oxides were also used by the potters of tin-glazed earthenware but in this case the colours were applied onto the powdered surface of the glaze prior to firing, a technique that calls for great skill as there is no opportunity for the decorator to correct any badly painted work unless he washes off the entire coating of tin-glaze from the biscuit and glazes a second time.

The only colour that could be satisfactorily fired with a hard-paste porcelain was cobalt, or underglaze-blue; this was a manner of decoration practised by the Chinese potters from the beginning of the fourteenth century. On occasions, the Far Eastern potters also succeeded in obtaining excellent results with an underglaze copper-red, but it was a colour that called for very precise kiln conditions and critical temperatures. It was not until the second decade of the nineteenth century that improved knowledge of chemistry enabled further underglaze colours such as greens and pinks, derived from chrome, to be successfully applied.

The full range of colours normally seen on porcelain and later earthenwares are known as enamel colours – vitreous colours that are fired to a previously fired glaze of any type of porcelain, tin-glazed or lead-glazed earthenware, or sometimes to wares still in the biscuit. These colours are usually applied in a muffle kiln at a temperature not exceeding about 800 °C (beyond this they would very likely burn away).

Whenever enamel colours are fired to the surface of the glaze of a soft-paste porcelain or an earthenware, the colours are inclined to sink deeply into the fusible lead-glaze. The potter is in fact fusing two identical materials, a coloured lead-glass to either a translucent or an opaque lead-glaze, a feature that again helps the collector to differentiate between hard and soft-paste. In the case of a hard feldspathic glaze, the colours are inclined merely to fuse to the surface, sometimes even flaking off, a fault at times seen on the hard-paste porcelain of the English Bristol factory.

These enamel colours were used initially on ancient Roman glass, but are not encountered at their best until the reign of the Chinese Emperor Ch'êng Hua (AD 1465–1487). If gold was wanted as an additional decoration, another firing was necessary, which entailed mixing gold powder or ground-up gold leaf with one of several media, usually honey. After application as a pigment, the gilding was fired at a low temperature and then burnished with a bloodstone or agate, resulting in a bright finish. This early honey-gilding was usually thick and durable, enabling further decoration to be added in the form of chasing or tooling. In about 1780 a rather inferior type of gilding was introduced, known as mercury-gilding. In this process an amalgam of gold and mercury was applied to the glazed ware; during the firing in the muffle kiln, the mercury was lost through vaporization, resulting in a thin film of gold that burnished to an extremely bright and hard tone, considered by today's collectors to be very inferior and a guide to a late date. The modern 'liquid-gold', often seen on late reproductions of Staffordshire flat-backs is even more inferior but has the advantage of not requiring burnishing.

A further decorating technique, introduced in England in about 1751, is transfer-printing, a style of decoration that can be seen on the Wedgwood figure of Taurus the Bull, modelled by Arnold Machin (19, p 125). This technique calls for a skilled craftsman who first engraves the design on a copper-plate. The enamel pigment or underglaze colour, which would normally be used by the painter, is rubbed into the engraved design and any surplus colour is removed from the surface of the copper-plate. A very thin sheet of tissue paper is then carefully applied to the plate and rubbed down in close contact, so that when the paper is peeled off, the colour is lifted from the engraved pattern. The paper is then laid on the surface of the ware being decorated and, after pressure has been applied, is soaked off leaving the colour on the ware, ready for firing in the muffle kiln or, in the case of underglaze colours, the glost kiln.

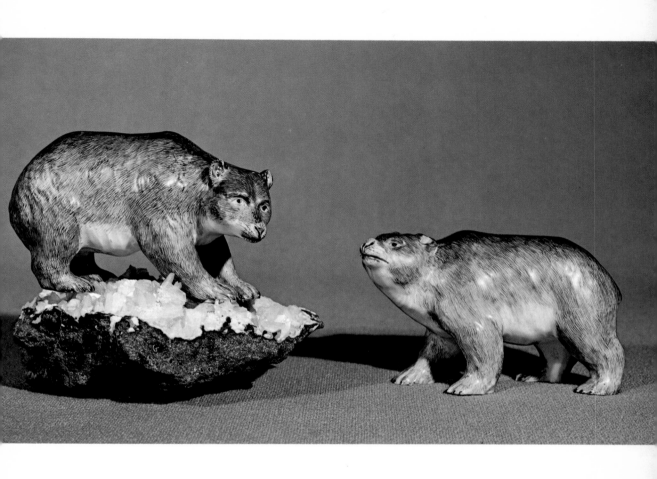

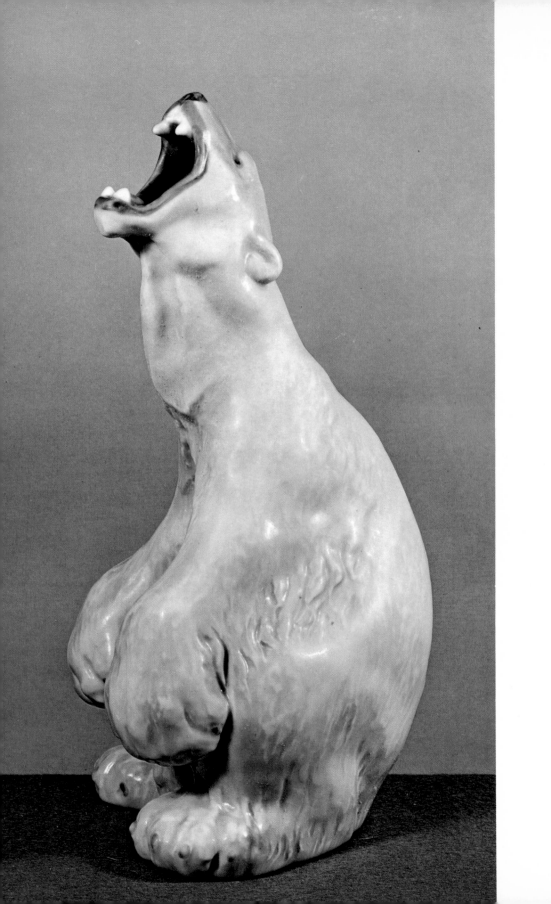

2 The modelling of pottery and porcelain figures

The earliest Chinese ceramic wares were made by coiling. In this method, vessels were built up from ropes of clay in a spiral fashion and the resulting ridged walls of clay were then beaten smooth with a tool. To make the process easier, a slow-wheel was introduced, enabling the potter to slowly rotate the growing form, rather than have to walk around the work. Further developments gradually took place that eventually resulted in the introduction of the fast-turning potter's wheel: the centrifugal tendency of the ball of clay placed in approximately the centre of the wheel is governed by the nestling hands of the potter, who first hollows out the solid mass to form a cylinder of clay, which in turn can be shaped to a wide range of forms, from a shallow saucer-like dish to a tall and narrow or bulbous vessel with a narrow neck. The date of the introduction of the fast-turning potter's wheel is not precisely known but specialists in this field of research suggest around 1900 BC, when a hand-turned wheel was depicted in an Egyptian wall-painting. The potter's wheel is further mentioned in Chinese writing of the Chou dynasty (1027–771 BC). (See *Beginnings of Porcelain in China*.) These methods of forming clay are only applicable for circular forms; the production of more irregular forms or figures calls for different techniques.

The major difference between most ceramic figures and sculptured terracottas is that the majority of figures formed of earthenware, stoneware or porcelain have been produced with the aid of a mould and can thus be easily duplicated, whereas a sculptured terracotta is the original free-hand work of the artist, which is rarely repeated unless as a bronze or plaster-cast. Today a number of contemporary studio potters do form earthenware or stoneware figures by direct modelling, but these call for fairly heavy walls of clay.

The modellers of the early ceramic figures worked in several materials – clay, wax and often wood being used to create the master model. The modeller had to be fully conversant with the technical processes of firing: for example, all ceramic clays shrink considerably on the initial firing, calling for oversize models; there is also a tendency during this biscuit firing for any unsupported part of a figure, such as a limb or other protruding feature, to sag at the peak firing temperature, when the clay has almost reached melting point. The Chelsea Girl-in-a-Swing factory had considerable trouble in this way, due to high content of frit in its material. In consequence, some of their models copied from other factories appear to have been modified to cater for this, so that an arm which may well have been initially raised aloft was placed on the lap instead.

Some of the earliest vessels were probably formed by pressing the plastic clay into a primitive pre-formed mould which could even have been of basket-work. Later, use was made of moulds of either stone or

baked clay. Early Chinese figures were certainly produced by pressing the prepared sheets of clay into simple fired-clay moulds, often consisting of only two parts. A back and a front of a simple tomb figure would thus only require joining down the side seams with clay slip (watered-down clay of the same body as that in use). This process, called press-moulding, had to be carried out while the clay was still in a moist state, referred to as green, or cheese-hard; otherwise the application of wet slip to a dry clay would have caused sudden expansion in a small area, resulting in the clay cracking.

The majority of the German porcelain factories used this method for producing their many figures but assembled the two or three pieces of the mould – say an arm, leg or head – with the clay still pressed to the inner wall. Slip could then be applied inside the hollow shape to weld the pieces together, after which the sections of the mould were again parted and the cast part of the figure in the making removed. Such plaster moulds could often be used as many as twenty-five times but, after this, details of the fine modelling of the original became rather poor. If further models were required, new moulds would be made from the original parts of the model or fired clay replicas, and a factory with a large output would probably make more than one set of moulds initially from the original model. Press-moulded figures are more or less hollow and where it is possible to look inside a figure from the base, it will be seen that the walls of the interior are rough and irregular, often showing tool marks or impressions of the potter's fingers.

The alternative method of producing figures or forms other than in the round is known as slip-casting. The early stages are much the same as for press-moulding. Here the various sections of the mould are assembled, completing a negative of the shape required, and this hollow plaster-of-Paris mould is then filled with slip. The water in the slip immediately starts to be absorbed into the plaster, causing a deposit of clay to form on the inside walls of the mould. When, by experience, the moulder knows he has sufficient thickness of clay, the surplus slip is poured off, and within a very short period the clay shell has dried sufficiently to enable the mould to be opened and the cast removed. The various parts of the figure made in this fashion are then assembled using slip as an adhesive and working to a standard figure for details such as posture.

This method of slip-casting was in use in England from at least 1740, and it was by such means that the Staffordshire potters made their finely moulded salt-glazed stonewares (for example teapots) in the form of horses or camels. However, using this method quickly wore out the moulds, and the salt-glaze potters found it an advantage to make a fired stoneware master block from which further plaster-of-Paris moulds could be made.

Despite all the advances made in the potteries today, the production of a complicated bone-china figure calls for a skill at least equal to that of the men concerned with making some of the finest eighteenth-century figures like those modelled by Kändler at Meissen or Bustelli at Nymphenburg. And so it is fitting that a detailed study should be made of the manufacture of a Dorothy Doughty bird as produced today at the Royal Worcester Porcelain Company, aided by illustrations kindly supplied by the company with technical data by their chief designer, Peter Ewence, who worked so closely with Miss Doughty up to the time of her death in 1962.

The American Birds of Dorothy Doughty is probably the finest volume ever produced to deal with only one type of ware from a factory with more than two hundred years of ceramic history behind it. The modeller and her creations are dealt with in the appropriate chapter devoted to English birds and animals on p 109; here, we will explain the manufacture and the technical problems of this fine porcelain.

The material chosen for the birds was bone china, a material composed of the ingredients of true porcelain together with calcined animal bone, which not only results in a purer white body, but also produces a ware far less brittle than the Chinese type of hard-paste porcelain. The aim of the artist and the company was to produce a series of birds that were accurate in every detail of size and colouring, with the appropriate foliage and surroundings. This meant that the original figures had to be made over-size, to allow for the shrinkage of approximately one sixth on the biscuit firing. What the craftsmen concerned wanted to avoid were the very obvious 'props' seen on even the finest of eighteenth-century wares, where a male figure was made to lean on a tree-stump or pedestal, and the long dresses of the ladies were especially arranged to give the necessary support to help prevent warping. Instead, they wanted each bird, where necessary, to stand on its own two fragile legs.

figure 1

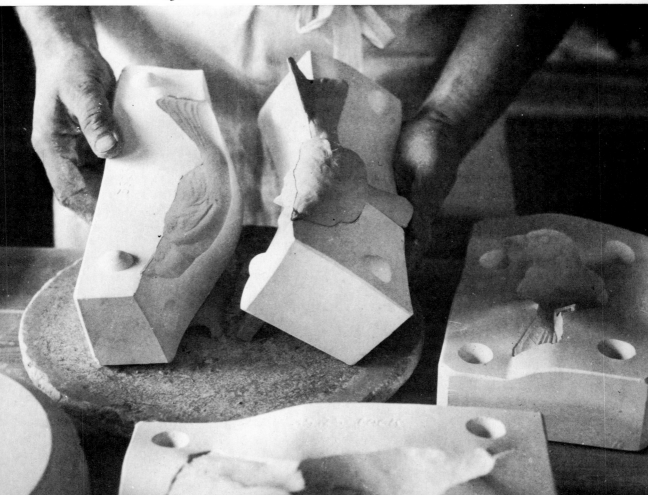

After the modelling is completed, each bird is placed in the hands of the Worcester mould-maker, who cuts it up into pieces suitable for moulding, avoiding any 'undercutting', which would lock the cast into the porous plaster-of-Paris moulds. The average bird together with foliage requires about 20 separate moulds; the magnolia warbler, produced in an edition of 150 pairs in 1950, called for 57 separate moulds. This intaglio mould, or negative, is then used to produce a case mould that is made of plaster to prevent shrinkage occurring. All the various parts of the original model are thus reproduced in plaster. These case moulds are in turn used to make further plaster-of-Paris hollow moulds: the latter have a fairly short life, but when worn can be replaced from the plaster case mould. Work now starts on the making of hollow clay casts, which go to make up the final figure.

Figure 1 shows the craftsman opening the three-piece mould in order to remove the cast, in this instance the body of a scarlet tanager cock, of which five hundred pairs were produced, beginning in 1956. The third part of the mould is shown in the forefront of the photograph, and the portion on the right is from the mould of the hen bird. Care has to be taken at this stage to ensure that no air is trapped in any part of the hollow mould, as this would be likely to cause fire-cracks when the piece shrinks during the biscuit firing. When all the various parts of the figure have

figure 2

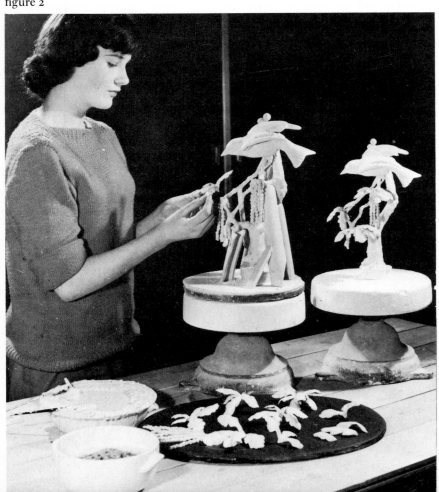

been cast, other craftsmen (or women) assemble the pieces, working to a standard figure. This is illustrated in figure 2, with the scarlet tanager cock being mounted upon the white oak foliage. It is interesting to note that contrary to the usual practice, the leaves and flowers are dry at this stage and the stems are nearly dry. Miss Doughty found that the leaves on her earliest model were too thick and lacked the naturalism she was aiming for. In order to achieve this, she was assisted by an elderly Maltese craftsman at Worcester, whose speciality at that time was making by hand the beautiful fine flowers used for decorating pin-trays. His technique was passed on and is now used by a team of craftswomen at the Worcester factory, who still make these flowers by hand.

The smaller model on the right of the photograph is a fired and glazed standard which is used as a guide for the correct assembly of the leaf sprays. A comparison of the two models shows dramatically the shrinkage that takes place on firing.

It is during the first firing that the model is at greatest risk and without the skill of the foreman of the casters, could well become a 'waster'; in the case of these birds, such a piece would be destroyed in order to main-

figure 3

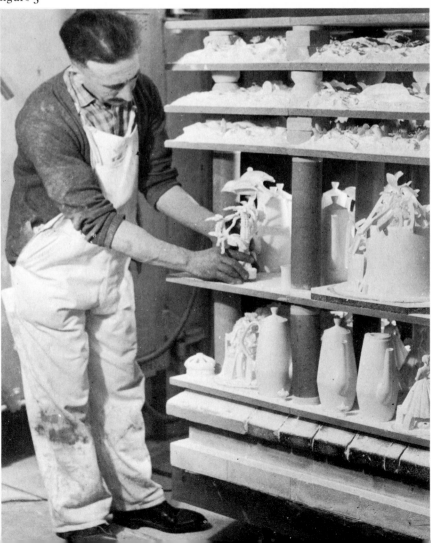

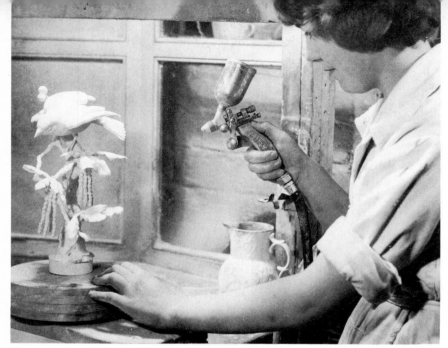

figure 4

tain the highest possible standard. Figure 3 shows a craftsman holding a
fired group, with the props already removed. The complicated assembly
seen on the right is straight from the kiln; here the figure is still
obscured by the props that helped to hold the clay in position during
firing. These clay supports are necessary to hold the free-floating parts,
which are often quite heavy, in the position required during firing; they
prevent sagging and, where the props actually touch the model, the
surfaces are dusted with powdered alumina to stop adhesion. The
wares are still on the conveyance where they are stacked, which is then
pushed on rails into the tunnel kiln for firing at a temperature of 1260 °C
(2300 °F). Today these critical temperatures are controlled by highly com-
plex instruments – something one should remember when admiring the
many fine figures of the eighteenth century that were produced under
comparatively primitive conditions.

After removal from the biscuit kiln, the figure is ready for glazing. With
the Dorothy Doughty birds, the fine layer of glaze is applied by air-
spray (figure 4) rather than by the more usual dipping which would put
too thick a glaze on such fine modelling. It is only on the eyes that a thick
glaze is placed, in order to capture a life-like lustre. The glaze is then
fused to the surface of the figure in a glost fire, after which it is ready for
colouring. The finished colours of the series were only decided on after
long consultations and many trials by Miss Doughty and the foreman
painter of the factory.

The enamel colours derived from metallic oxides are fused to the glaze
in a muffle kiln at temperatures ranging between 720 and 850 °C, different
colours requiring slightly different temperatures. In the case of the figure
illustrated (figure 5) three separate firings are necessary to add all the
colours.

The skill required to assemble these birds is further shown in the last
three photographs, where a craftsman is seen assembling a whitethroat hen,

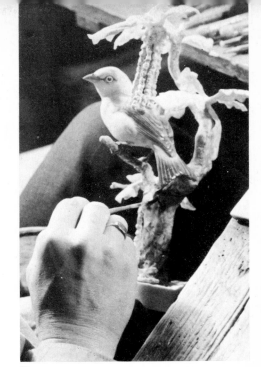

figure 5

figure 6

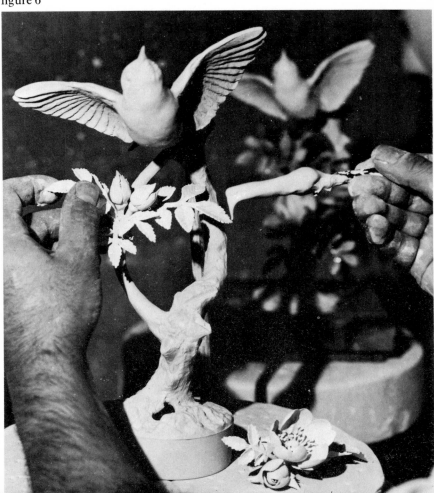

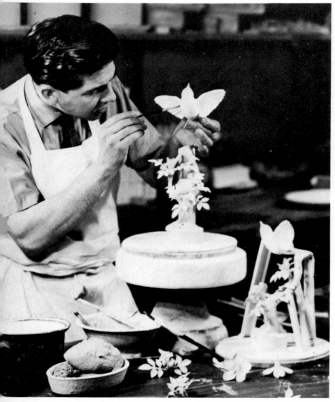

figure 7 figure 8

Figures 1 to 8 courtesy The Royal Worcester Porcelain Company Limited

one of the series of Doughty British birds first published in 1962. In figure 6 the wet slip is being held on a piece of wood and used as an adhesive to attach the dry flower sprays to the nearly dry framework of stems. Figure 7 shows the same group in stages of assemblage, and the props used to hold the figure up during firing are being placed in position in figure 8.

Despite all the advantages of modern technology, such fine figures can only be successfully produced by skilled craftsmen, and even today the high standard insisted upon at the Worcester factory often necessitates the destruction of models not considered one hundred per cent perfect. Since their introduction these fine Doughty figures have been produced in limited editions. The first pair of birds in the American series, redstarts on hemlock, were produced in a limited edition of 66 copies in 1935. The series now consists of 38 pairs and 7 single figures. There were only 22 examples of the bob-white quail issued, making this a rare collector's item, whereas the majority of the later figures were issued in editions of about 500. Once the requisite number of figures has been produced, the moulds are destroyed, thus creating what might well be termed instant antiques.

The history
of animal sculpture

3 The Middle East

In the introduction, comment was made how primitive man quickly learned to model clay in the form of human or animal figures, and then bake them for greater durability. The earliest evidence of man using clay for the production of useful wares dates back to about 6000 BC and it was almost certainly the Near Eastern potter who first made clay shapes to serve his daily needs and replace the many wares he had previously fashioned from other less practical materials such as skin or natural gourds.

By 4000 BC the potters of Mesopotamia and Persia had abandoned the early type of open hearth firing (where both fire and clay wares were piled up under a covering of earth) in favour of the vertical kiln, where the wares were stacked within the kiln and were not in direct contact with the fire. Glaze was unknown at this early date and so earthenware vessels were made less porous, either by removing impurities or irregularities from the clay by smoothing out the surface while it was still very wet, or by coating with a slip of refined clay that would later be burnished to a pleasing glaze-like finish with a stone or some other implement of a hard, smooth substance.

Egypt

The figure of a hippopotamus (123, p 208) was made in Egypt during the Middle Kingdom and dates to about 1900 BC (XIV dynasty); it is coloured to a rich bluish-green by a copper alkaline glaze that was used in Egypt from pre-dynastic times. The hippopotamus is a well-known early animal form of a type found among the funerary furnishing of tombs of this period. It is difficult to justify this animal as a tomb figure but according to contemporary wall-paintings both the hippo and the crocodile were hunted in the Egyptian waters of the Nile. Foxes, apes and dogs have also been found as pottery tomb figures of the same period.

Animals appeared in many guises during the XXVI dynasty (Ptolemaic period) and were at times very realistically modelled: this is particularly the case with figures of crocodiles, sows, camels, and so·on. The cosmetic vessel in the form of an ibex (1, p 32) is a typical example and it is interesting to note the amount of detail achieved by the modeller on this extremely small figure.

The small toilet-pot or *aryballos* comes in many forms, both in Egypt and Greece, where similar vessels are termed *Aeginetan* because many such objects were found in the island of Aegina. The Greek examples are usually of much poorer quality and far less interesting than that illustrated (124, p 208).

The early Egyptian potter frequently used animal or bird forms as terminals on various items of ritual regalia; these were sometimes birds such as hawks with human heads, but the terminal of a staff in the form of a monkey clasping its young one (100, p 194) is an exceptionally fine illustration of this fashion. By comparison with these, the crocodile in the form of a foot-rasp (107, p 198) is comparatively modern. This functional piece was made at Assiut in Upper Egypt, in about the middle of the nineteenth century; it is of red earthenware, decorated by incising into the clay prior to the biscuit firing, and burnished with a tool composed of a stone or a similar hard material to give a glaze-like finish. The base is roughed up in the manner of a coarse metal rasp, making an ideal implement for removing the hard skin from the soles of the feet. Similar wares were also produced in the same area at a slightly later date in a black burnished earthenware.

1 Cosmetic vessel in the form of an ibex, in earthenware. EGYPTIAN (Memphis), about 600 BC; height 7 cm/2¾ in. (p 31)
Courtesy The British Museum, London

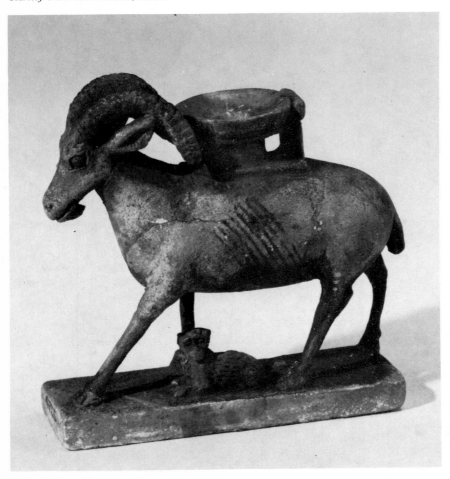

Persia

The potters of the Near East had no access to ready supplies of either china-clay or china-stone, the two clays essential to the manufacture of true porcelain. However, from the twelfth century this deficiency was made good by the introduction of a translucent white composition that had much in common with some of the earlier soft-paste porcelains of Europe.

The cat (43, p 160) is composed of this type of material and dates from some time during the first half of the seventeenth century. It was made at Meshed where, according to the writings of Chevalier Chardin in about 1670, some of the best Persian pottery was produced. This is no ordinary cat for, apart from being a Persian, it forms the water-container of a 'hubble-bubble' tobacco-pipe *(kalian)*. A metal tube from the pan of the burning tobacco ran down through the vessel into the water, and when the smoker inhaled through a tube from above the water-level, the smoke was drawn through the water. Kalians are also to be found in the form of birds or other animals, while others are obviously based on the simple Chinese water-pourer. Wares of this same material are to be found in the shape of sitting birds and made to serve as foot-rasps, as previously described.

The Persian style of painting in underglaze-blue was very similar to that of the Chinese and evidence has now come to light that a great deal of Persian ware was shipped to Europe by the Dutch East India Company during the third quarter of the seventeenth century when, because of unrest in China, it was difficult to obtain sufficient Chinese export porcelain to meet the demand for it.

Turkey

The ewer in the form of a horse (95, p 191) is of no great age and such examples of Turkish peasant-ware are encountered surprisingly frequently in this country. Both horses and camels were made in this style at Chanak Kalé on the Dardanelles during the nineteenth century. They are of reddish earthenware body, decorated with various coloured slips and high-temperature coloured glazes. New collectors sometimes confuse these pieces with the English eighteenth-century earthenwares that have the Whieldon-type glazes, but the Turkish examples can be very easily distinguished by their 'cotton-reel' legs. Another common type of vessel from the same area is the tall jug with a very bulbous body and a long neck that terminates in an animal-form mouthpiece. These are usually decorated with crudely applied flowers under a green or purplish-brown glaze.

4 China

It is generally accepted among ceramic collectors that the finest pottery and porcelain ever produced is of Chinese origin. Dating from the end of the Stone Age (about 2500–1500 BC) is a class of fine, hard, reddish earthenware jars, made by the technique of coiling with ropes of clay, painted with gracious geometrical patterns in red and black pigments. These wares, which have been found in tombs in the Kansu area, flanking the Yellow River in the north of China, were made as funerary jars and vary considerably in size. No figures of a comparable material or period appear to have been made; none in any case have been identified.

The earliest Chinese dynasty of which we have knowledge is the Shang-Yin period (1600–1027 BC). From this time the Chinese made not only some exceptionally fine bronzes, but some coarse thinly-made stoneware, partially glazed with the use of feldspar, a type of ware that by the end of the succeeding Chou dynasty (1027–771 BC) was also being made in the south-east of the country.

We owe the survival of many figures to the long-established practice of placing pottery models in burial tombs. An exhibition of Chinese art was held in 1973/74 at the Royal Academy, London, showing wares excavated from tombs only four years previously. Excavation of graves dating from the late Chou period at Hsi-Hsien, Honan, Manchen, Hopei and elsewhere has cast new light on a wealth of material that can be dated almost precisely. Many pottery vessels were made as a cheap form of the more precious metal ones and were termed *ming-ch'i*, meaning 'that which is for the usage of the dead'. These wares were probably inferior to the contemporary pottery wares made for 'the living', but the latter did not survive. The practice of burying a wealth of material with the deceased was to ensure that they had sufficient for their needs on their way to the next world. Much later, during the Sung dynasty (AD 960–1279), the pottery tomb furniture gave way to similar articles in wood which, like the pottery, have only rarely survived. Today the custom is continued by the burning of paper images.

It is from the period of the Han dynasty (206 BC to AD 220) that tomb figures have been found in such large quantities. The dog (67, p 173) is in a good state of preservation and still retains its green lead-glaze; it is of the Ch'ang-sha type. This green glaze, of which so many figures still show traces, was a lead-glaze coloured with copper, and often these pieces take on an unintended beauty owing to the partial decay of the glaze which results in a colourful surface iridescence. An enormous variety of animals has been found among the tomb figures of this very early date.

Great importance was attached to the *ming-ch'i* and the correct placing of the individual pieces within the tomb. In the case of a military personage, the retinue comprised what amounted to a funeral procession, sometimes

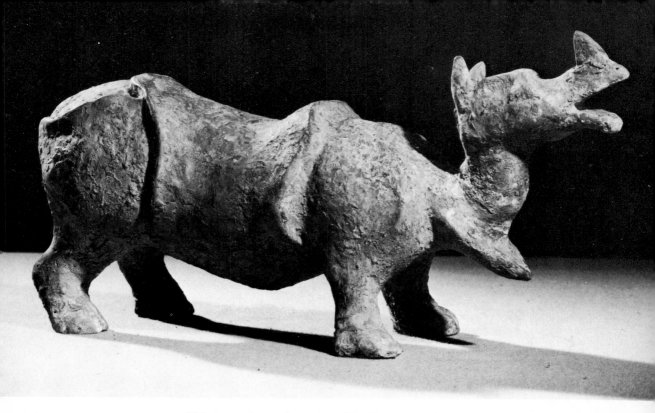

2 Rhinoceros in earthenware with olive-green glaze. CHINESE (Han dynasty), 206 BC to AD 220; length 29.2 cm/11½ in. (p 35)
Crown copyright, Victoria and Albert Museum, London

of as many as seventy-five pieces. Their number and size were standardized according to the rank of the deceased, the numbers ranging from ninety for a very important person down to fifteen for a commoner. It has been suggested that it was quite usual for a person to visit the model-maker and select the figures that he wished to have accompany him at a later date.

It cannot be said that these early figures had any tendency towards delicacy. On the contrary, they are usually exceedingly lumpy, and give the feeling of clay sculpture in its early stages of making; this is well illustrated in the vigorous figure of the rhinoceros (2, above). In this instance the animal is partially covered with an olive-green glaze. There must also be some doubt as to whether an animal of this obvious form was really intended for tomb furnishing.

The Six dynasties (AD 220–580) is a time that has been referred to as the Dark Ages of China, when the country was divided under several rulers and subject to many invasions from Central Asia. In consequence the progress of many forms of art suffered. The production of sculpture and bronzes continued almost alone, and indicates the increased following of Buddhism; the few pottery wares attributed to this period can sometimes be dated by their similarity to such examples, but it is again tomb excavation that enables an authentic date to be given. The horse shown in such an unusual pose (87, p 185) is an exceptionally fine example of a tomb figure considered to date to the Six dynasties, when there was a movement towards finer detail and realism. The modeller no longer relied solely on a good form, and it is often noticeable that even simple figures of ducks and

35

other birds were incised with lines to simulate feathers and other details. The figure of the ram (117, p 204) is a particularly well-preserved piece of this date; it is of white clay with rich brown and brownish-yellow glaze.

Guardian lions and dragons were common tomb figures used to ward off any evil spirits, and they were placed near the entrance to the tomb. The lion, of course, is sacred to Buddhism and from the time of the Six dynasties he is increasingly used in many forms of Chinese art.

The animal of fantasy (78, p 179) is dated to the Northern Wei dynasty (AD 319–535) and is made of earthenware with painted decoration. This dynasty is famous for being the first in China to adopt Buddhism as a state religion.

Of special importance during the Six dynasties was the introduction of a fine high-fired stoneware, sometimes referred to as protoporcelain. Made in Chekiang from some time in the third century, these Yüeh wares contained clay of a fusible nature that was rich in feldspar, and this material was eventually to be developed to form the first white, translucent, hard-paste porcelain in the world. It is rather surprising to find it being used to make figures merely for burial. The beautifully modelled figure of a Bactrian camel (40, p 158) is also of the Wei dynasty; of earthenware painted in coloured slips, it is a forerunner of the many camels made during the T'ang dynasty that followed. A further essential part of the tomb furnishings appears to have been a wagon drawn by oxen. Illustration 3 (p 39) is a splendid example of this, and was made sometime during the sixth to seventh centuries. There are very few genuine examples of models of this type in existence: because of their very complicated and fragile form, they seem to have only rarely survived.

With the accession of the T'ang dynasty (AD 618–906) the *ming-ch'i* became even larger and more prolific so that by the end of this period regulations had to be enforced as to their number and size. The figures took on a new naturalism and rhythm of movement and their beauty was further enhanced with the addition of richly-coloured glazes. The majority were made of soft pinkish earthenware, with a coating of clay slip. Many were covered with lead-glaze decorated with rich colours of high-temperature oxides, best seen on the camel and groom (2, p 2). These camels are often shown laden with the articles of trade that they normally carried on the overland caravan routes between China and Islamic Iran and Mesopotamia. There is a very fine example of one in the British Museum. It stands 83 centimetres (33 inches) high and is an authenticated model from the grave of Chancellor Liu T'ing-hsün who died in AD 728. Caution must be exercised when such figures appear in unusual forms, for figures of both horses and camels have at times been re-assembled from broken pieces of a variety of models and made up into interesting postures by skilled repairers. An early suggestion by W B Honey that the fighting stallions from the well-known Eumorfopoulos Collection had been reconstructed in this manner has since proved correct.

From the days of the Han dynasty the horse played an important part in the exchange of goods with Central Asia, for the Chinese had need of fine horses of Arab blood for their warriors. Sometimes they were obtained by trading with silk, and other times by seizing the large swift horses used

5 Incense burner in the form of a cockerell in hard-paste porcelain, painted in enamel colours and gilt. JAPANESE (Arita), early eighteenth century; height 24.8 cm/9¾ in. (p 44)
Victoria and Albert Museum, London

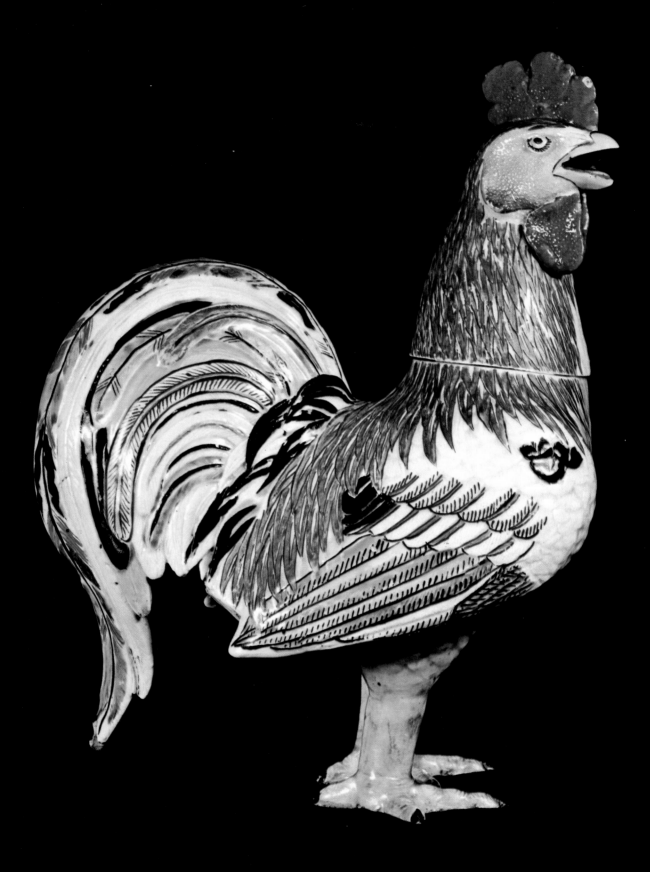

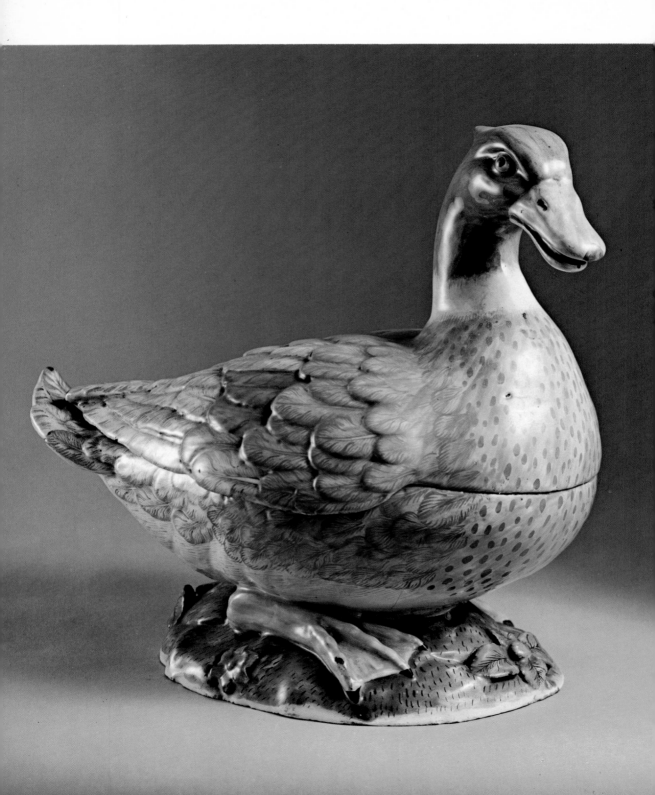

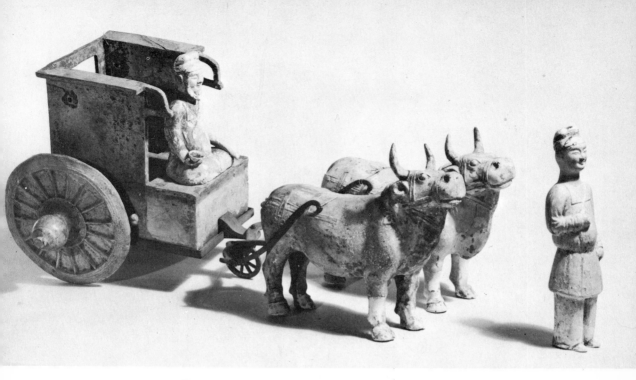

3 Oxen and cart with attendants, in earthenware. CHINESE, sixth to seventh century; length 45 cm/17½ in. (p 36)
Courtesy The Ashmolean Museum, Oxford

to bring trading caravans from the West. Horses were, therefore, a necessity for both the deceased and his attendants, and there are many forms of this animal in a variety of postures. One early and interesting form is made up in separate sections: the head and the neck are made to dowel into the robust body, but on the underside of the body, where the legs would normally join up, there are only holes. The legs would almost certainly have been carved from wood and a tail of real hair inserted into the hole left in readiness. These horses were often decorated in red and white unfired pigment, and are a class that has been reproduced over more recent years.

One of the outstanding exhibits in the 1973/74 London exhibition of Chinese art was a bronze horse from a late Han dynasty tomb at Lei-tai, near Wu-wei in the Kansu province. This horse shows all the Chinese desired of a fine steed: a swift galloping stance comparable to a flying bird and a proud impatience to carry the warrior to battle and victory. Records tell of the six blood-sweating horses used by the Emperor T'ai-tsung during the early seventh century, and of the ten chargers, presented to him in AD 647 by Turkish tribesmen, with such names as Sunset Flying Roan and Running Rainbow Red, names sounding more appropriate to the American Indian. The sale of such horses was strictly controlled by regulations, restricting their ownership to certain people of high social standing. Thus it can clearly be understood why fine models of horses were considered so important as tomb furnishings. The horse illustrated (88, p 186) is an excellent example.

6 Tureen in the form of a duck in tin-glazed earthenware (faience), decorated in enamel colours. FRENCH (Strasbourg), about 1750; length 39.5 cm/15½ in. (p 80)
Copyright Germanisches Nationalmuseum, Nuremberg

Further interesting T'ang period figures were made in a buff-white clay with mottled blue, yellow and white glazes, but because of the yellow tinge of the lead-glaze, blue was not the most successful of the range of high-temperature underglaze colours. The water-buffalo and rider (125, p 209) is an example of this material and palette; tidied up, it could well pass for an eighteenth-century model by a Staffordshire potter such as Thomas Whieldon. Similar figures were also produced in the *blanc-de-Chine* of the eighteenth century made in the Fukien province of south-east China. The large jar in the form of a goose (25, p 149) is again a reminder of how the Chinese potters seemed to anticipate all future ceramic forms; this piece can well be compared with the French faience tureens of the eighteenth century made at Strasbourg. The goose is of the usual pinkish earthenware body, with the well-placed coloured glazes as seen on the camel.

During the late T'ang dynasty the secret of the manufacture of true porcelain was discovered and in the period of the Five dynasties (AD 907–960) the improvement of wares in this new material continued and a great deal of porcelain was exported as far as the Middle East and Japan. Although the practice of burying large quantities of cheap earthenware in the tombs largely discontinued, a certain amount of lead-glazed earthenwares, which are difficult to date precisely, were undoubtedly still being made in the early Sung period that followed.

The Sung dynasty (AD 960–1279) is of particular importance for the production of high-fired stoneware and porcelain. Apart from a late class of figures made at T'zu Chou from a stoneware covered in cream-coloured slip and decorated with red and green enamels, almost the entire dynasty was devoted to the manufacture of superior vases and dishes illustrating many varieties of beautiful glazes, often made to imitate bronzes or jades.

The great Ming dynasty (AD 1368–1644) has often been referred to as the Renaissance period of China. Ming means bright, and the colourful pottery is quite a contrast to the comparatively sombre Sung wares. The city of Ching-tê chên took on a new importance as the ceramic centre of China when the Emperor Hung Wu decided in 1369 to establish an imperial kiln within the city for the production of porcelain, most of which was decorated in underglaze-blue.

From the start of the Ming dynasty it became the practice to write on the base of wares the mark of the reigning emperor. However, this identification very soon became untrustworthy, particularly during the reign of the Emperor K'ang Hsi, because the wares were often marked with the names of earlier Ming emperors such as Hsüan Tê, Ch'êng Hua, and Chia Ching, during whose reigns some very fine porcelains were produced. These false reign marks were not at first intended to defraud, but were more a mark of veneration for the vintage years of porcelain.

During the Ming dynasty, as in the Sung, very few figures were produced in either earthenware, stoneware or porcelain to preserve a continuity in spirit with earlier T'ang examples. Ridge-tiles are an interesting exception. These tiles were placed upon the corners of the roofs of buildings and were intended to fend off evil demons. They took the form of horsemen, dragons, fighting men, lions, and many other fantastic shapes. Their quality varied, but they were nearly all glazed in the bright high-temperature colours.

From the time of Emperor K'ang Hsi (AD 1662–1722), in the Ch'ing

dynasty, there was a noticeable influence throughout China of western fashions and styles in all the decorative arts. In 1680 the emperor set up an imperial kiln in the city of Peking itself, but this idea did not prove practicable and by 1682 the factory had been re-established in Ching-tê Chên. It is difficult to visualize at that early date a city where, according to Père d'Entrecolles, over one million people were working on the production of porcelain, involving the use of more than three thousand kilns. Porcelain now took on an almost monotonous perfection, and the wares are of such refinement that it is difficult to appreciate that they were made by hand from a plastic clay.

The majority of figures made in the K'ang Hsi period were of the *famille verte*; this *wu ts'ai*, or five-coloured painting, was in two shades of green, iron-red, yellow and aubergine. These coloured glazes were in most cases applied directly onto the biscuit porcelain, in preference to fusing enamel colours onto a previously glazed body. This technique was used to make numerous small figures – lions (or dogs of Fo), horses, elephants, parrots (which have been the subject of many recent imitations), and so on. In the past much confusion has arisen over the various symbols and motives used in Chinese art, and probably no two mythological animals have been more subject to misnomers than the kylin and the dog of Fo.

The kylin was considered in China in much the same way as the unicorn in Europe. It was a completely legendary animal, half male *(ch'i)* and half female *(lin)*, hence *ch'i-lin*, or kylin. It is one of the four mythical animals of China, the others being the dragon, the phoenix and the tortoise. The kylin was thought to have a life span of a thousand years and, if sighted, was considered a wonderful omen of good fortune. Although they have been modelled in other materials in many sizes, images of this creature are hard to find in pottery or porcelain; this is certainly not the case with figures of the dogs of Fo, or guardian lions.

Dogs of Fo (52, p 164) are generally found in pairs; these are intended to depict the male at play with a brocaded ball, with the female fully occupied with one or more cubs. The lions are usually made to serve a useful purpose and often have small cylinders attached which were intended to hold a joss stick. The true lion is not indigenous to China and it was not depicted in primitive art, but gifts of such animals were most probably received by emperors of the T'ang dynasty. The Chinese interpretation of this animal is usually of a ferocious and frightening guardian rather than an attacker, and it was particularly associated with Buddhism as a defender of law and a protector of sacred buildings and tombs. Dogs of Fo were made in great quantities during the reign of the Emperor K'ang Hsi and have been reproduced in China for sale in Europe right up to the present day.

Some of the most delightful pieces of porcelain made during the reign of the Emperor K'ang Hsi were for the use of the scholar. Illustration 113 (p 201) shows a small water-pot used for mixing ink; it is painted in enamel colours applied onto the biscuit.

Since the seventeenth century many birds and animals have been made in the beautiful white porcelain from the kilns of Tê-hua in the southern province of Fukien. This material has a colour range varying from a warm white to a pale grey; its glaze is fine and well fitting, giving the appearance of a 'solidified milk jelly' (W B Honey).

In the first quarter of the eighteenth century a new opaque rose-pink enamel was introduced to China from Europe for the decoration of porcelain and enamels that were primarily intended for export to Europe. This colour gave the name to a new class of porcelain known as *famille rose*. During the reigns of the Emperors Yung Chêng (1723–35) and Ch'ien Lung (1736–95) a great many porcelain birds were produced that often included this rose-pink enamel in the palette. The birds were generally of an exotic type, cocks, hawks, cranes, pheasants and the phoenix, and were usually standing on a rocky mound. Great experience is necessary to attribute these figures to a definite period, for like so many wares that proved popular to European collectors, they have been made continuously from the eighteenth century up to today. A close examination of the material, the glaze and the painting and a comparison with documentary specimens, as shown in major museums, is absolutely essential.

During the eighteenth century some rather fine stonewares were produced in the Canton area of the Kuangtung province; these Canton stonewares are usually in the form of rather large, heavy vases with glazes coloured to resemble those used during the Sung dynasty. A charming figure made in this material is the hare (114, p 202); it is covered with a very appropriate semi-opaque white glaze and is one of a pair.

5 Japan

Hard-paste porcelain was unlikely to have been made in Japan prior to about 1616, when a Korean potter named Ri Sampei first discovered the necessary ingredients of china-clay and china-stone in the area of Arita. From that time their wares consist almost entirely of vases and dishes and were mostly decorated in a poor quality underglaze-blue. But by 1700 the Dutch traders were shipping large quantities of the so-called Imari wares to Europe, decorated in the characteristic confusing and fussy manner with chrysanthemums and scrollwork in blue, red and gilding.

4 Incense-box in the form of a swan in light buff clay. JAPANESE (Kōtsuke), 18th or 19th century; length 9.4 cm/3¾ in. (p 44)
Freer Gallery of Art, The Smithsonian Institution, Washington DC

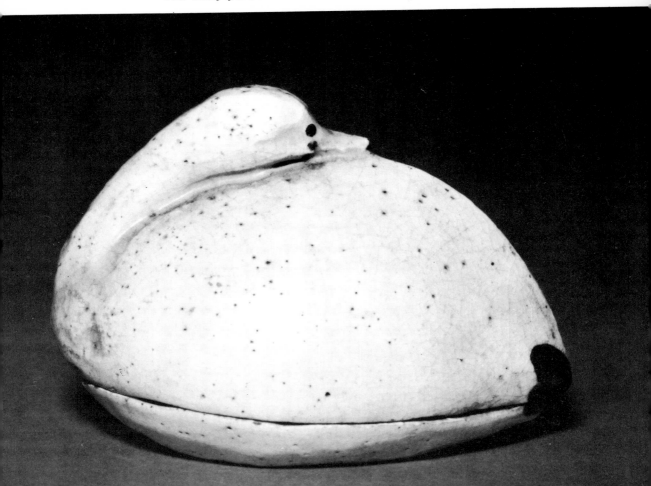

A more pleasing decoration is the so-called Kakiemon style, said to have been introduced in about 1644 by Sakaida Kakiemon, a Japanese potter who was to bring fame to the manufacture of ceramics by his beautiful styles of decoration – styles that were to be imitated throughout Europe during the eighteenth century. An example of Arita porcelain is the cockerel (5, p 37). It is in the form of an incense-burner, and is decorated in the popular Kakiemon palette; one must forgive the very thick legs, which were obviously introduced to enable the bird to stand up without support.

The incense-box (4, p 43) is considered to be a resting swan and is of light buff clay with cream-white glaze, has black eyes and tail, and a red and yellow bill. It is difficult to date and could have been made in either the eighteenth or the nineteenth century. This box was made in the Owari province and is described as Shino-Oribe: Shino wares are covered with a rich white feldspar glaze, Shino being a corruption of the word *shiro*, Japanese for white; Oribe is derived from the name of a pupil of a famous potter of wares made for the tea-ceremony.

The figure of a cat (45, p 160) serves no useful purpose; it is of grey-buff clay, with mingled cream glaze, yellow, pink and greenish-brown glaze, and again dates to the eighteenth or nineteenth century. It was made in the province of Yamashiro, in the neighbourhood of Kyōto. Also of the same place and time is the pair of incense-burners in the form of quail (34, p 154); they are of stoneware decorated with dark bronze touched with silver, the upper body being in bright brown mottled with grey.

The dating of Japanese pottery is very difficult. Wares are usually peculiar to a particular kiln, family or school and there is very little difference in style over many generations. Most are named or dated by the contemporary pieces being made by the potters who achieved fame through the wares they made for the tea-ceremony, which called for utensils of an extremely high aesthetic standard.

6 Central and South America

Among the most fascinating of all animal forms in pottery are those about which we know comparatively little: such are the wares made in Central and South America in places like Mexico, Peru and Ecuador, during the pre-Columbian centuries.

The materials necessary for the manufacture of any type of porcelain appear to have been completely unknown to the potters of these areas, and glaze was only rarely applied to their wares although the clay was often burnished to a glaze-like finish. The potters responsible for these primitive but highly original figures and vessels in animal form were likewise ignorant of the advantages of 'throwing' a pot on a fast-turning potters' wheel, but they were fully conversant with all the other known methods of forming clay to the desired shape, including coiling, moulding and modelling by hand.

Interesting variations of colour were achieved by changing the kiln conditions: for example, the bright clay colours of reds and orange obtained through the use of an oxidizing kiln fire, and the drab sombre colours obtained by reducing the amount of oxygen (in a reduction kiln). In addition, various coloured clay slips and paints of many hues were applied in a great variety of interesting and unique styles.

Some of the earliest animal forms illustrated here are those from Mexico between about 1500 BC and AD 300, known as the Formative period. The skill of the potter during the early part of this period was devoted primarily to producing the essential cooking utensils, although small clay effigies, possibly votive offerings, are known. The delightful figure of a frog (104, p 196) is attributed to the culture of Colima in western Mexico, where the potters had developed an individual style, differing in many respects from wares produced in other Mexican areas. The Colima craftsmen were particularly skilled in modelling their clay in the form of human and animal subjects. The large red earthenware vessel in the form of a crayfish (83, p 182) illustrates their familiarity with marine creatures. Among the most familiar of their animal forms are the rather comical little Mexican dogs, made to serve as vases.

The Classic period covers the years from about AD 300–980, during which time great developments were made in South American civilization. These years saw the building of large cities, temples and other major constructions, many of which were associated with the worship of gods. Among the most progressive areas during those seven centuries was the south-east, embracing Chiapas, Yucatan, Guatemala and Honduras, where the Maya culture prospered. The painted red earthenware alligator (106, p 198) is considered to have been produced in this region, where use was often made of clay slips of all the available colours, with incised decoration.

45

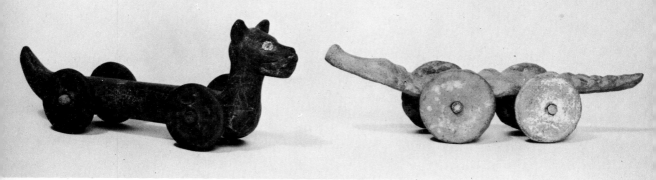

5 Two wheeled toys in the form of a dog-like animal (left) and an alligator (right), both in clay. MEXICAN (left, Tarascan, state of Nayarit; right, Maya culture, state of Veracruz), about AD 800–1250; lengths 24.7 cm/9¾ in and 25.4 cm/10 in. (p 46)

Courtesy Museum of the American Indian, Heye Foundation, New York

Also attributed to Mexico is the animal of fantasy with two heads (79, p 180) which dates from about AD 300–1250. Such pieces were made by the Tarascans, who lived in the state of Nayarit in the western part of the country, and who are probably better known for their beautiful jewellery made towards the end of this period. The dog-like animal, obviously made as a wheeled toy (5, above left), is also thought to be the work of these people. The wheeled alligator on the right of the illustration is almost certainly of the same date (late Classic to early Post-Classic period, AD 800–1250) but is said to have been made in the state of Veracruz, an area seemingly influenced by the art of the surrounding regions. Animal figures from this area are comparatively rare, although elaborate figures in human form were produced over a long period with the aid of moulds.

From about 800 BC the people of the Central Andes, who were among the most skilful of all early South American potters, worshipped a god in the form of a cat, and this cult became very widespread throughout Peru. The people making up this culture were the Chavin or Cupisnique (taken from the name of the valley where they were originally established). The stirrup-spout vessel in the form of a cat (42, p 159) is the work of these Chavin people and dates from about 800 BC. These stirrup spouts remained a popular form up to the time of the Spanish conquest of Peru in 1528 and were produced in the shapes of a large variety of animals (or sometimes just their heads), most of which were modelled in a highly stylized fashion, often making it difficult to give a precise name to the creature depicted. Painting was only rarely used on these Cupisnique wares, most

opposite

7 Two swans in salt-glazed stoneware, painted in enamel colours by William Duesbury. ENGLISH (Staffordshire), about 1750; height 14 cm/5½ in. (p 122)

Victoria and Albert Museum, London

overleaf

8 Pair of parakeets in soft-paste porcelain, decorated in enamel colours, and marked with an anchor in red enamel on an applied medallion. ENGLISH (Chelsea), about 1755; height 12.7 cm/5 in. (p 95)

Courtesy Winifred Williams Limited, London

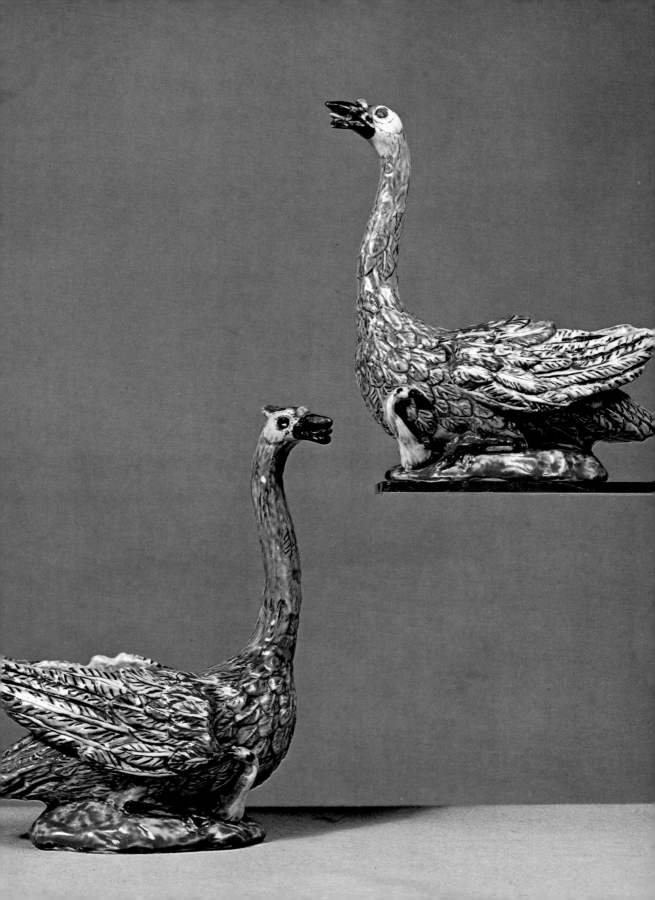

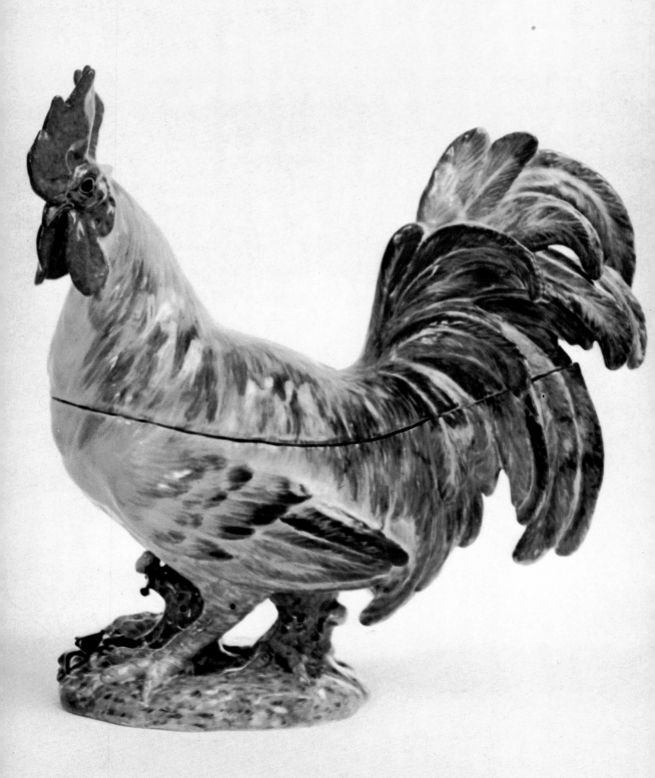

decoration or representation being achieved by modelling, incising or stamping of the clay to give a variation in the texture.

Also from Peru, but of later date, is the black pottery jar with a small mouse in full relief (111, p 200) attributed to the area around the Lambayeque Valley, in the north.

From the beginning of the Christian era a great advance was made in the production of pottery by the peoples centred around the northern Peruvian valleys in the area of the Chicama River, where both the Mochica and the Nazca groups achieved a very high standard. A typical example is the red and white decoration on the tiger vessel (50, p 163). Because the full relief modelling was achieved by using moulds, near duplicate wares are by no means uncommon. Their stirrup-spouted vessels were like those produced by the Cupisniques but were generally of a finer pottery with thinner clay walls; similar, well-potted forms were often made of animals or decorated with animal or bird subjects. Many Mochica pots were buried in the tombs of the deceased at the time of interment; these tombs have in many instances been robbed during more recent years and the 'loot' made available to museums and collectors throughout the world.

Although the country of Ecuador borders on Peru, its pottery has much more in common with South American areas other than Peru. Despite its comparatively small size, its pottery is by no means of a consistent type. One kind of vessel, found in the north, is of an animal, such as a bear, lying on its back with the stomach opened to form a bowl.

Of all the various peoples known to have inhabited pre-Columbian America, the name Inca is probably the most commonly associated with those times. The Incas originally settled at Cuzco in Peru in about AD 1200, but were of not much consequence until the early fifteenth century when, with a little fighting and a lot of diplomacy, they quickly established an empire that covered territory from north Ecuador down to Chile – a domain they dominated until they themselves were in turn conquered by the Spaniards.

In spite of producing a great deal of pottery, their forms and styles of decoration were few. The drinking vessel, called a *paccha* (80, p 180), consists of an animal's head surmounted with an *arybal* (Greek). It is of buff earthenware, painted in red and black. Other popular forms that often incorporated animals, either in full relief or as painted decoration, include a water jar with attachments for a rope, enabling it to be carried on the back like a haversack. Dishes were also made with modelled protrusions of a bird's head on one side and its tail on the other. These popular forms were produced in local clays in the majority of the countries forming the Inca empire.

overleaf
9 Pair of tureens in the form of partridges in soft-paste porcelain, painted in enamel colours, and marked with an anchor in red enamel. ENGLISH (Chelsea), about 1755; length 12.7 cm/5 in. (p 96)
Courtesy Winifred Williams Limited, London

opposite
10 Tureen in the form of a cock in tin-glazed earthenware (faience), painted in enamel colours, and marked with a fleur-de-lys in purple (manganese). FRENCH (Sceaux), about 1760; height 43.8 cm/17¼ in. (p 83)
Courtesy The Campbell Museum, Camden, New Jersey

7 Greece

It is not every collector of pottery and porcelain who is fully acquainted with the early history of Greece and the Mycenaean culture. In his book on Greek pottery the late Arthur Lane (who, prior to joining the staff of the Ceramics Department of the Victoria and Albert Museum, was a scholar at the British School of Athens) clearly explains the events of these early years.

From about 1700 BC large tribes of Hellenes expanded southwards through the region we now refer to as Greece. At this time the Minoan civilization of Crete was at its height and was 'freely creative in all branches of art. When the kings of Mycenae on the Greek mainland came to dominate a loose confederacy of lesser chieftains, they derived the equipment of culture from Crete. At length, about 1400 BC, they set sail for Crete and overthrew the Minoan Kingdom. A common Mycenaean (or so-called "Helladic") culture now spread throughout the Eastern Mediterranean.'

The earliest Cretan pottery, of about 1800 BC, usually had a matt-black ground, and was decorated in white or red-painted pigment, the so-called Kamares style. The ritual vessel in the form of the head of a bull (6, p 53) is more typical of the late Mycenean wares of about 1300–1200 BC; it is of a buff-coloured clay with blackish-brown pigment that shows a slight gloss.

Finds in Crete of typical Mycenean wares prove that there must have been a considerable export trade in pottery of this type during that period, and excavated examples show some extremely interesting painting of both bird and animals forms.

Animals were occasionally depicted on drinking vessels known as *rhytons*. This term is used to describe a small vase-like form that consists of a figure or head; it can be either in a human or animal likeness and it is suggested that they were intended to strike a humorous note. The form of the head of a cow or a ram makes a quite acceptable drinking vessel, but those in the shape of human heads are rather grotesque and often impractical – in the same way as many of the eighteenth-century Staffordshire wares of the Toby-jug family.

A class of terracotta figures, which at times seem more suited for door-stops, is referred to generally as Tanagra, as many came from the place of that name in Baeotia. The earliest of the figures were produced in the latter part of the fourth century BC and were made in the form of various gods, mythological characters or young ladies posturing like present-day young ladies modelling a dress. These figures are very easy to reproduce, usually requiring only a simple two-piece mould, and today there are many more fakes on the market than genuine pieces – often the well-defined fakes are more pleasing to the eye than the very worn soft terracotta originals.

6 Ritual vessel in the form of a bull's head, in painted terracotta. GREEK (Mycenean, Carpathos), 1300–1200 BC; height 15.3 cm/6 in. (p 52)
Courtesy The British Museum, London

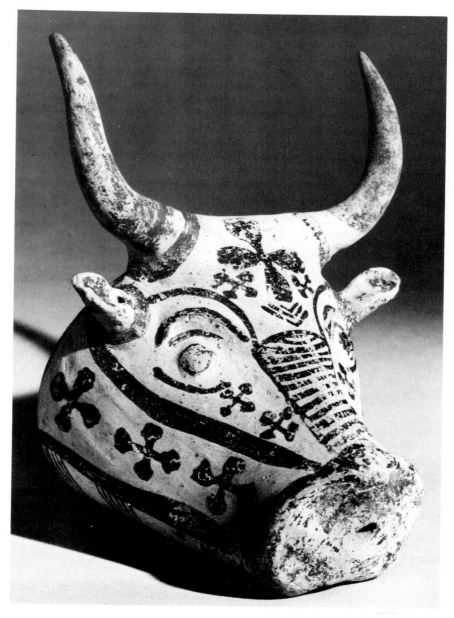

8 Holland

The early tin-glazed earthenwares made in the area we know today as Holland date to about 1510, when immigrant Italian potters were producing wares at centres such as Antwerp, Haarlem, Rotterdam, Amsterdam, Middelburg and other potteries in Friesland. These earthenwares had so much in common with the contemporary Italian wares that they are best described as maiolica.

As a result of the trading by the Dutch East India Company (founded in 1609) with both China and Japan, the Netherlandish potters soon became familiar with Far Eastern porcelain and from this time the over-decorated maiolica styles gave way to earthenwares made in imitation of the finer oriental porcelains. These are the wares we normally associate with the many potters who, from about 1620, were to set up in the town of Delft, hence the term Delftware which we can rightly associate with Holland. At this time Delft was the centre of the beer-brewing industry of the country, but towards the middle of the seventeenth century, due to increasing competition from English brewers, many of the Delft premises fell into disuse and were taken over by the various potters. Some of the new pottery factories retained the names of the former occupiers, thus we refer to potteries such as The Golden Flowerpot, The Porcelain Bottle, The Hatchet, and Two Little Ships.

Despite their skill at making tin-glazed wares look so much like seventeenth-century Chinese porcelain, these same potters were by no means such skilful modellers as the French were, and their imitations of Chinese or Meissen porcelain figures are usually very crude.

Perhaps the best known (and among the most faked forms) are the figures of cows, sometimes with a calf. The example (58, p 168) is unusually well-modelled and can be seen to advantage without any additional decoration, which so often bears no relation to actual form.

The Rijksmuseum in Amsterdam possesses two interesting figures of parrots, each seated on a mound of rocks, which are modelled after the well-known class of porcelain birds made in China during the latter years of Emperor K'ang Hsi (early eighteenth century). The earlier of these two specimens is marked 'IDV 1729', the later '1784'. A further form of colourful parrot was also made to swing from a metal hoop.

The pair of horses (7, p 55) is very fine and bears the mark of 'VDuijn': Johannes Van Duijn was the owner of De Porseleyne Schotel from 1763 until 1777. All the painting of the caparison is in high-temperature colours – yellow, manganese, blue and green. The quality of this decoration is vastly superior to the dull blue painting on so many figures of today. The Rijksmuseum also has a pair of a cock and hen, again fully decorated in high-temperature colours, marked with the initials of Jan Theunis Dextra, 'ITD' (at that time 'J' was written as an 'I'), who was proprietor of

7 Pair of horses with trappings in tin-glazed earthenware, painted in high-temperature colours, and marked 'VDuijn'. DUTCH (Delft), about 1765; height 21 cm/8¼ in. (p 54)

Victoria and Albert Museum, London

the Greek A factory from 1759–65. Figures of monkeys, goats and frogs are also recorded.

Many wares being sold today in Delft are not made in the traditional manner. Instead of painting the high-temperature blue on the glaze prior to firing, they would appear to adopt the easier method of firing the glaze and painting on the surface, and this is usually detected by a brighter blue and a much crisper design. Of even poorer quality are the wares being made in a white earthenware and decorated with high-temperature blue under a clear lead-glaze much in the manner of Staffordshire pearlware.

9 Germany

Meissen

There must be very few people today who do not associate the word Dresden with fine porcelain; unfortunately many, including new porcelain collectors, do not realize that this is only the word most commonly used when the more precise word Meissen is intended. During the eighteenth century the name of the city of Dresden was considered sufficient to imply the fine porcelain made at nearby Meissen, twelve miles away; even the early English Derby factory of William Duesbury advertised as the 'second Dresden'. However for over a hundred years this rather loose definition of the site of a famous porcelain factory has been dangerous to the buyer, for in the mid-nineteenth century many small factories started to operate within the city of Dresden itself, sometimes manufacturing, but more often only decorating, wares made elsewhere in Germany in the popular styles of early Meissen. Many of these nineteenth-century undertakings also adopted marks near enough to the underglaze-blue crossed swords mark of Meissen to cause confusion. A similar mark known to have been used in Dresden was the early 'AR' monogram, originally only placed on special wares made either for Augustus Rex himself, for a special court favourite, or for the head of a foreign state.

Up to the time of the establishment of the Royal Saxon Porcelain Manufactory in 1710, the only porcelain suitable for court use was imported from the Far East, and a great deal of the wealth of the major European courts had been spent on the purchase of such wares, as an alternative to silver plate. In 1694 Augustus II of Poland, a great collector of porcelain, succeeded to the title of Elector of Saxony. One of the earliest requests he made of his economic adviser, Ehrenfried Walther von Tschirnhaus, was to organize a survey of the country's mineral wealth, particularly relating to semi-precious stones and the materials necessary to manufacture fine glass of a quality that was then being made only in Bohemia. Tschirnhaus had himself been experimenting for nearly twenty years on the production of a porcelain akin to that of China, but all to no avail.

The man more usually credited with introducing true porcelain to Saxony is Johann Friedrich Böttger, a young alchemist. Having exhausted large sums of money put at his disposal by Frederick I of Prussia, Böttger was forced to seek refuge in the neighbouring state of Saxony where he

8 Sabre-tooth tiger in glazed hard-paste porcelain. GERMAN (Meissen), modelled by J G Kirchner, 1732–33; height 75.6 cm/29¾ in. (p 61)
Dr Ernst Schneider Collection, Schloss Lustheim, Germany

was able to continue his gold-making experiments, this time for Augustus II who was as anxious as Frederick to make unlimited wealth. Soon Böttger was considered to be an impostor and was imprisoned for about two years, being released on condition that he undertook to aid Tschirnhaus in his pursuit of the secrets relating to true porcelain. Their first combined success was the production of a fine red stoneware, comparable to that made earlier at Yi-hsing in China but much harder and of a much finer grain, sometimes cut and polished as a semi-precious hardstone and sometimes glazed with either a dark brown or near-black lustrous glaze. It has been suggested that these wares were only glazed if slightly under-fired, in which case they probably remained partly porous.

· A small white translucent bowl was eventually produced early in 1708, but Tschirnhaus soon died, leaving Böttger to take all the credit for 'producing good white porcelain with a very fine glaze – and even the painting – which is equal, if not better than that from the East Indies'. (There was a great deal of confusion at that time concerning the origin of much Chinese porcelain, probably because the wares arrived in Europe via the ships of the various East India companies.)

Augustus was already a lover of porcelain to the extent that he himself termed it a malady. He brought his large collection with him from Poland and, in 1717, went to the extreme of exchanging with Frederick William I of Prussia 600 dragoons from his unoccupied army in return for a total of 127 pieces of Far Eastern porcelain, valued at 27,000 *thalers*. He then purchased from his Field Marshal, Count von Flemming, a large palace which he re-named the *Japanisches Palais* (Japanese Palace) and filled it with his collection of Chinese and Japanese porcelain, together with wares produced to his orders from his own factory.

Up to the time of Böttger's death in 1719, very few figures of any distinction were produced at Meissen, apart from a large series of seated China-men, made in both the red stoneware and the hard-paste white porcelain. Two of the names associated with early Meissen figures are Fritzche and Müller, but knowledge concerning their actual work is very scanty. Much more is known of Johann Gottlieb Kirchner, a very talented artist who, by 1730, was creating some very fine, large animals of the type Augustus was demanding to furnish his palace. It was a comparatively easy task for the artists to create the original models, but the kiln-master found it extremely difficult to fire such large masses of porcelain without the excessive shrinkage invariably causing fire-cracks. In consequence, it was only rarely that a successfully-fired piece was risked to yet another firing in order to add enamel colours, and cold lacquer colours were sometimes added in preference. As late as 1745 it is recorded that out of a collection of 200 animals and birds sent from Meissen to Frederick the Great of Prussia, only 123 items were decorated.

The large figure of a monkey (101, p 194) is attributed to Kirchner and is thought to be one of the models made during his first period at the factory, in about 1727. The success of these early models warrants considerable

11 Cock and hen in soft-paste porcelain, painted in enamel colours. ENGLISH (Bow), about 1760; height 10.2 cm/4 in. (p 100)
Victoria and Albert Museum, London

12 Peacock in lead-glazed earthenware (majolica). ENGLISH (Staffordshire, Minton), modelled by Paul Comolera about 1850; height 137 cm/54 in. (p 130)
Courtesy The Minton Factory Collection, Minton Limited, Stoke-on-Trent

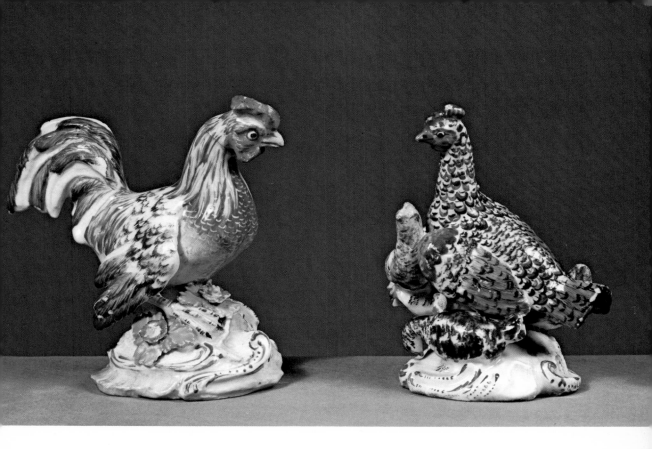

praise for both the modeller and the kiln-master. Either Kirchner or Augustus himself must have had a great love of monkeys judging by the number that were made over the years. In another example (102, p 195) the monkey appears to be enjoying a pinch of snuff; this model is decorated with enamel colours, though other models are known in the white. Any enamelled figures claimed to be of this early date (about 1733) should be carefully studied, for in many cases the enamel colours have been added during the nineteenth century.

The sabre-tooth tiger (8, p 57) is very typical of Kirchner's work which, although at times seems rather static, has a fresh approach, and often borders on fantasy rather than a photographic similarity to nature. During his short stay at Meissen, Kirchner accomplished a great amount of work and among the larger animals attributed to him by Carl Albiker are elephants, leopards, lions, bears, foxes, dogs and some large birds.

Kirchner remained as a modeller at Meissen until 1733, having prepared the way for an even more famous modeller who was appointed in 1731. This was Johann Joachim Kändler, who continued to work at Meissen until his death in 1775.

Kändler was born in Fischbach in 1706, the son of a churchman. Having received a good education he was apprenticed as a carver to the court sculptor, Benjamin Thomae, who was himself a pupil of the more famous Permoser. It was while working at the court that his skill was noticed by Augustus himself, who arranged to have him work in the porcelain factory. Here he immediately adapted himself to working in the new material and, within a month, had produced three models, including a large eagle. Kändler was obviously fond of parrots and kindred birds, and from the time of his arrival at the factory until 1745 he personally had modelled fifteen different parrots. Many of these were probably derived from living birds in the aviary in the Moritzburg, near Dresden; others were taken from stuffed birds or engravings. The cockatoo (26, p 149) was originally modelled in 1734: such birds invariably make high prices in the sale rooms and are often seen with very fine ormolu (gilt bronze) mounts, almost certainly added in France.

The passion Augustus had for all animals and birds was not confined to those made at his porcelain factory, and he went to great lengths to acquire animals for his zoo in the Jägerhof at Dresden-Neustadt; some of these animals were also used to satisfy his love of hunting. He was particularly keen to acquire rarer animals and birds, and with this aim sent an expedition to Africa. In addition he had a very large collection of stuffed animals and birds in his natural history collection.

Up to the year Augustus died (1733), Kändler had created 16 different types of birds and animals, and a total of 439 pieces were produced from these models for the Japanese Palace. After Augustus's death the demand for large porcelain animals became less urgent although similar pieces were made, at intervals, until about 1740. His son, Augustus III, was more interested in pictures than in porcelain and consequently his ambitious minister, Count Heinrich von Brühl, was appointed as director of the factory, a post he held for thirty years throughout which his love of Kändler's work continued unabated. Kändler's best models were produced during the height of the vogue for baroque styles and so the majority of

13 Nightingale on honeysuckle in bone china, decorated in enamel colours.
ENGLISH (Worcester), modelled by Dorothy Doughty, published 1971; height 26.7 cm/10½ in. (p 109)
Courtesy The Royal Worcester Porcelain Company Limited

his figures remain unmarred by the extravagant rococo scroll-work bases that soon followed (most probably from the French ormolu bases that were so often added to his earlier wares).

The African springmouse (112, p 201) was modelled by Kändler in about 1734 and is marked with the underglaze-blue crossed swords that were adopted as a factory-mark in 1723. This mark should always be carefully checked, especially if very small, for the French firm of Samson & Cie, first established in 1845, use a very similar mark when producing wares in imitation of Meissen. The blades of the swords are crossed like the original, but the guards are omitted and a short stroke is drawn across where the swords intersect.

In the same year, Kändler modelled the pheasant (9, p 62). It is really a remarkable achievement to fire such a large piece with a straight, un-supported tail like this, bearing in mind the way in which Worcester are compelled to support their birds with props. This well illustrates the great advantages models in hard-paste porcelain had over other hybrid materials.

Count Brühl had the privilege of being able to order any wares he wished from the Meissen factory without any charge. To cater for his wishes, Kändler began to model large, elaborate table-services with high relief decoration. It was on one of these that he first made full use of the osier or basket-work pattern. A more famous service is the Swan Service he made for Count Brühl between 1737 and 1741, which consisted of over two thousand pieces. The swan was the main theme and, when set out, the whole service depicted an aquatic display, with low-relief swans modelled on all the practical wares, while nereids, dolphins and tritons acted as supports for the smaller shell dishes and *tazzae*. In addition, swans made to serve no purpose other than decoration were modelled to 'swim' around on lakes of mirror (27, p 150).

The majority of porcelain figures made at the Meissen factory during Kändler's lifetime were for table decoration, and they replaced the sugar, wax or ice decorations that had formerly been used. The table could well be arranged as a hunt, complete with horses, riders and victims, or a farmyard scene. Dating from about 1740 are a particularly rare and fine pair of bears (3, p 19) that would have graced many banquets.

The writer recently saw a 'snuff-box' that appeared to have been made from the hollow head of a broken figure of a hound, originally modelled in 1748.

Kändler's talents were unlimited and in his modelling of horses he again achieved an unsurpassed realism. The inspiration for most of these fine horses is considered to have been the renowned Lipizzaner horses from the Spanish School of Equitation in Vienna. In contrast to the slightly rococo bases of the Monkey Band of 1750 (see below), the flower-strewn bases seen on these horses (90, p 188) indicate a slightly earlier date, and the fact that they were reproduced in soft-paste porcelain at the English factory of Longton Hall in about 1755 (91, p 189) would help to bear out

9 Pheasant in hard-paste porcelain, painted in enamel colours. GERMAN (Meissen), modelled by J J Kändler about 1735; height 78 cm/30¾ in. Note the unsupported tail. (p 63)

Courtesy Rijksmuseum, Amsterdam

this suggestion. Furthermore, a version of the horse with a blackamoor groom was formerly in the René Fribourg Collection, mounted on a fine French ormolu base, bearing the *poinçons* of the crowned 'c', a mark used only until 1749.

The figure of Europa on a horse (89, p 187) is typical of the more fussy figures made by Kändler from 1746, often aided by assistants, foremost of whom were Eberlein, Ehder, Meyer and Reinicke. Albiker lists figures of Europa as being modelled in 1746 and 1747 by both Kändler and Reinicke, as was the case with the matching figures of Asia and America, although that of Africa was apparently modelled only by the master. The version illustrated differs from what is considered the early version, where Europa is seated alongside the horse; Albiker refrains from dating the mounted version (illustrated) and this might well be slightly later than 1746.

In his first edition Albiker attributed the famous Monkey Band (**27**, pp 114–15) to Kändler and Reinicke in 1765, but these pieces were obviously made earlier, for in the Chelsea sale catalogue of 1756, under lot 57, some monkey band figures are well described as 'A set of five figures *representing monkies* playing on musick in different attitudes'. Judging by the slight rococo bases, they were modelled in about 1750 and, although it is a good story, there seems to be little foundation for the suggestion that the orchestra was originally made to ridicule the orchestra of Count Brühl. For some reason the conductor (**26**, p 113) is considerably larger than the rest of the orchestra and so for the photograph a similar figure (who is actually the drummer for the kettle-drums that are held on the back of another figure) was made to 'stand-in' for the conductor.

Much as we all admire and enjoy the collections of porcelain as shown in major museums, it is only when these pieces are shown in their contemporary surroundings that they can be fully appreciated. This is particularly true of the outstanding collection at Clandon Park, the splendid eighteenth-century Surrey house in the care of the National Trust. Among the many fine examples of Meissen porcelain exhibited is an interesting pair of sheepdogs (**19**, p 82), modelled by Kändler in about 1750.

By the mid-eighteenth century the Meissen factory was employing over five hundred workers and exporting large quantities of its wares to Russia, Turkey, England, Poland and France, but this period of prosperity was to be short-lived, for in 1756, the state of Saxony became involved in the Seven Years' War. The country was invaded by the troops of Frederick the Great of Prussia and the factory occupied. The only major customer during these years was Frederick himself, who had pieces made there as gifts for his friends. Many of the foremost workers left the factory and found employment elsewhere. Such was the case with the modeller Elias Meyer who had been engaged to replace Eberlein in 1749. Meyer was persuaded by Frederick to work at the factory he had taken over in Berlin in 1763 and he created some of the finest figures ever made there.

A late figure attributed to Kändler is the charming Bolognese hound (**70**, p 175) of 1769, which was apparently a very popular model. Less pleasing copies are sometimes seen, apparently made during the nineteenth century, when an all too obvious 'slickness' and dull perfection of manufacture is very apparent. An even later creation is the large tureen in the form of a stag (**65**, p 172) which, according to the factory records, was not modelled until 1774.

Although Kändler must be considered the finest porcelain modeller of the Baroque period, he was probably second in the age of Rococo to Franz Anton Bustelli of Nymphenburg (see below). Kändler died in 1775, just prior to the popularity of Winckelmann's neoclassical theories, which though adopted were never really suitable for translation into the medium of porcelain.

Höchst

Adam Friedrich von Löwenfinck, both a practical potter and decorator, started at Meissen in 1726 then went to Bayreuth, Ansbach, Fulda and Weissenau, eventually arriving at Mainz, where he set up a pottery that produced tin-glazed earthenware *(fayence)*. Knowledge about the German *fayence* potteries is usually considerably less than that about the more organized porcelain factories. Tin-glazed wares were made at Höchst from 1746 until about 1758, and Löwenfinck was probably responsible for most of the fine painting in enamel colours seen on the earliest pieces, which included almost the entire range of tablewares. Later painters, whose initials are seen together with the 'wheel mark' of the Höchst factory (as used on their porcelain), were G F Hess, I Hess, Adam Ludwig, Johannes Zeschinger and J P Dannhöfer.

In the early years some very fine large animals including parrots were made, together with numerous tureens in the form of pheasants, turkey cocks, boars' heads and ducks. Many of these finer pieces are today attributed to the modeller J G Becker who had studied under Kändler at Meissen and worked at Höchst from 1746 until 1755. Later reproductions of some of these early models were made from about 1830 by Daniel Ernst Müller of Damm, using the original moulds.

In 1750 Johann Benckgraff arrived at Höchst from Vienna. With the aid of J J Ringler he produced a fine quality hard-paste porcelain, rather opaque, with an exceptional milky-white glaze. The mark adopted was the same six-spoked wheel (from the arms of the Elector of Mainz) as that used on *fayence*; at first the mark was applied to the glaze in either red enamel or gold, but from about 1762 the more customary colour of underglaze-blue, used by the other German factories, was adopted. Between 1765 and 1774, the Electoral Hat or Crown was added to the wheel mark. Höchst produced a very rare figure of a horse that can be dated precisely to 1770 because in that year it was given as a prize at a porcelain lottery held in Höchst. It has a base with a rococo scrollwork surround, which was then very popular at the factory.

Fürstenberg

The porcelain factory of Fürstenberg in Brunswick has a long history: founded by Duke Karl I in 1747, it is still producing fine wares. Siegfried Ducret relates how the court enthusiasm was so great at the establishment of their factory that the Duchess Philippine Charlotte threw out all her

old porcelain under the impression that the material could be melted down and used again! The early wares show many faults in the form of black specks in the paste.

Simon Feilner, employed from 1754–58, was without doubt the outstanding modeller of this factory, but he was discharged for being lazy and insubordinate. Apart from his fine Italian comedy figures, Feilner is recorded in the factory archives as producing equestrian figures and animals. Leuenberger, another modeller employed in about 1755, is credited with a very fine group of a lion attacking a horse, which is in the Brunswick Museum. In 1775 two further modellers, J C Rombrich, and A C Luplau were engaged in modelling copies and original versions of monkey band figures, previously discussed under Meissen (p 64).

Certain pieces from this factory would be very difficult to attribute in the absence of a mark (though this is true of a great deal of German porcelain), and the mark of the cursive 'F', used in slightly varying forms over a very long period, is difficult to date accurately. The cow (61, p 170) is most probably early nineteenth century.

Nymphenburg

By the middle of the eighteenth century the knowledge concerning the manufacture of hard-paste porcelain was no longer a secret known only to Meissen and the Far Eastern potters. The Vienna factory of Du Paquier was making a similar ware by 1719, to be closely followed by the short-lived Italian factory of Francesco Vezzi which was producing a hard-paste in Venice from 1720–27. Renegade workmen from these early undertakings had learnt the secrets concerning the necessary clays and kilns, and they were prepared to sell their knowledge to the highest bidder.

Many factories owe their success to J J Ringler. He deserted from Vienna in 1747 and eventually turned up in Nymphenburg in 1753, where they had been experimenting towards producing a fine porcelain from 1747, and stayed there until 1757.

The fame of Nymphenburg is undoubtedly due to the outstanding ability of one modeller, Franz Anton Bustelli, who came to the factory in 1754 and was *Modellmeister* from that time until his early death in 1763. The most widely known of all Bustelli's models, which he carved from lime-wood, are those depicting the various characters from the Italian comedy.

His figure of a horse being attacked by a lion (10, p 67) illustrates his usual treatment of bases. The flat slab of porcelain shows the typical rococo scrollwork edging that he used even better on examples where the wave-like motion of the rococo theme was employed to take the place of the all-too-obvious pedestal or tree-stump used as a necessary support for the majority of the more delicate figures created by earlier modellers.

It is to Bustelli's successor Dominikus Auliczek that we look for the realistic groups attributed to Nymphenburg. As if with the deliberate intention of producing figures and groups of an entirely different feeling to those of his predecessor, his creations at times border on the sadistic. He is recorded as having produced twenty-five hunting scenes, most of

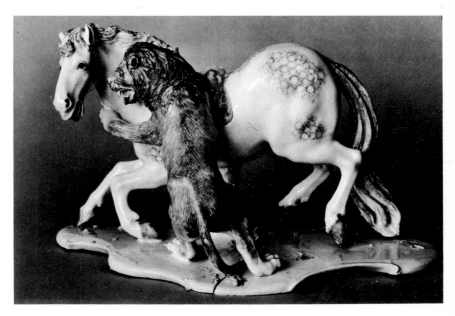

10 Horse being attacked by a lion, in hard-paste porcelain painted in enamel colours. GERMAN (Nymphenburg), modelled by F A Bustelli, 1755–60; height 15.5 cm/6 in. (p 66)

Copyright Bayerisches Nationalmuseum, Munich

which are left undecorated. Some of his bases are of the flat rococo type, as used by Bustelli, others are a simple rectangular form with the corners cut off. The seahorse (81, p 181) is from a centrepiece featuring Neptune and Aphrodite. The free style of this model is very much in the manner of those made to grace the banqueting tables of Dresden some twenty years earlier.

The most common mark used at Nymphenburg consisted of an impressed shield from the arms of Bavaria; the alternative mark is a six-pointed star composed of two reversed triangles, known as the hexagram mark.

Frankenthal

The severe restrictions forced upon Paul Hannong while working at Strasbourg, due to the monopolies granted to Sèvres, made it necessary for him to transfer his production across the Rhine to Frankenthal, where he enlisted the support of the Elector Palatine, Karl Theodor. Hannong started work at Frankenthal in 1755 and within the same year was producing porcelain of such quality as to warrant its presentation as a gift from the elector to the Saxon ambassador. The Hannong family were associated with the Frankenthal factory until 1761, when the concern was sold very cheaply to Karl Theodor. Hannong's price-list of Frankenthal wares for 1760 includes two fine figures of stags; one standing, the other

leaping, they are about 13 centimetres (5 inches) long and bear the impressed 'PH' (Paul Hannong).

There is, in the collection of the Brooklyn Museum, New York, a figure symbolic of Africa considered to be of about 1780; it has a very sculptured look and could well be the work of J P Melchior, who arrived at the factory in 1779. Melchior had previously been sculptor to the Elector of Mainz, and *Modellmeister* at Höchst from 1767. This figure bears the mark of a lion rampant in underglaze-blue, which one would not normally expect to see on a figure of such late date. The more common Frankenthal mark is 'CT' in monogram form under an electoral crown, in use until 1795.

Ludwigsburg

This factory of Württemberg was producing porcelain from 1758 until 1824, and again the name of the arcanist J J Ringler is recorded. He was the first director of the porcelain concern of Duke Charles Eugene, who claimed it to be 'necessary to the splendour and dignity' of his realm.

The modeller most worthy of note at Ludwigsburg was Jean-Jacob Louis, whose original work has been identified by an incised 'L'. This 'chief repairer', who was engaged from 1762 until his death in 1772, had first developed his modelling skill at Tournai, and many finely-modelled birds, especially parrots, and animals groups are ascribed to his hand. The wares of the Ludwigsburg factory were generally marked during the life of Charles Eugene (died 1793) with two interlaced 'C's under a ducal coronet.

Tin-glazed earthenware

One of the most productive centres of the German tin-glazed earthenware or *fayence* industry was at Nuremberg, where three porcelain merchants arranged with J C Ripp to establish a factory for its manufacture. Ripp remained in Nuremberg for only two years, but the factory continued until 1787 in the family of Christoph Marx, one of the original proprietors. The concern produced a great amount of good material and at the peak of their production employed as many as forty-five hands. Among the many painters employed was Andreas Kordenbusch (1723–54) and his nephew, G F Kordenbusch, whose wares were signed with a 'K' and dots, under the letters 'NB'. Their painting is seen to advantage on the typical German tankards with pewter lids, painted in the full range

opposite

14 Little owl in bone china, painted in enamel colours. ENGLISH (Staffordshire, Spode Design Studio), modelled by Anthony Green, 1973; height 22.2 cm/8¾ in. (p 112)

Courtesy Spode Limited, Stoke-on-Trent

overleaf

15 Two cats in a mixture of white and terracotta clay. ENGLISH, modelled by Iris Sonnis, about 1970; length 30.5 cm/12 in. (p 139)

Courtesy Iris Sonnis

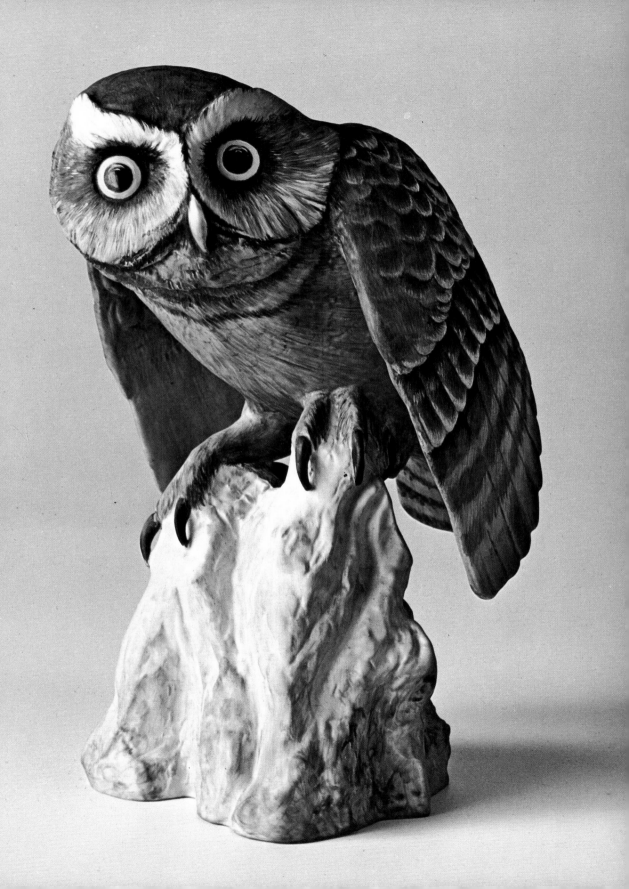

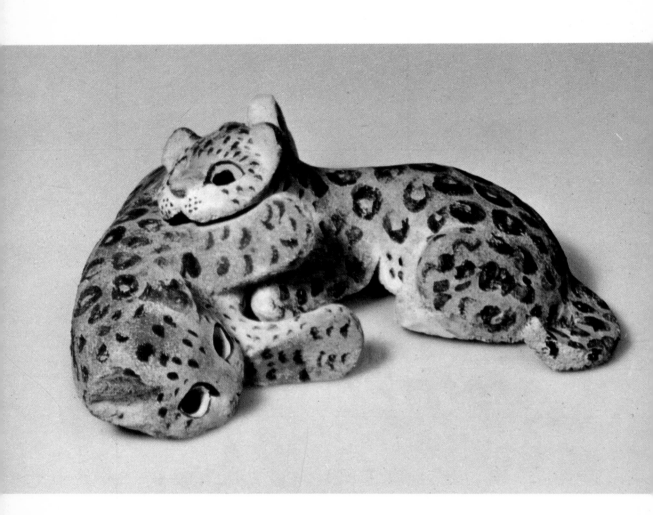

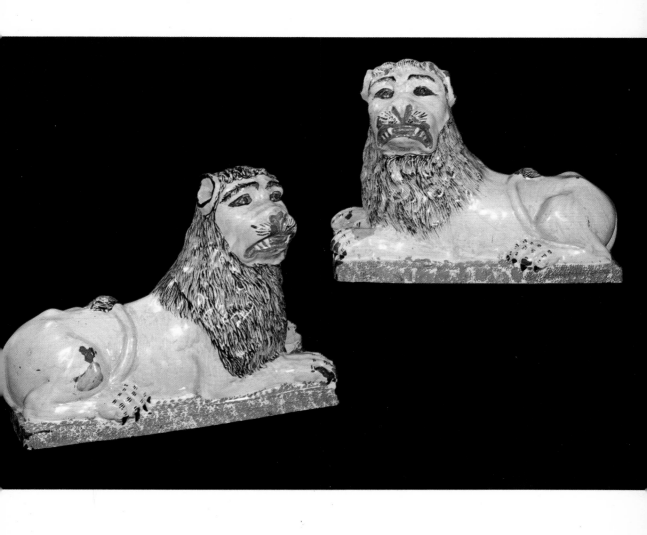

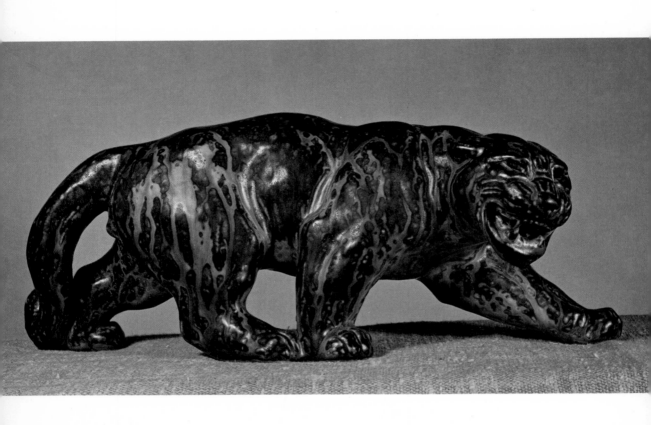

offered by the high-temperature colours. The pert figure of a German *Mops* (69, p 174) is attributed to this latter painter and is considered to be of the mid-eighteenth century.

Many attractive tin-glazed wares were made in the various eighteenth-century factories of Thuringia: Dorotheenthal, Erfurt, Bernberg and Abtsbessingen are among those best known. The tortoise (108, p 198) is made in the form of a dish and cover and could well have served as a butter-dish. It is decorated in yellow and purple enamel colours, and is marked in purple with a hayfork from the arms of Schwarzburg, and 'P7' and 'v'.

The rather soulful-looking serpent (109, p 199) is attributed to North Germany. However there were several factories in Hanover, Hannoversch-Münden, Magdeburg, Anhalt-Zerbst and Rheinsberg, and it is very difficult to attribute wares to any particular factory, as marks were only rarely used.

Some interesting tin-glazed wares were made at Proskau in Silesia from 1763 until 1850 although, as was often the case with such factories that continued into the nineteenth century, their last sixty years or so were spent in the production of Wedgwood-type wares. The founder, Count Leopold von Proskau, was only associated with the factory until 1769 (when he was killed in a duel) but it was in this short period that many wares were made in the popular Strasbourg fashions, though they were decorated in outstandingly vivid colours of yellow, crimson and green.

overleaf

16 Pair of lions in tin-glazed earthenware (faience), painted in enamel colours. FRENCH (Lunéville), eighteenth century; length 44.5 cm/17½ in. (p 83)
Courtesy The Antique Porcelain Company Limited, London

opposite

17 Panther in stoneware. DANISH (Royal Copenhagen Porcelain), originally modelled by Knud Kyhn in 1932; length 42 cm/16½ in. (p 86)
Courtesy The Royal Copenhagen Porcelain Manufactory Limited

10 France

Saint-Cloud

The French were the second people in Europe to succeed in making a fine soft-paste porcelain in imitation of the Chinese true hard-paste wares. The early history of French porcelain manufacturers is a little unclear. The first porcelain would appear to have been that made at Saint-Cloud, when Claude and François Révérend were granted a privilege as early as 1664, but because of the confusion at that time about the meaning of the word porcelain, their wares are thought to have most likely consisted only of a type of faience.

According to Dr Martin Lister's account of his travels, written in 1698, there was a potter named Morin who had a factory at Saint-Cloud. After many years of experimenting, he succeeded in about 1695 in producing porcelain of such a high standard that Dr Lister wrote, 'I confess I could not distinguish betwixt the pots made there and the finest China ware I ever saw.' However, from present-day knowledge, one can only suggest that either Dr Lister's appreciation of 'the finest China' was at fault, or he was seeing a type of Saint-Cloud porcelain with which we are unacquainted today.

The Saint-Cloud factory that we have more certain knowledge of is that established by Pierre Chicanneau. The process of manufacturing a soft-paste porcelain had apparently been discovered by this faience potter prior to his death in 1678. Chicanneau's widow then married another potter, Henri Trou, whose son took a great interest in the factory, and in 1722 he renewed the original patent that had been granted to the concern by Louis XIV in 1702. The factory remained in the family of Trou until 1766, when it went into liquidation.

The early wares of Saint-Cloud consist solely of pieces for the table, and it was only from the second quarter of the eighteenth century that they produced some interesting animal forms. Their soft-paste porcelain is of a warm ivory tone, usually rather thickly potted in the baroque style and having a good glassy glaze with minute surface pitting. The larger pieces tended to develop fire-cracks, and slight warping is often apparent. The fine pastille-burner in the form of a hare (28, p 116) must date to about 1750, when the factory was working under difficulties caused by the monopolies that had been granted to the new factory at Vincennes (see below). This piece shows to advantage the beautiful quality of the Saint-Cloud paste, coupled with very fine ormolu mounts, which would almost certainly have been added by one of the Paris merchants.

During the second quarter of the eighteenth century the factory produced some very attractive snuff-boxes which sometimes took the form of simply modelled rabbits or other animals; these pieces can often be dated

almost precisely by the marking of the fine silver or silver-gilt mounts. Silver mounts are found so frequently on Saint-Cloud wares that it has been suggested that the factory had an arrangement with a Paris silversmith. The boxes of Saint-Cloud are always comfortable to hold, as though the modeller has 'rounded off' the modelling with precisely this intention.

The majority of Saint-Cloud wares are marked. The early mark found on tablewares took the form of a sun-face that is always in underglaze-blue, while the later and more common mark is 's'c' over 'T' (Saint-Cloud/Trou). This is applied either in blue or by incising into the clay before firing, and is consequently under the glaze.

Rouen

There is still doubt as to the sure identification of porcelain made at Rouen following the granting of a patent in 1673 to Louis Poterat and, in 1694, when Poterat applied for a renewal of a faience privilege, the question of his porcelain manufacture was taken up by the authorities. It seems that he had made only a very limited amount of this material entirely unaided, in order that his workmen should not learn the secrets and sell the knowledge to rival potters. The wares at present attributed to this potter consist only of tablewares decorated in underglaze-blue, usually in the same *lambrequin* styles as seen on Rouen faience.

Chantilly

This soft-paste porcelain factory, established in 1725 by the Prince de Condé, continued under a long succession of proprietors until about 1800. The best porcelain was made during the first twenty-five years when most of the tablewares and vases they produced were covered with a glaze that had been opacified with tin oxide in order to make it look more like the hard white Japanese porcelain they were trying to imitate. Their figures were mostly of a *Chinoiserie* type and the only animal forms consist of finely-potted *bonbonnières* or other toys. The mark of Chantilly is a hunting-horn, first in red enamel, later in underglaze-blue or other enamel colours, and both these marks are frequently encountered on nineteenth-century reproductions.

Mennecy

Another soft-paste porcelain factory was at Mennecy. It was first established in 1734 in Paris under the patronage of the Duc de Villeroy and was transferred to Mennecy in 1748. In 1773 it was again transferred, this time to Bourg-la-Reine, where it continued until 1806. It is likely that the last years saw only the production of cream-coloured Wedgwood-type earthenware. Their fine milky-white porcelain with a brilliant 'wet' glaze is probably the finest example of a true soft-paste and exhibits all the

charm of this material. The fact that they were prohibited from using gilding (because of the monopolies enjoyed by Vincennes and Sèvres) actually adds to their wares. Mennecy figures are usually marked with an incised 'DV' (Duc de Villeroy). The few animal groups that are recorded are usually based on Meissen or other German originals, but otherwise it is again only in the form of snuff-boxes and similar articles that sheep, rabbits, and such like are seen.

Vincennes and Sèvres

The factory of Vincennes was first established in a disused royal château near Paris in 1738. Gilles and Robert Dubois claimed to have learned the secrets of porcelain manufacture during their employment at Chantilly, and so a nobleman, Orry de Fulvy, financed their attempts, with help from Louis XV, to produce a fine-quality porcelain comparable to that of the earlier factory. After three years of unsuccessful experimenting, the two brothers were discharged and the venture was continued with the help of yet another disloyal worker from Chantilly, François Gravant. By 1745 a good, soft-paste porcelain was apparently being produced.

A company was then formed in the name of Charles Adam, and privileges were granted in an attempt to eliminate competition from other French manufacturers. The company was given the exclusive right for a period of twenty years to manufacture 'porcelain in the style of the Saxon [Meissen], that is to say, painted and gilded with human figures'. In 1747 a further privilege not only prohibited the rival manufacturers from making porcelain, but also from hiring Vincennes workers. It is obvious that through their influential patronage, the three factories previously mentioned (Saint-Cloud, Chantilly and Mennecy) were permitted to continue operations in defiance of these orders, but their production was undoubtedly controlled.

The factory quickly grew and by 1750 over one hundred hands were employed. The following year Orry de Fulvy died, and a second company was formed under the name of Eloi Brichard, Louis XV again subscribing one fourth of the capital of 80,000 *livres*. In 1753 further harsh restrictions were introduced forbidding not only the manufacture elsewhere in France of porcelain, but also of any faience decorated in colour. In this same year the royal cipher of the crossed 'L's was declared to be the true factory-mark and a series of letters was introduced to indicate the year of manufacture (for example, A for 1753, B for 1754) eventually going into double letters (AA, BB) until 1793, when the factory was taken over by the French Republic. As production increased, the Vincennes building became unsuitable and so, in 1753, work was started on a new building at Sèvres, between Paris and Versailles. This factory was eventually occupied three years later, but as a result of its lavish productions, debts quickly accumulated, and by 1759, when something like a half million *livres* was owing to creditors who proposed closing the concern, the Marquise de Pompadour persuaded Louis XV to buy the factory, which had already been known for several years as the *Manufacture royale de porcelaine*.

The Marquise de Pompadour was, despite her humble parentage, quick to acquire an appreciation of beautiful works of art, and she soon

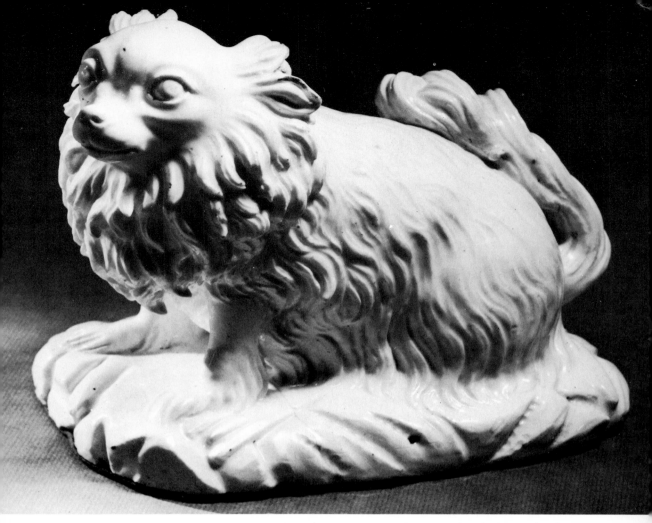

11 Dog in soft-paste porcelain, said to be the Marquise de Pompadour's pet.
FRENCH (Vincennes), about 1750; height 17.8 cm/7 in. (p 77)
Courtesy The Antique Porcelain Company Limited, London

proved to be one of the factory's best customers. Illustration 11 (above)
is an early figure of about 1750, and is reputed to be the Marquise's
pet dog. Other animals appear in the list of their productions, but are very
rare: among such pieces is a fine figure of a water-spaniel of about 1755,
nearly a foot in length and covered with turquoise glaze on an enamelled
base. The registers of the Sèvres sales also mention birds decorated in
blue or lapis lazuli.

The unsurpassed tablewares made by this royal factory are well known.
The early wares, under the influence of the renegade workmen, were in
Japanese-Chantilly style, with copies of decoration made popular at
Meissen, such as naturalistic paintings, harbour scenes, and so on. In their
second period, from 1753 to 1772, the early simple forms gave way to
large and overdecorated vases of the type so well represented in the Jones
Collection at the Victoria and Albert Museum and the Wallace Collection
at Hertford House, London. Vincennes and Sèvres porcelain can often
be judged merely on the fine quality of the gilding. The knowledge for
this process was originally purchased from a monk of the Benedictine

order, Frère Hippolyte, and a particularly attractive use of this gilding was made by the painter and gilder, Mutel, who applied heavy gilt-relief birds in silhouette to a clear porcelain reserve on a ground of underglaze-blue (*bleu lapis*). The previously used common term of *gros bleu* is incorrect as it was not used in the factory records until after 1773.

Some time prior to 1753 Jean-Jacques Bachelier, art director at Vincennes and Sèvres from 1751 until 1793, introduced the fashion for leaving the porcelain figures in the biscuit. However, this fashion did not really become popular until after 1770, despite the excellent work of Etienne-Maurice Falconet.

The fine soft-paste continued to be the only material produced at the factory until 1769, when deposits of china-clay and china-stone (kaolin and *petuntse*) were discovered at Saint-Yrieix, near Limoges. From about 1772 the manufacture of soft-paste gradually gave way to the harder material of true porcelain until about 1800, when Alexandre Brongniart was appointed by Napoleon to take over the administration of Sèvres and the early type soft-paste porcelain was finally abandoned as being too costly.

Earthenware

Probably the best-known type of early French lead-glazed earthenware is Palissy ware. Bernard Palissy was born in about 1510 and was to become famous as both an alchemist and a potter, working at Saintes (Charente-Inférieure), Paris and elsewhere. Initially he was engaged with the manufacture of stained glass and, according to his own writings, it was about 1540 whèn he first became interested in creating various forms of pottery; in 1542 he was working at Saintes. Later he was patronized by the high constable of Montmorency and Catherine de' Medici, who arranged for him to move to Paris where, in 1566, he produced large rustic grottoes for the Tuileries gardens.

His palette consisted of the usual range of colours made possible by tinting the lead-glaze with high-temperature oxides, resulting in a pleasing harmony of blues, purples, browns, yellows, and an off-white, obtained by using the natural colour of the white clay of the body with a coating of clear glaze. The large dish illustrated (**29**, p 133) is rustic to a point of becoming rather macabre.

The early wares attributed to Palissy or his followers are usually of good, clear translucent colours over a body that is light in both weight and colour; the original moulds are also crisply modelled, and his work bears no mark. Because of the popularity of Palissy-type wares during the middle years of the nineteenth century, they were widely imitated both in England and on the continent. The imitations made by 'MAFRA, CALDAS, PORTUGAL', are sometimes marked in this manner under an impressed crown, but the wares are usually very heavy, with 'muddy' colours and often with little piles of weed-type vegetation on the edges, looking very much like helpings of spaghetti. More deceptive imitations were produced by Charles Avisseau at Tours, Lesme at Limoges, Georges Pull in Paris, and Minton at Stoke-on-Trent; but even many of these can easily be recognized as reproductions, for they often bear colours that were not

available at the time (such as flesh tints). They are also very often just the necessary degree smaller than the original, indicating they were made from a mould taken from an original piece, and have less crisp modelling, as the detail is obscured by glaze.

The early tin-glazed earthenwares of France (faience) made at the centres of Rouen, Lyons, and Nevers are hard to distinguish from the Italian wares that they at first imitated. Apart from the occasional figure of an ecclesiastical nature, the entire output of French faience during this sixteenth and seventeenth-century period consisted of wares for the table. Until the middle of the eighteenth century, faience and tin-glazed wares of other countries were decorated with colours derived solely from high-temperature metallic oxides. Thus the decorators were confined to a rather limited palette of which all the colours were painted onto the raw glaze before firing – a process calling for a sure hand, since mistakes could not be rectified. The middle of the eighteenth century found tin-glaze potters all over Europe in competition with the manufacturers of porcelain. The soft-paste porcelain of both England and France was

12 Boar in tin-glazed earthenware, painted in enamel colours. FRENCH (Strasbourg), 1750–55; length 22.5 cm/8¾ in. (p 80)
Crown copyright, Victoria and Albert Museum, London

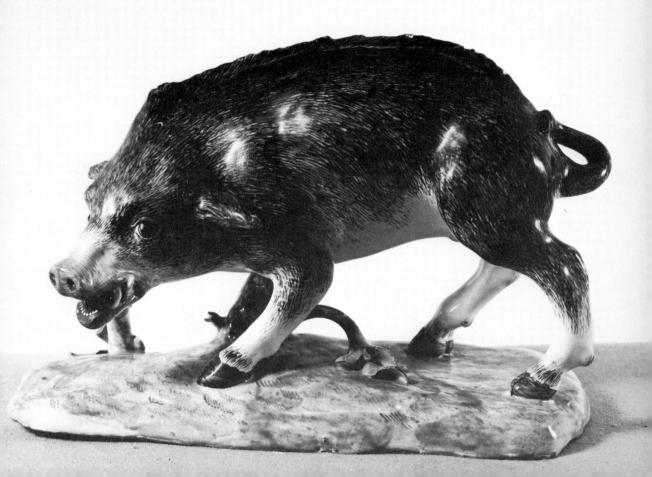

enjoying great popularity; there were several German factories producing large quantities of hard-paste porcelain; and in addition Chinese porcelain was becoming available in increasing quantities at a very low price through the various East India Companies. It was therefore desirable to decorate faience in a manner similar to that used on porcelain. These low-temperature colours (*petit feu*) offered a new and exciting range of reds, crimsons, pinks and blues. They consisted of metallic colours compounded with powdered glass and merely fused to the surface of the previously fired glaze in a muffle kiln at a temperature ranging around 800 °C.

The important factory at Strasbourg started in 1721 and remained in operation until 1780. The founder of the concern was Charles-François Hannong whose son, Paul, acted as manager from 1732 until 1739 when he became director. The faience made during their early years was decorated in the limited range of high-temperature colours, and it was probably about 1748, after Paul Hannong had managed to enlist the aid of several highly skilled German decorators, modellers and chemists (including Adam Friedrich von Löwenfinck, his wife and two brothers, Ringler and J W Lanz), that he first commenced to decorate his wares in the full range of the enamel palette.

Most of the large earthenware animals were made to serve as tureens and many fine examples are recorded, such as turkeys, pigeons and boars' heads. The duck (6, p 38) is a very fine piece but it cannot with certainty be considered the work of Strasbourg since similar birds were also made at Höchst. There is another particularly well-known tureen in the form of a duck, also attributed to Strasbourg, which was modelled by the German J W Lanz, and is the only known example still to retain its separate oval stand. Among the smaller pieces obviously made to serve as table decorations are sets of huntsmen, leaping stags and animals such as the fine figure of a boar (12, p 79).

One colour so often used by the Strasbourg decorators is a rich crimson, better known by the more romantic name, purple of Cassius, after Andreas Cassius of Leyden, who first discovered how to achieve this colour by using chloride of gold. The same colour was used on Chinese export porcelain from about 1720, when it became known in France as *famille rose*.

Following the arrival of Ringler at Strasbourg in 1753, Paul Hannong began the manufacture of a hard-paste porcelain, but was prevented from marketing this new ware by the authorities of the royal porcelain factory of Sèvres. So in 1754 Hannong moved to Frankenthal in Germany, where he produced porcelain until his death. His son Joseph returned to Strasbourg to take charge of the faience factory in 1762, but its productions never again reached their former high standard, and the factory came to an end in 1780. The much-copied monogram of 'PH' was used from 1739 to 1760, while from 1762 until the close the initials were 'IH'.

Although not faience, it is appropriate to mention here a category of Strasbourg wares of hard-paste porcelain. These figures are difficult to separate from those made at the slightly later factory at Frankenthal, but the bases of the latter usually include rococo scrollwork rather than a simple grassy mound. The 'PH' impressed mark is also more often seen on the French examples.

18 Stag and doe in earthenware, decorated in coloured lead-glazes. ENGLISH (Staffordshire, Ralph Wood), about 1775; heights 15.9 cm/6¼ in. and 11.4 cm/ 4½ in. (p 124)

The Gubbay Collection (Clandon Park, National Trust)

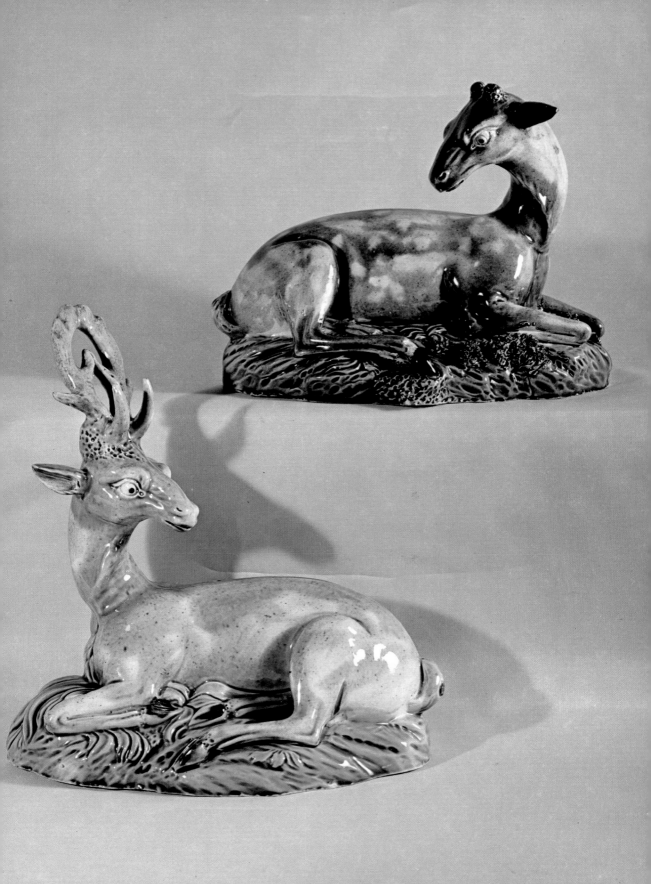

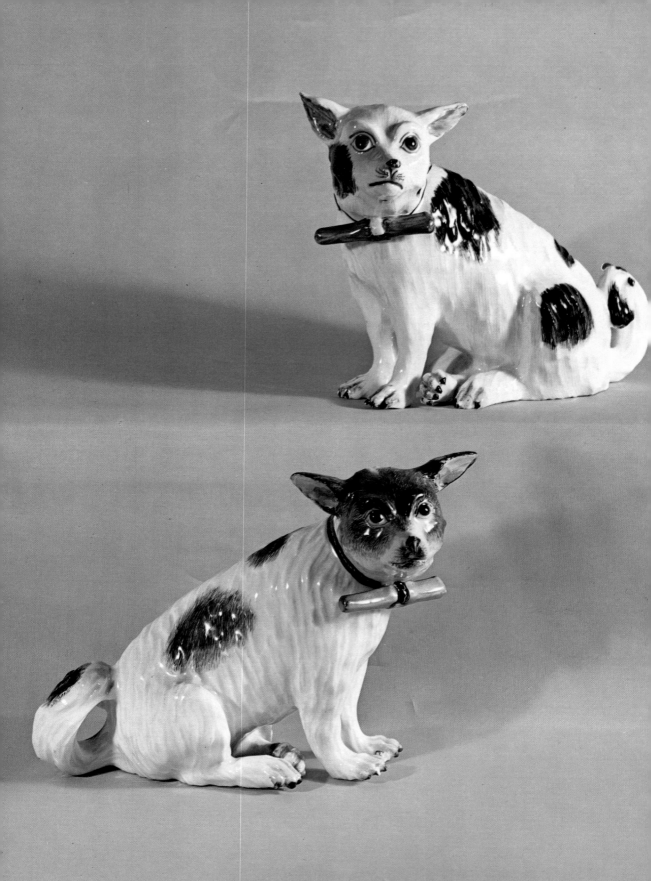

The tureen in the form of a cock (**10**, p 50) is plainly marked with the fleur-de-lis painted in manganese, considered as one of the many marks used at the factory at Sceaux, where both faience and soft-paste porcelain were produced. Good-quality faience was made soon after Jacques Chapelle became manager in 1748, and he made some fine tureens in naturalistic style in the form of ducks and other large birds, melons, cabbages and bundles of asparagus. Chapelle became proprietor of the factory in 1759 and retired four years later, although production of wares continued until 1794. The Sceaux porcelain seems to have been used only for the production of useful wares, often decorated with paintings of colourful birds of the same type as can be seen on their faience.

The factory at Lunéville (Lorraine) dates from 1723 and continued throughout the nineteenth century. Lions such as the pair illustrated (**16**, p 71) appear to have been a speciality of this factory. These recumbent creatures are exceptionally large and were often set in doorways or used as garden ornaments. Their production was continued during the next century by the later proprietors of the Lunéville potteries, Keller and Guérin.

The striking *gargoulette* or water-pitcher (**24**, p 103) in tin-glazed earthenware is the work of Pablo Picasso, and is called *Cavalier sur sa Monture* (Mounted Cavalier). The vessel itself was produced at the Vallauris pottery, where a popular local industry produces a repertoire of traditional forms. Picasso began working in the Madoura pottery of Suzanne and George Ramié at Vallauris in 1947. Sometimes he was content to accept the form of one of the traditional 'ready-made' wares, but more often he decided the form the vessel or object should take, sometimes even making the prototype himself. From this master model his associates produced the same form in a specific quantity (usually between twenty and fifty) and these were then decorated by Picasso in a variety of styles. Made for him by the Ramiés but designed and decorated by the master every item is thus unique.

Some interesting figures have been made in France recently by studio potters who, since about 1946, have used their skill to create purely decorative, rather than functional, wares. George Jouvé has made some interesting bird forms of earthenware, in very clear-cut clinical styles, decorated with black glaze. A further group of potters working in the region of Bourges have preferred to use the more interesting textures offered by working in stoneware; foremost members of this group are Jean and Jacqueline Lerat, who over the last decade have also produced some highly exaggerated bird forms.

19 Pair of sheepdogs in hard-paste porcelain, painted in enamel colours, and marked with crossed swords in underglaze-blue. GERMAN (Meissen), modelled by J J Kändler about 1750; height 10.8 cm/4½ in. (p 64)
The Gubbay Collection (Clandon Park, National Trust)

11 Spain and Portugal

Spain

From at least the early years of the thirteenth century the potters of southern Spain were producing tin-glazed earthenwares, generally referred to today as Hispano-Moresque. Large dishes and vases were often decorated with the metallic lustre of copper or silver, a technique that had been in use in the Near East since the ninth century. Lustre decoration was applied to the tin-glaze after it had been fired to the body of the ware. It required a third kiln-firing in which damp brushwood or rosemary was burnt in order to acquire the necessary smoky atmosphere to produce the carbon required to unite with the oxygen in the applied metallic pigment. This resulted in a layer of pure reduced metal being partially absorbed into the glaze which after polishing took on the lustrous mother of pearl finish, so admired both then and now.

The high quality of these wares continued well into the sixteenth century but the decoration consisted mainly of a coat-of-arms surrounded by flowers and foliage, or simple repetitive designs. However, there are some dishes of the early sixteenth century that are decorated with highly stylized painting of animals, especially the bull, and a few lustre-decorated ewers in the form of scarcely-recognizable elongated animals.

While other Spanish pottery centres produced many vessels with birds or animals as painted decoration, very few full relief figures of any type were produced apart from those made at the pottery and porcelain factory at Alcora in the province of Valencia. This factory was first established in 1726 by the Count of Aranda and within a year pottery was being made 'in the manner of China, Holland and other localities'. The man responsible for this quick success was Joseph Olerys, a painter who had previously worked at Marseille and was eventually to return to Moustiers in 1737. The tin-glazed pottery made at Alcora was popular throughout Spain, and the Count's manufactory was granted many privileges such as freedom of custom-house duties.

The original sucess of the Alcora faience was undoubtedly due to the influence and the skill of the painters the Count had brought from France, who taught their skills to the Spaniards so quickly that by 1737 the entire personnel was Spanish. Their work was of a very high quality and letters to the Tribunal of Commerce tell of 'pyramids with figures of children, holding garlands of flowers and baskets of fruit on their heads' and many other pieces, 'some as large as five feet high . . . statues of different kinds and animals of different sorts and sizes'.

The figure of the ram (118, p 204) is unmarked, as is the case with many wares attributed to the Alcora factory. Apart from the distinctly reddish clay body, the surest guide to Alcora faience is the makers' very distinctive

palette of high-temperature colours, which include orange, purplish-black and strong greens, with the occasional use of the copper-lustre as used at nearby Manises. The founder of the factory died in 1749, but the factory remained in his family with successive Dukes of Hija until 1858, when it was acquired by private owners. The only reference to their having made figures of animals appears in a list of sculptural figures published in 1777.

Portugal

In 1767 a little-known factory was established at Rato, near Lisbon in Portugal, by Thomaz Brunetto, an Italian from Turin. His wares consisted of tin-glazed earthenware, including large tureens in various forms: some were in the style of contemporary silver, others in more natural forms of birds, or the even more interesting shape of a tub full of fish (21, p 92). The factory was well patronized by the royal family and there is a tureen comparable to the one shown in the Espirito Santo Silva collection in Lisbon. The mark from 1767 until about 1771 was the 'FR/TB' monogram, then Thomaz Brunetto was succeeded by Sebastião de Almeida and the 'TB' was replaced by the letter 'A'.

12　Denmark

Nearly all the ceramic animals to be discussed under Denmark are comparatively modern, but the very fine boar's head tureen, complete with matching dish (120, p 206), is the exception. It was made in about 1770 in Kiel, Holstein, where J S F Tännich from Strasbourg had started a faience factory in 1763 for the Duke of Holstein, who sold out to a company in 1766. In about 1768 Tännich was succeeded by Johann Buchwald who had been working at the Eckernförde factory, in Schleswig, Germany. Buchwald left the concern in about 1771 and after that date few fine wares were made, with the factory finally closing in 1788.

The Royal Copenhagen Porcelain Manufactory was founded in 1775 as a private company. In 1779 the factory was taken over by the king and it remained in royal possession until passing once again into private ownership in 1868, the mark and name continuing. The man given credit for the fine reputation of the factory, maintained to this day, was a young architect, Arnold Krog, who became art director in 1885 and gathered around him a crew of young skilled artists, a policy that has been continued.

It is a surprise to learn that the polar bear (4, p 20) was modelled as early as 1894 by C F Liisberg (1860–1909). Liisberg was a sculptor and painter, studying both arts at the Royal Academy of Fine Arts, Copenhagen, in 1876–86. He was employed at the Copenhagen factory from about 1885, when he worked closely with Krog, and he modelled a great number of animals decorated with the typical underglaze colours associated with the factory even now.

The figure of a sea lion (31, p 135) was originally made in 1900 by Theodor Madsen, and has proved such a popular item that it is still in production. Madsen was apprenticed at the Copenhagen factory in 1896; from 1898 until 1902 he studied modelling at the Royal Academy of Fine Arts. He worked periodically at the factory until 1935, when he was awarded a silver medal for his work for the company at the World Exhibition in Brussels (1935). Another Copenhagen item that has remained popular for many years is the panther (17, p 72). This piece was modelled in 1932 by Knud Kyhn, who was born in 1880 and died as recently as 1969, having worked at the factory from 1904 until his death. He was one of the earliest Copenhagen modellers to experiment with stoneware, for which he rapidly developed a great understanding. The beauty of Kyhn's work is often enhanced by a 'Sung' glaze, perfected by Patrick Nordström. The glaze is made up basically of iron, which fires to varying shades of brown-black and grey, with further colour effects sometimes being achieved by the use of underglaze painting.

Jeanne Grut trained at the Swedish Society of Carpentry and Handicraft School in Gothenburg, Sweden, from 1945 to 1947; after further study

at the Royal Danish Academy of Fine Arts, she established her own workshop, but in 1960 joined the staff of the Royal Copenhagen Porcelain Manufactory, where she has specialized in modelling a variety of animals for production in either porcelain or earthenware.

Among her works is a beautiful white porcelain horse, modelled in 1959 on a famous Lipizzaner steed (as mentioned in the work of the Meissen factory and the copies made at the English factory at Longton Hall, Staffordshire). She certainly works in a variety of sizes for she is also the modeller of the huge reproduction of the coelacanth (**22**, p 93), a fish that lived in the Devonian age, about 320 million years ago. Until a live specimen was caught in 1938 it was thought that this species, Latimeria Chalumnae, had been extinct for at least 70 million years.

The present-day catalogue of the Royal Copenhagen Porcelain Manufactory lists a whole variety of animals and birds, including robins, parakeets, kingfishers, penguins, geese, swans, owls, chickens, squirrels, rabbits, mice, frogs, cows, lambs, dogs, and cats. All are fine examples of the factory's high quality and naturalism maintained throughout the years.

13 England

Chelsea

As Dresden is to German porcelain, so Chelsea is to English, the names most commonly associated with the finest and earliest porcelains of their type in Europe. One vast difference is that while Meissen (Dresden) was producing a type of hard-paste porcelain as early as 1710, the London factory of Chelsea was throughout its entire establishment concerned only with the manufacture of an artificial soft-paste. When comparing the achievements of the early continental porcelain factories with those of England, it is important to note that the majority of the factories in Germany, France and elsewhere all enjoyed a royal or princely patronage, and they did not necessarily have to show any financial profits, whereas those in England relied solely on the sale of their wares to survive.

The history of the Chelsea factory is one of the easiest of porcelain undertakings to memorize, falling into five clearly-defined periods: the triangle, the raised-anchor, red-anchor, gold-anchor, and the Chelsea/Derby. This last period (1770–1784) was when the factory was taken over by William Duesbury, the proprietor of the Derby factory (see p 105).

Very little of the porcelain produced at Chelsea was entirely original in either form or decoration, since it would have been difficult to invent a new, acceptable style and find a ready market for any wares that had not previously been made fashionable by either the Meissen factory of Saxony or one of the early French factories. French influence was only to be expected as Nicholas Sprimont, the founder of the Chelsea works, was born at Liège. He was by profession a silversmith who had his mark registered in London in 1742 and continued to produce silver until about 1748. In the beginning he was probably assisted or partnered by another silversmith, Charles Gouyn.

Sir Everard Fawkener, secretary to the Duke of Cumberland, brother of George II, is known to have patronized the Chelsea factory and the duke himself was said to be 'a great encourager of the Chelsea China' but there is no record of any actual financial aid.

In collecting circles, the first period of Chelsea, the triangle period, is now regarded as having lasted from 1745 until about 1749. It was the period of the Sprimont/Gouyn partnership, and the mark most commonly used consisted of a small triangle incised into the clay on the base of an object prior to the initial firing. The Chelsea wares of this period usually consist of a fine milky-white paste with a very glassy appearance and are invariably rather heavily-potted, probably to counteract warping; any fine modelling was obscured by the rather heavy glaze. Chemical analysis has disclosed that the early paste had a high content of lime, indicating the use of chalk, a feature also of the early soft-paste porcelains of France.

The salt, in the form of a shell and crayfish (84, p 183), is typical of the range of Sprimont's wares that more or less reproduce his earlier silver shapes; wares of this type are usually marked with the incised triangle.

A rare animal subject considered to have been produced about the end of this first period is the very fine greyhound (68, p 173). It is marked with the unusual device of a crown intersected with a trident in underglaze-blue, and it is very difficult to suggest a reason why a factory that so seldom used this colour in its decoration should have suddenly chosen it as a mark. The crown and trident mark would certainly be much more acceptable for the Greenwich factory, about which we still lack much information, but for the time being chemical analysis indicates these pieces were made at Chelsea. The greyhound is so superior to any contemporary English porcelain figure that it was considered by Arthur Lane to have been cast direct from a bronze or ormolu original. This view may well be correct as only recently the writer was shown a nineteenth-century bronze of the exact figure (though one must not overlook the fact that the porcelain could well have been the model for the later bronze). This piece was undoubtedly made by the slip-cast method used at Chelsea for reproducing their models from the original. The Chelsea craftsmen who were initially recruited from the Staffordshire potteries must have been well-versed in this technique which had been used by them for producing intricate shapes in high-fired salt-glazed stoneware from about 1740 (see p 16).

13 Hogarth's dog Trump in white-glazed soft-paste porcelain. ENGLISH (Chelsea), 1747–50; length 26.7 cm/10½ in. (p 90)
Crown copyright, Victoria and Albert Museum, London

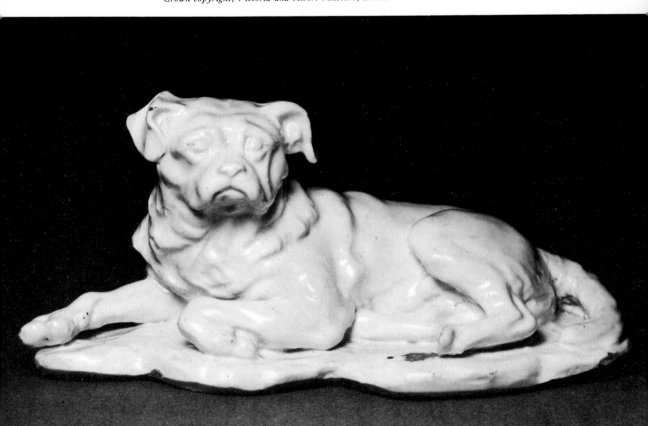

One of the most important dogs to have been produced in English porcelain must surely be the figure of William Hogarth's pet pug, Trump (13, p 89). There was originally some doubt as to whether this dog was of Chelsea porcelain, but research has proved that this is so: the figure was made by slip-casting, and the paste compares very favourably with that used at the Chelsea factory during the 1745–49 period; the enamel painting is also of the type occasionally seen on early Chelsea (see Victoria and Albert Museum Bulletin vol III, no 2, 1971, article by J V Mallet).

The fact that the figure represents Hogarth's pet is proved by the engraving in the second volume of Samuel Ireland's *Graphic Illustrations of Hogarth* published in 1799. The engraving, signed 'Phillips Sc', shows a bust of Hogarth above an engraving of Trump that matches the museum porcelain copy in every detail, except that it is in the reverse position, with the head to the right. Ireland comments 'that there was a close resemblance betwixt his own countenance and that of this favourite dog, who was his faithful friend, and companion for many years' This same dog appears again in Hogarth's self-portrait of 1745, now in the Tate Gallery, London.

The second period of Chelsea dates from 1749 until 1752, when the mark (seemingly adopted by Sprimont to identify a new paste) consisted of a small relief anchor on an applied oval medallion, generally placed on the wares in a rather prominent position. This raised-anchor paste, which was to prove very superior to the original material, is less glassy in appearance, resulting from a slight amount of tin oxide being used in the glaze, not sufficient to render the glaze completely opaque, but enough to tint it.

It was during this second period that so many figures were made in imitation of the slightly earlier Meissen models. Through his patron, Sir Everard Fawkener, Sprimont had gained access to a large collection of Meissen porcelain (belonging to Sir Charles Hanbury Williams, the British plenipotentiary in Dresden) which at the time was stored in Holland House, London. The many human figures made after these German originals are not the concern of this book but, although Sprimont did not copy them, he might well have been inspired by the Meissen birds to produce his own more original series.

The Natural History of Uncommon Birds was originally published in 1743 by George Edwards, library keeper to the Royal College of Physicians. The four volumes, now very rare, were the result of twenty years of study and drawing of birds from nature. Edwards was particularly proud of the fact that he had 'for variety's sake, given them as many different turns and attitudes as I could invent'. He was justifiably proud of his accomplishment and even went to the length of receiving personal instruction in the art of engraving or etching on copper-plate in order to maintain a high standard.

opposite
20 Dolphin (probably a paperweight) in soft-paste porcelain, painted in enamel colours. ENGLISH (Bow), about 1760; height 12.1 cm/4¾ in. (p 100)
Victoria and Albert Museum, London

overleaf
21 Tureen in the form of a tub of fish in tin-glazed earthenware, painted in enamel colours, and marked with 'FR/B' in blue. PORTUGUESE (Rato), 1761–71; height 28.8 cm/11⅓ in. (p 85)
Courtesy The Campbell Museum, Camden, New Jersey

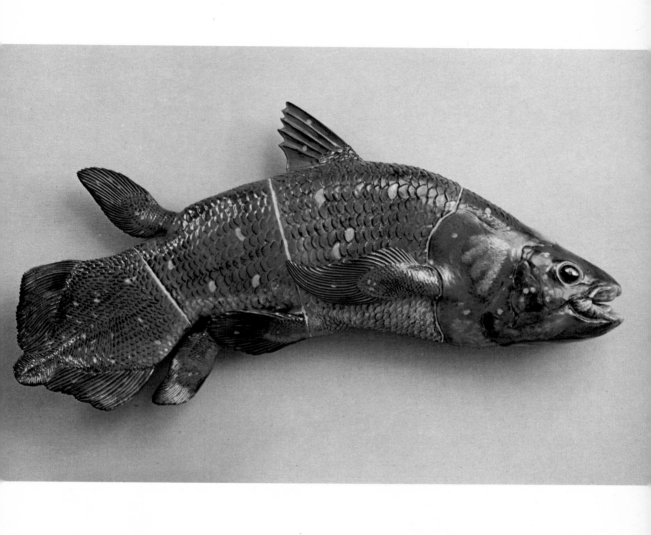

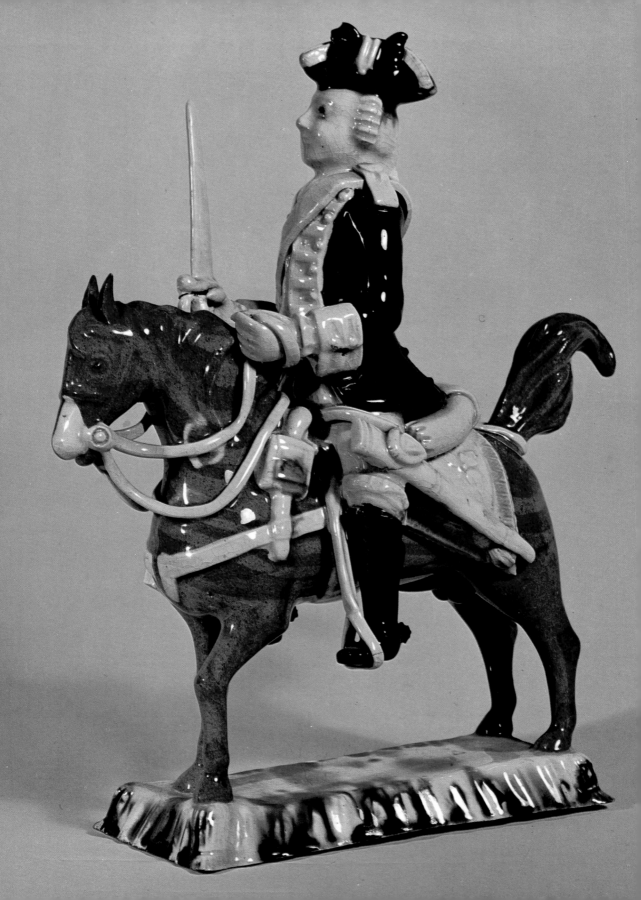

The figure of a partridge (29, p 151) shows to advantage the fine white porcelain of the raised-anchor period; in contrast, the little hawk owl, shown together with a photograph of the relevant plate in George Edwards' volume (30 and 31, p 152), is fully decorated with enamel colours. The painting on this series of birds has little in common with other Chelsea painting of the same period, and one cannot rule out the suggestion that these coloured birds may well have been decorated outside the factory. William Duesbury (1725–1786) is probably best known as the proprietor of the Derby factory which he established in 1756, but of far greater interest to collectors are the many porcelains and stonewares of other English factories that passed through his hands during the time he was working in London (1751–53) as an independent decorator. Many of the figures that now appear to have been left in the white were almost certainly at one time decorated in the cheaper unfired colours that have since worn off. Duesbury's account books tell of painting such wares for an average of half a crown, whereas his 'inhamild' decoration was usually treble the cost of unfired painting.

The beautiful pair of parakeets (8, p 48) also bear the mark of the raised anchor, which, like that on the little hawk owl, is picked out in red enamel. The Chelsea modellers made an excellent job of their reproductions within the limitations of the difficult material of soft-paste porcelain. They were not, however, of sufficient merit to please Edwards. In describing imitations of his work (both models and drawings) he writes, 'most of which are sadly represented both as to shape and colouring . . . the world can form but a mean opinion of the work from which they are plundered, unless they examine the original itself.'

Many wares of the red-anchor period, the third Chelsea period (1752–58), were almost exact copies of those originally made to decorate the tables at the court of Dresden. One example is an excellent model of a squirrel made after a Kändler original of about 1732. The Meissen piece is somewhat marred by the animal wearing a heavy black collar fastened to the base with a gilt chain; the base itself is decorated in the customary Meissen fashion of the period, with applied foliage and flowers. The later Chelsea version seems a much happier squirrel, free from tethering, more liberally decorated and on a simple mound base, typical of Chelsea at its best. Although based on the German figure, the actual modelling is original, and it is slightly larger. Many of the nineteenth-century reproductions of eighteenth-century figures that were made by Samson of Paris can be identified as such because they have been made from moulds taken from original figures: in consequence they are distinctly smaller due to the further kiln-firing.

overleaf

22 Coelacanth (rare early fish) in earthenware with lead-glaze. DANISH (Royal Copenhagen Porcelain), modelled by Jeanne Grut, 1963; length 118 cm/44 in. (p 87)
Copyright The Royal Copenhagen Porcelain Manufactory Limited

opposite

23 Mounted dragoon in lead-glazed earthenware tinted with coloured oxides. ENGLISH (Staffordshire, Astbury-Whieldon), about 1755; height 20.3 cm/8 in. (p 122)
The Gubbay Collection (Clandon Park, National Trust)

A further interesting copy is the large white glazed lion (55, p 166); it was once thought to be a rare example of early Bow but is now attributed to the Chelsea factory. Notice just how closely it is modelled on the original marble figure (54, p 166), which is early classical and is sited at the bottom of the steps of the Loggia dei Lanzi in Florence, where it is accompanied by a further lion carved by Flamino Vacca in about 1600 to make a matching pair. The Chelsea lion is very heavily potted and dates from 1750–55.

A tureen in the form of a life-sized hen and chicks on a large moulded platter, decorated with sunflowers, is easily identified in the sale of wares from the Chelsea Porcelain Manufactory, held for sixteen days in 1756 at the Great Room of Mr Ford in St James', London. The piece is listed as 'A most beautiful TUREEN in the shape of a HEN and CHICKENS *as large as life* in a fine sunflower leaf dish'. Similar tureens are listed in the shapes of a boar's head, swan, drake, and partridges (9, p 49), while other animals listed for the 'desart' (dessert) or table-decoration include cows, sheep, cow and calf, goats, ewes, bantam cock and hen, lambs, fox, dog, and 'A set of five figures *representing monkeys* playing on musick in different attitudes' (see p 64).

The Victoria and Albert Museum in London owes much to Lady Charlotte Schreiber: in 1885 she presented to what was then known as the South Kensington Museum a truly remarkable collection of English pottery and porcelain, almost all of eighteenth-century date. the *Journals of Lady Charlotte Schreiber* (edited by M J Guest, 1911) tell of her travels throughout Europe in search of rare specimens for her collection. Born Lady Charlotte Elizabeth Bertie, she married the wealthy iron manufacturer J J Guest. After his death Charlotte remarried in 1855, this time to her elder son's tutor, Charles Schreiber. Ten years later she became obsessed with a passion for collecting, and for the next fifteen years this amazing couple toured Europe and amassed a treasure-house. In addition to the English ceramics that she gave to the nation in 1885, she also collected European and Oriental ceramics, playing-cards, fans, furniture and interesting prints and paintings that were related to the decoration on many of her pieces of pottery and porcelain. In 1884 Lady Charlotte was again widowed and she spent her remaining years cataloguing her collections; in 1895 the self-styled 'China maniac' died.

The gold-anchor period of Chelsea is today considered to date from about 1758, a few years later than previously accepted. Nicholas Sprimont was suffering ill health during 1757, but despite this the output of the factory must have been considerable, for in 1758 sufficient wares were accumulated to warrant a fourteen-day sale in Dublin, Ireland (though this may have included wares produced previously that had remained unsold in England). A further large sale was held in 1763, at which time Sprimont announced he was going out of business because of his lameness; similar 'closing down' advertisements appeared in 1764 and early 1769, but it was not until August 1769 that he finally disposed of the factory, and he seemingly kept sufficient finished material himself for a four-day sale he held in 1770.

The change-over from the red-anchor to the gold-anchor period seems to have been spread over a considerable time and does not necessarily indicate a particular new phase in the life of the factory. The major change concerning these two periods was in the body of their wares: the fine white

glaze of the raised and red-anchor years was now replaced by a much glassier glaze, sometimes very aptly described as 'juicy'. This was very prone to crazing especially when thick, and whenever the glaze was inclined to gather, such as in any depth of modelling, it took on a distinct greenish hue. The paste also changed and liberal use was made of calcined bone, a material that had been used by the London factory of Bow (see below) for many years.

Porcelain fashions were now to be dictated by the French factory at Sèvres. Saxony was in a state of war with Prussia (the Seven Years' War having started in 1756), and with the factory of Meissen occupied by the troops of Frederick the Great, the French factory faced little competition from the earlier concern. The age of rococo had arrived and the simplicity of the former figures was now replaced by wares of rich coloured grounds, with a tendency towards over-decoration in both painting and lavish gilding. Figures were now coupled with an elaborate and fussy background of flowers and foliage *(bocage)* and were often made to serve as candle-holders with porcelain or gilt metal supports rising from the *bocage*. The whole groups were then perched on pedestals with heavily scrolled rococo modelling, at times looking as though they were on a small desert island.

It is in this setting of lavish figure subjects, intended to be seen only from the front, that we meet the few animals being produced at that time. These groups were mostly inspired by illustrations of Aesop's Fables: the pair of elaborate candlesticks illustrated depict the Vain Jackdaw and the Cock and Jewel (28, p 150). It was the vain jackdaw who arrayed himself in the bright plumage that other birds had shed and then endeavoured to be crowned king on account of his appearance, but he was attacked by the birds to whom the feathers had originally belonged and was left a very dejected creature, giving rise to the proverb: fine feathers don't make fine birds. The story of the Cock and Jewel tells of the cockerel who was scratching on a dunghill, when he turned up a precious stone. 'Well', he said, 'this sparkling foolery to a jeweller would have been something, but to me a barley corn is worth a hundred diamonds.' (A wise man will always prefer the necessities of life.)

During this period the usual factory-mark was a boldly painted gold anchor which, it must be remembered, was also the popular mark used on so many continental reproductions of similar models made in hard-paste porcelain during the second half of the nineteenth century. These same models were also produced at the Derby works.

Girl-in-a-Swing factory

In a paper read by Arthur Lane and R J Charleston to the English Ceramic Circle in 1960 (*English Ceramic Circle Transactions* 5, part 3, 1962) it was told how the evidence of chemical analysis was first used to help prove beyond all reasonable doubt that from 1749 to about 1754 there were two rival factories working at Chelsea, the later concern probably not making wares on a commercial basis until nearer 1751. For many years a group of unmarked pieces that were vaguely similar to those known to have been made at Sprimont's Chelsea factory had worried collectors. It was

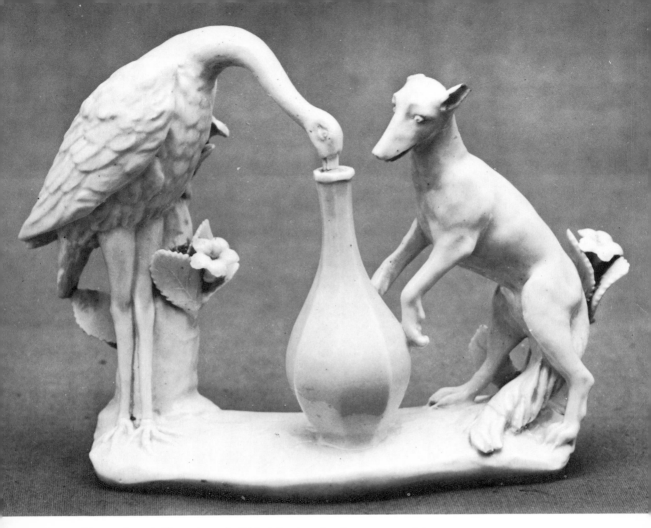

14 Fox and stork (from Aesop's fables) in glazed soft-paste porcelain. ENGLISH
(Girl-in-a-Swing), about 1751; height 14 cm/5½ in. (p 98)
Courtesy Museum of Fine Arts, Boston

possible to align this group of wares with a well-known key piece, the
Girl-in-a-Swing, models of which are in the Victoria and Albert Museum
and the Museum of Fine Arts, Boston. All the articles in question were of
a very glassy paste and were found to contain a far greater percentage of
lead than the wares of the original Chelsea concern (averaging over 15
per cent against about 9 per cent in the triangle period of Chelsea).
Also, the pieces all appeared to be the work of a single modeller, who
seemingly had very little training in the study of anatomy judging by the
peculiar proportions of some of his creations.

The figure illustrated (14, above) is the only recorded example of this
fable group, and clearly shows features that, when pointed out, are all too
obvious: the serrated leaves on the tree trunk and the crescent-shape
indentations on the upper surface of the base, as if made with a thumb-
nail. These same peculiarities are found on the white glaze figures of
birds mounted on easily-identified hexagonal bases with bevelled edges, a
type often used by this factory.

The glaze on the Girl-in-a-Swing groups fits the paste much better than on the wares of the earlier Chelsea factory, adding clarity of detail to features such as eyes. But due to high lead content the factory had a large proportion of 'wasters', and fire-cracking and distortion was quite common: in consequence, they limited the size of their wares to about 25 centimetres (10 inches) in height. There has been a lot of doubt cast concerning the accuracy of many statements made by Simeon Shaw in his book *History of Staffordshire Potteries* but it seems reasonable, however, to accept his story that the 'breakaway' factory was started by a group of Staffordshire workers who were originally recruited by Sprimont to help establish his own factory in 1745. These people would certainly have had a good knowledge of the technique of slip-casting, such as was necessary to produce the fine small hollow scent-bottles, seals, snuff-boxes, etuis and trinkets that followed later. These miniature pieces were described in the auctions of the period as 'porcelain toys', and it is fairly evident that Sprimont's Chelsea factory never made such pieces until after the failure and winding-up of the rival factory in 1754. The Chelsea toys show superior workmanship to those of the Girl-in-a-Swing factory, and were most probably modelled by Joseph Willems.

Bow

Only during recent years was it discovered that the Bow China Works were in fact in the county of Essex and not Middlesex. Although an early patent was granted in 1744 to 'Edward Heylyn of the Parish of Bow in the county of Middlesex, merchant, and Thomas Frye of the parish of West Ham, in the county of Essex, painter', this patent referred only to the manufacture of materials for the making of porcelain and it was not until 1749 that a further patent concerned with the actual manufacture was granted to Thomas Frye alone. Bow is especially important as it would appear to be the first porcelain factory to make wares that contained calcined animal bone as one of the ingredients and they were certainly making such wares on a commercial basis from about 1747.

According to Daniel Defoe's *Tour of Great Britain* published in 1748, Bow was a flourishing concern making wares comparable to those then being imported from China. Their wares were obviously intended to cater for less wealthy customers than those of Chelsea; they aimed at producing good useful wares, not lavishly or expensively decorated and, judging from the number of wares they produced in the popular Chinese blue-and-white fashion, they were endeavouring to compete with cheap Chinese imports.

The paste of Bow during the first five or six years of production is a fine creamy soft-paste porcelain, similar to the paste of the French factory of Saint-Cloud, but in this same period they were constantly experimenting with a variety of glazes, which sometimes makes quick recognition rather difficult. The delightful figure of a fox (126, p 209) is of about this period. The earliest dated pieces of Bow include a few inkwells marked 'Made at New Canton', the name given to the factory; 1750 is the earliest date recorded. It would appear that Bow never marketed any enamel-decorated figures until after 1752, but early figures are at times encountered

with enamel colours that have been added by decorators such as William Duesbury, who makes mention in his account books of adding colours to 'Bogh' figures.

In the succeeding period of 1754 up to about 1760, the paste greatly improved and a soft waxen-like glaze was generally used. The palette included several easily identifiable colours peculiar to the factory: for example, a bright translucent green that is apt to run in 'tears', a soft pastel opaque blue, and a strong rose-purple (especially used in their reproductions of Chinese *famille rose*). Gilding, when used, was rather soft and dull with a tendency to wear off rather quickly. The fine owl (32, p 153) is typical of this 'simple' period. The birds made at Bow were doubtless inspired in many cases by those produced at Meissen, but while the Chelsea decorators endeavoured to copy faithfully the colours of George Edwards's originals, the Bow painters usually set out to make a gay composition with clear, bold and fantastic colouring more appropriate to birds of paradise. However, this owl is far more attractive with its sparse application of colour, enabling the modelling to be better appreciated.

From about 1755 many well scaled figures of both human and animal form were produced. A late example (about 1765) is the delightful group of the child and tame leopard (51, p 164). Many of these figures have a common characteristic in the form of a small square-cut hole in their back. This hole is in addition to the normal vent hole that all hollow porcelain figures require and is intended for the fixing of a metal *bocage* with porcelain flowers or a metal candleholder (though these additions would only be added at the customer's request). A further mark often seen on the base of Bow figures of this period is an impressed 'T' or 'To', said to be the mark of the repairer Mr Tebo, or Thibaud; this same mark is sometimes found on Worcester figures and centrepieces, and Plymouth and Wedgwood wares.

By about 1756 the attractive simple mound bases had given way to the increasing use of the more fashionable rococo, which can be seen on the pleasantly colourful figures of a cock and hen (11, p 59) and the equally colourful dolphin (20, p 91), which was probably intended to serve as a paperweight. The full rococo base commonly used consists of a very characteristic four-footed table-like pedestal seen on the matching pair of phoenixes (15, p 101) which, apart from the bases, would be more at home in the classical period to follow.

In 1759 Frye retired from the factory because of ill health. The factory was flourishing at the time and the undertaking was carried on by Messrs Weatherby and Crowther. The former died in 1762, and Crowther was declared bankrupt in 1763. The firm was eventually taken over in 1776 by William Duesbury of Derby who, after removing the equipment, closed it down.

About 1760 Bow, in common with other English porcelain factories, was making tureens in the form of partridges sitting on their nests, and these figures were usually painted in sombre, naturalistic colours. According to papers left by John Bowcocke, the clerk to the Bow concern, he had on one occasion to purchase 'a partridge alive or dead', which might well have been to provide the creator of these tureens with a true model.

From 1763 an irregularly used factory-mark seems to have been adopted: it is on both useful wares and figures, giving the title 'anchor and dagger'

15 Pair of phoenixes in soft-paste porcelain, painted in enamel colours.
ENGLISH (Bow), 1760–65; height 21 cm/8¼ in. (p 100)
Courtesy Wernher Collection, Luton Hoo, Bedfordshire

to this period. The two devices were drawn in a reddish-brown enamel
and are sometimes the subject of sharp practice for, by removing the
dagger with acid, an anchor remains that could well be mistaken by new
collectors for the red anchor of Chelsea. This last period of Bow was
devoted mostly to the manufacture of poor imitations of Chelsea table-
wares and also of large figures with distinctive orange-tinted cheeks and
an over-blued glaze.

Derby

The porcelain of the Derby factory has never been so popular with
collectors as the wares of some of the other English soft-paste factories
such as Chelsea, Bow or Worcester. This is probably because until
recently the positive attribution of some specimens to this particular
factory was difficult.

Among the most interesting examples of Derby porcelain are those
produced prior to 1756. Made as if in competition with the well-known
goat-and-bee jugs of triangle-period Chelsea are three small jugs: two
have the incised letter 'D' and '1750', while the third bears the word
'Derby'. The potter to whom these pieces are attributed, together with
a class of early figures, is Andrew Planché.

The early groups of figures are now generally accepted as having been
made around 1750–55, before the establishment in 1756 of the Derby
Porcelain Manufactory that was to continue until 1848. These early

pieces bear no recognized factory-mark and it is only on the evidence of constantly recurring features in their construction and materials that they are separated as a group. The main features are: first, the dry edge around the base, which suggests that after being dipped in the glaze a narrow margin was wiped clean to prevent the risk of 'tears' fusing the figures to the base of the fire-clay saggar in which they were placed during the glost firing; second, the characteristic funnel-shaped or 'screw' hole in the base; and third, the slip-cast method by which all this group were produced. The boar is probably the best known of this Planché family.

The paste of the 'dry-edge' family is very rich and creamy in appearance, but sometimes marred by the thick glassy glaze. It is appropriate to mention here a very dangerous class of fakes of boars, other animals and birds made in the West Country of England over recent years. These reproductions are of a rather poor chalky material with a waxen-like glaze and are often decorated in a palette that includes an unpleasant fleshy pink, sometimes applied in a manner resembling dried blood, and a blackish-grey.

Among the other animals attributed to Planché are sheep, goats, bulls and stags. There is a pair of charging bulls in the collection of the Derby Museum, painted in the palette attributed to William Duesbury while he was still employed as an independent decorator. The simple mound bases of these bulls and other groups rely on painted flowers and leaves for decoration in place of the more customary relief flowers found on similar Meissen figures.

The names of Andrew Planché, John Heath the financial backer, and William Duesbury all feature in a draft agreement of 1756; this agreement was never executed and later in that same year Heath and Duesbury alone were named as the 'Proprietors of the DERBY PORCELAIN Manufactory' and offered at a four-day sale in London 'A curious collection of fine Figures . . . after the finest Dresden models'. It is apparent that it was the intention of the partners to use the fame of the Meissen factory to popularize their own wares, and in 1757 another advertisement refers to 'Derby or second Dresden'. The partners must have been unduly optimistic and could only have hoped that their customers would have seen little of the real German porcelain, for their hybrid paste was very light in weight and chalky in body, while the intense blueing of the glaze to give the illusion of a hard-paste was so overdone that flesh-tints took on a ghostly pallor.

During the third period of the factory, from about 1758 until 1770, the unpleasant blued glaze over a chalky paste gradually gave way to a creamier white body with a clear colourless glaze. Another constantly recurring feature of this period found on figures and some useful wares helps to identify otherwise unmarked pieces. The wares of this 'patch' family are marked on the bases with three or more patches of dark, unglazed porcelain, caused by the small blobs of fire-clay on which the pieces were supported in the kiln during the glazing stage; this feature can be seen on the wares over a long period. The styles of this phase of Derby modelling were much dictated by the fashion of gold-anchor Chelsea, which in turn came under the influence of Sèvres. The Derby craftsmen only rarely

24 Water-pitcher in the form of a horse and rider in tin-glazed earthenware (faience), decorated in enamel colours. FRENCH (Vallauris), the work of Pablo Picasso, 1951; height 39.4 cm/15½ in. (p 83)

Victoria and Albert Museum, London

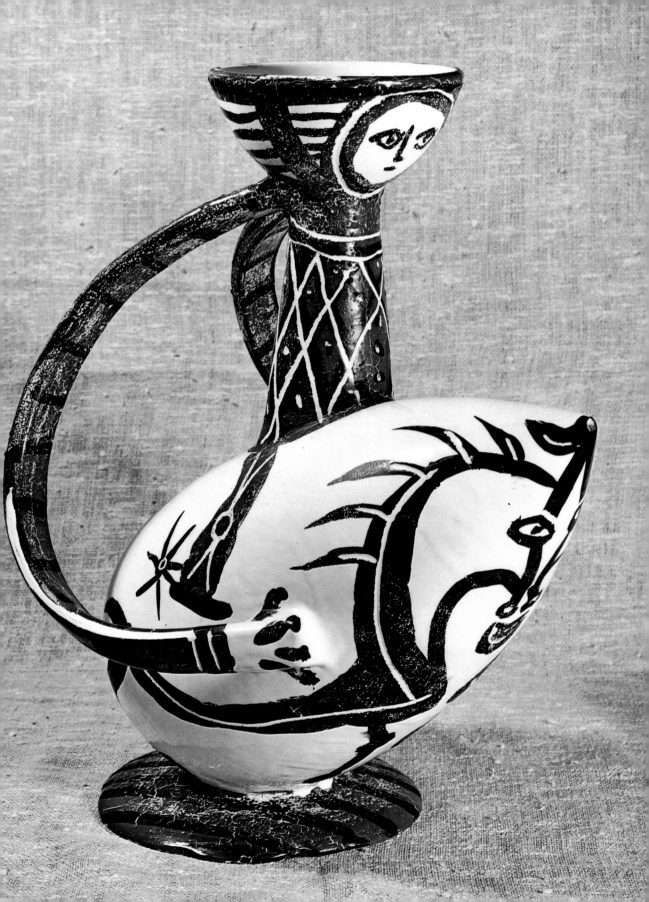

modelled animals on their own, but they often featured in some of the more ambitious groups such as Europa and the Bull (60, p 169) and Leda and the Swan, both fine examples of this period, unspoilt by the popular rococo bases soon to follow.

During the time that both Chelsea and Derby were under the control of William Duesbury (1770–84) great improvements were made in paste and palette. While the production of exceptionally fine useful wares appears to have been their main aim, many figure subjects were still made, with an increasing number being left in the biscuit, a fashion popularized by Vincennes and Sèvres. It is of interest to note that these unglazed groups were more expensive than the same model fully glazed and decorated. This was because to be sold in the biscuit a piece had to come from the kiln in an unblemished condition, whereas glaze and decoration could always be used to remedy slight defects where necessary.

Late in the eighteenth century Derby made reproductions of the popular Meissen groups of the tailor and his wife mounted on goats, modelled originally by Kändler and Eberlein. The Derby price list describes this pair as Welch Taylor and Family. The publication by John Haslem, *The Old Derby China Factory* is of great interest, for it includes a price list of Derby figures together with their size and number, which is generally incised under the base of wares made from about 1770.

Soon after 1811 the Derby factory was purchased by Robert Bloor, and although Bloor himself was insane from 1828, the factory continued to be associated with his name until 1848. The Royal Crown Derby Porcelain Company of today was not established until 1876.

Lowestoft

From 1757 to about 1799 there was a small soft-paste porcelain factory in operation at Lowestoft, a fishing-port on the east coast of England. Apart from many modest but attractive tablewares, they produced a limited number of charming figures of small animals, including cats, sheep, rams, swans and dogs, which are all very small and extremely rare. The entire range has been identified by finds of both porcelain wasters and the plaster-of-Paris moulds found on the site of the factory. These pieces are comparatively heavy and usually have flat bases covered with glaze; the small air vent is of the same form as found on the early Planché period Derby figures and always appears to have been reamed out, as though for a countersunk screw.

There is a group of small pug dogs (71, p 175) that was previously attributed to Longton Hall, but following a chemical analysis check the figures were found to include the ingredient of bone-ash that Lowestoft is known to have used. These pugs have a fairly large vent-hole in a very thin base, and they are decorated with underglaze manganese and cobalt (giving purple and blue). This is an unusual treatment for Lowestoft figures, which are normally only decorated with enamel colours but, in his book on Lowestoft porcelain, G A Godden draws attention to the fact

25 Swallow-tail and short-tail blue butterflies on yellow bull-head water-lilies and branched bur-reed, in porcelain on a Brazilian green onyx base. ENGLISH, modelled by Patrick O'Hara, about 1972; height 17.8 cm/7 in. (p 104)

Courtesy Patrick O'Hara

that manganese was also used on the rare cream-jugs in the form of a cow, also at one time thought to have been made at Longton Hall. These too can now be identified as Lowestoft because their flat bases are so similar to those of the standing dogs—thin slab-like bases with concave indentations at the edges.

The figures are well represented in the Castle Museum at Norwich, where there is also a large collection of fragments found on the factory site.

Longton Hall

Prior to Dr Bernard Watney's publication *Longton Hall Porcelain*, there was much difference of opinion among porcelain collectors as to the accurate identification of the wares of this Staffordshire factory. Although north Staffordshire was the centre of the English ceramic industry, Longton Hall appears to have been the only factory in the area producing porcelain in a commercial quantity during the middle of the eighteenth century. The potters of the towns that now make up Stoke-on-Trent had worked for so many generations on the various forms of earthenware and stoneware that they apparently found it very difficult to adapt to soft-paste porcelain and were therefore unable to compete with the high standard set by Bow, Chelsea, Worcester, and Derby.

The man most usually associated with Longton Hall is William Littler, who was also known as a salt-glazed stoneware manufacturer and for 'Littler's blue', the strong high-temperature cobalt colour that was at times applied in the form of a stained lead-glaze to previously fired salt-glazed stoneware. It has only come to light in recent years that after Longton Hall was closed in 1760, when over 90,000 pieces of porcelain were sold off against his wishes, William Littler moved to Scotland where, from 1764 until about 1770, he was working as a 'China maker' at West Pans near Musselburgh. Some pieces now identified as Longton Hall bear enamel decoration that was almost certainly added to some outmoded or faulty wares that Littler took with him and then decorated to local order, and there is also evidence of his manufacturing some typical Longton Hall forms in an earthenware, also covered with the familiar blue glaze.

In 1929 Mrs Donald MacAlister, a founder member of the English Ceramic Circle, suggested that an early group of figures referred to as the 'snowman' family might well belong to the Longton Hall factory. The keen observation of this collector has since been proved correct, for excavations from the site of the factory have produced parts of figures and wasters that can quite confidently be tied to this early group, and now be identified as a distinct class with a very thick glaze of almost pure glass containing a mass of minute bubbles. This glaze is very apt to gather in tears and pools, and in consequence the modelling takes on a very blurred but not unpleasing appearance. Most of the pieces recorded have been modelled after Chinese, Meissen or Chelsea porcelain originals, but some have been fashioned after lead-glazed or salt-glazed stonewares of Staffordshire. The figure of a heron (16, p 107) is a beautiful example of this class and was made between 1749 and 1753. Also well worthy of mention is a

16 Heron in glazed soft-paste porcelain. ENGLISH (Longton Hall), about 1749–53; height 10.8 cm/4¼ in. (p 106)
Courtesy Rous Lench Collection

typical German pug dog dated 1750 from the same collection, and the cows, horses, pheasants, pug, crane and group of birds and animals in the collection of the Victoria and Albert Museum.

From 1754 until 1757 (the middle period) there was an improvement in both the material and the quality of the Longton Hall modelling. Meissen was again used as a source for equestrian groups such as that featuring the blackamoor groom (91, p 189) made after Kändler's original (90, p 188). By comparison the figure of a mounted hussar (92, p 190) is very naïve. Early bronzes were often another source of inspiration for the modellers.

The period from 1757 until the closure of the factory in 1760 seems to have been mostly taken up with the production of tablewares. However, the love of horse modelling is still apparent in what must be one of the finest original models to have come from this factory—the Duke of Brunswick mounted on a galloping charger (93, p 190) and wearing the insignia of the Order of the Garter with which he was invested in 1759. This is one of the last of such important pieces made at this interesting factory.

Worcester

It is a fact that, among collectors of porcelain, even if certain models are not of a high quality, providing they are rare, they become important as collectors' items and command very high prices in the sale rooms. This is particularly the case with the Worcester figures.

Worcester has the pride of being the only English porcelain factory established during the middle of the eighteenth century that has continued in production to this day with an unbroken history. The Worcester concern might well be considered as having been born in Bristol, where a small factory was established by William Miller and Benjamin Lund in 1748. Dr Richard Pococke, a contemporary traveller and writer, notes that the Bristol china factory had been founded by 'one of the principal manufacturers at Limehouse which failed'. To date no wares have been recognized as having been made at this mysterious London undertaking, but it has been suggested that it was Lund who took the knowledge concerning the manufacture of a new type of soft-paste porcelain that contained soapstone (steatite) from Limehouse to Bristol.

The Bristol factory was purchased in 1752, by the group of fifteen partners who had formed the Worcester Tonquin Manufacture. Dr Wall and one of the partners, William Davis, claimed to have invented 'a new Manufacture of Earthen Ware', but it certainly seems more likely that the whole take-over business was arranged in order to give them access to the formula Lund and Miller were using to produce a type of porcelain that was advertised as having been tested with boiling water. Dr Wall died in 1776 and today collectors refer to the Dr Wall period as being from 1751-76, after which the factory was continued under Davis, the chemist of the concern, until it was purchased by Thomas Flight, the firm's London agent, for his two sons Joseph and John, giving the name Davis & Flight from 1776–93. The porcelain made at Worcester was a great advance on that of rival factories, for it contained 30–40 per cent soapstone

quarried under licence in the area of the Lizard, in Cornwall. The porcelain had a fine tight-fitting glaze, often blued with cobalt to overcome the creamy colour of the paste; it rarely crazed and so was an ideal material for the main production of tablewares of this prolific factory. During the eighteenth century very few figures, and even fewer animals or birds, were produced at Worcester, a situation that has certainly been remedied during this century.

In his excellent book, Henry Sandon gives a very detailed account of how the famous Dorothy Doughty figures of birds first came to be manufactured. As early as 1934 the company was already producing limited editions of plates decorated with bird subjects after Audubon's *Birds of America*. It was the success of this series that prompted the American agent to suggest a series of life-like models of birds indigenous to the United States. Freda Doughty was already engaged as a modeller for the factory and it was she who suggested that her sister, Dorothy, was capable of making the necessary models since, apart from her creative talent, she was a very knowledgeable ornithologist. The amazing results have proved that the choice of modeller could not have been bettered.

Her first pair of American birds, Redstarts on Hemlock, was made in 1935 and the issue consisted of sixty-six pairs, after which the mould was destroyed. In 1936 two more pairs were issued (goldfinch cock and hen, and bluebirds), and work was continued even throughout the war years for these models were an important American dollar earner. By this time Dorothy Doughty had become so knowledgeable about the production methods that she was able not only to create the models from plasticine hardened with an acrylic resin, but to cut up the figures into the appropriate sections in readiness for the mould maker.

In 1960 Miss Doughty was working on a new series of British birds and in the same year she wrote: 'I am aiming at a more delicate and living effect for the whole series, which should be far ahead of that hitherto for the American series.' In the following years she apparently fulfilled her ambition for she wrote: 'I am absolutely delighted with the Wren, for I now know for certain that we have got the technique we have been seeking for the whole series of English birds.' This may well be judged by the figure of a nightingale on honeysuckle (13, p 60) one of the many birds of the new series modelled by Miss Doughty before her death in 1962. This figure was published in an edition of five hundred in 1971. (The manufacture of the Doughty birds is discussed on pp 22–28).

Another Worcester modeller who has helped to bring fame to the figures produced at the factory during this century is Doris Linder, who as early as 1931 was employed by the factory as a free-lance modeller of animals. These early figures were followed in 1935 by the equestrian sporting groups of At the Meet, Over the Sticks, Cantering to the Post, and Huntsman and Hounds, models that are still in production to this day.

Illustration 17 (p 110) is without doubt the best known of all her creations: it shows Princess Elizabeth (now Queen Elizabeth II) attending the ceremony of the Trooping of the Colour. She is depicted in the uniform of Colonel-in-Chief of the Grenadier Guards and is mounted on the famous police horse Tommy. Made at the request of the Queen Mother in 1947, the group was modelled from life at Buckingham Palace, and today one of this limited edition of one hundred would fetch over £2,000.

Doris Linder is now recognized as one of the foremost modellers of

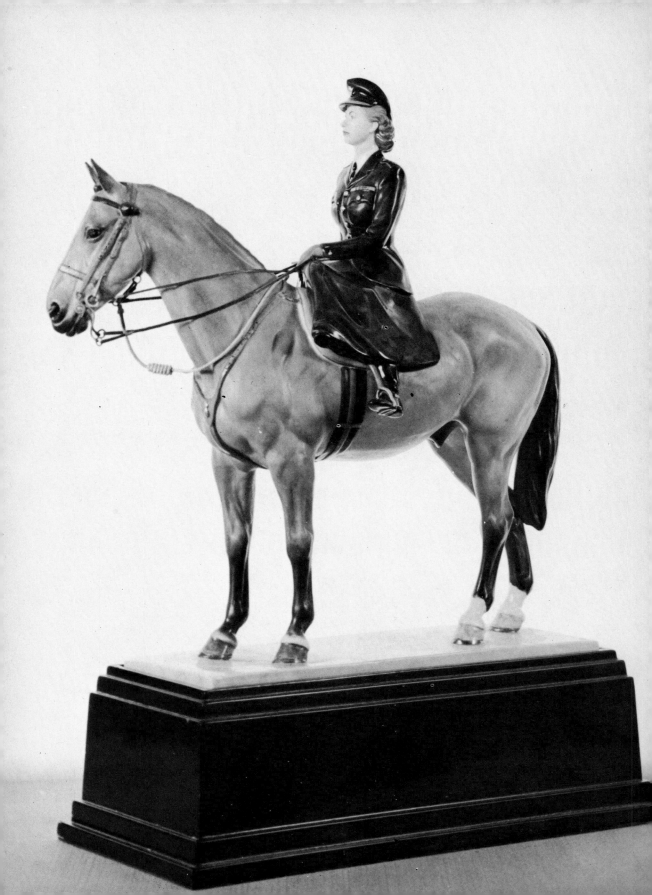

horses and cattle. She goes to great lengths to achieve a true likeness of her model, working from photographs and her own drawings and modelling from life. Since the 1950s she has produced a long series of limited editions that now all rank as collectors' items: a Hereford bull, 1959; Captain Llewellyn on Foxhunter, 1959; a Brahman bull, 1967 (63, p 171); a Charolais bull, 1967; a Suffolk stallion, 1967; HRH The Duke of Edinburgh playing polo, 1968; Prince's Grace and Foal, 1969; Marion Coates on Stroller, 1969; and Yellow Straw, 1971 (a Palomino horse, model only available in Canada and USA).

Ronald Van Ruyckevelt began work as a designer at the Worcester Royal Porcelain Company in 1953. He initially worked on the Dorothy Doughty bird series, both at her home in Falmouth, Cornwall, and at the factory. From about 1956 he was responsible for the modelling of a colourful series of fish, some small, some large, with the latter usually in a limited edition only. Following the death of Miss Doughty in 1962, Van Ruyckevelt was asked to produce a further series of bird models for the American market. The green winged teal (37, p 156), one of the American game birds, was modelled by him in 1970. This bird is the smallest of the pond ducks, yet the most agile in flight (with estimated speeds of an almost unbelievable 160 miles per hour).

Liverpool

It is only during recent years that research concerning Liverpool porcelain has made the identification of the large variety of wares originating in and around the city of Liverpool, in Lancashire, a little more certain. With the other porcelain factories already discussed, the output of only one major factory in that area was involved, but at Liverpool there were at least eight important individual undertakings. Previously the Liverpool porcelain factories have always been considered as those making wares of a very inferior type (which in many cases were obviously made in imitation of Worcester), and it was a common occurrence for any similar wares that were inferior in potting and painting to be disowned by Worcester collectors and attributed to the Lancashire factories. In many cases this is no longer justifiable and there is evidence that some excellent wares were made, but usually only tablewares.

Recently, finds in the form of fragments came to light on the site of Samuel Gilbody's factory on Shaw's Brow, which prove that they at least made a certain number of figures in addition to large quantities of the more common blue-and-white tablewares. Samuel Gilbody was working from about 1754 until 1761, making wares that justified his advertising in 1758 that he could supply 'wholesale and retail at the lowest prices, china ware of all sorts, equal for service and beauty to any made in England'.

Staffordshire

Josiah Spode was born in 1733 and at the age of sixteen was apprenticed to Thomas Whieldon and earned two shillings and threepence per week (and an extra threepence 'if he deserves it'). He obviously did, for by 1770 he had become a master potter. When he died in 1797, the fine traditions of the company were maintained by Josiah Spode II, who is credited with introducing the material of bone china in 1794, a body that has remained in popular use throughout the potteries to this day. Although the company has changed hands and is now American owned, the name of Spode has always been retained.

The little owl (14, p 69) is a recent Spode production modelled by Anthony Green of the Spode Design Studio; it is of bone china, painted in enamel colours, and is considered to be correct in every ornithological detail of both anatomy and plumage. The little owl is the bird of the Greek Goddess Athena, and during the Middle Ages it was regarded as a symbol of the 'darkness' prevailing before the coming of Christ. One of the 123 species of the Strigidae family, it is considered to be Britain's smallest and most common day-flying owl and is completely protected in Britain. The series also includes the greater spotted woodpecker, kingfisher, Montagu's harrier, mallard, pheasant, and misselthrush.

Today in the potteries, as in other industries, it is very difficult to keep up-to-date with take-overs. Many famous names are almost daily becoming part of a large group. Such is the case with the firm of John Beswick, who are now part of Royal Doulton Tableware Limited. This firm had already achieved a high reputation for the production of delightful, modestly-priced, miniature figures before embarking on a series that has proved even more popular: the characters made famous by the authoress of so many children's books, Beatrix Potter. A total of thirty-nine different pieces have been produced and the group illustrated (130, p 212) comprises Timmy Willie, Samuel Whiskers, Mrs Tittlemouse, Squirrel Nutkin, Little Pig Robinson, Jemima Puddleduck, Foxy Whiskered Gentleman, Jeremy Fisher, Peter Rabbit, and Mrs Tiggywinkle. Skilfully modelled and standing 10 centimetres (4 inches) high, they are hand-painted in the delicate colours of the authoress's original watercolour illustrations, and all are accurate to the finest detail.

Another well-known name is that of Coalport. Originally started in about 1797 in Shropshire, it moved to Staffordshire in about 1928; since then it has had several changes of ownership; fortunately the name still suggests fine work and they are now a member of the Wedgwood group. The set of four animals (32, p 136) was produced by the company in 1972. It comprises an elephant, rhinoceros, lion and buffalo and was modelled by the late John Kaposvary. Decorated in 22 carat gold, it was produced in a limited edition of 250 sets, each figure numbered and accompanied by a signed certificate.

opposite

26 The conductor of the Monkey Band shown in illustration **27**; height 17.1 cm/6¾ in. (p 64)

overleaf

27 A & B Eighteen figures of the Monkey Band in hard-paste porcelain, painted in enamel colours, and marked with crossed swords in underglaze-blue. GERMAN (Meissen) modelled by J J Kändler about 1750; average height 12.7 cm/5 in. (p 64)

The Gubbay Collection (Clandon Park, National Trust)

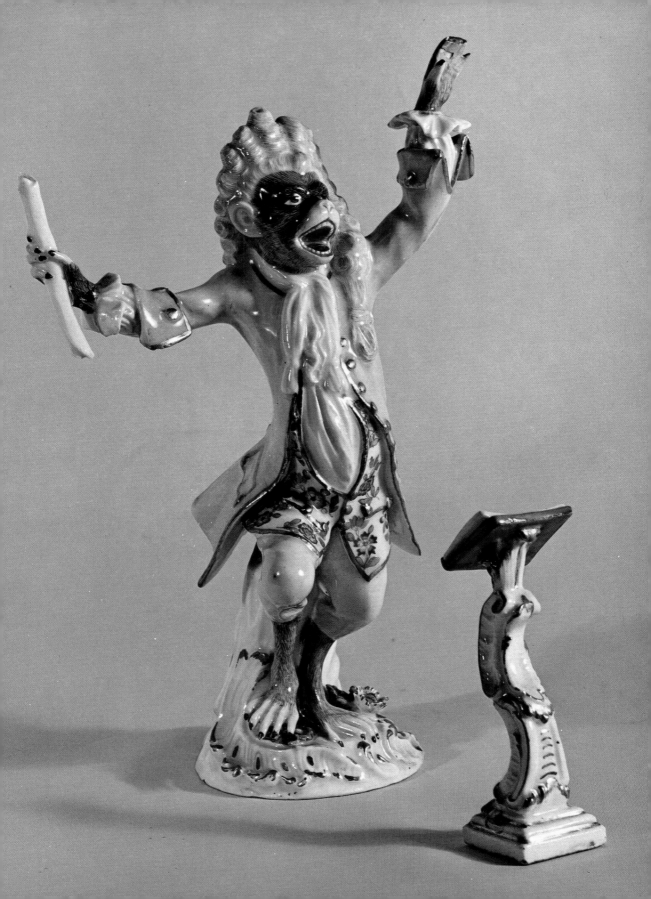

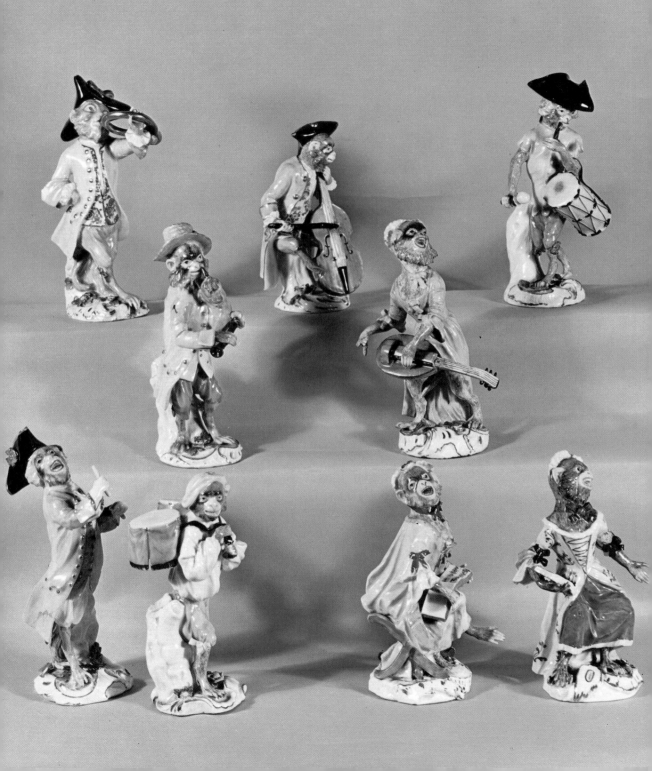

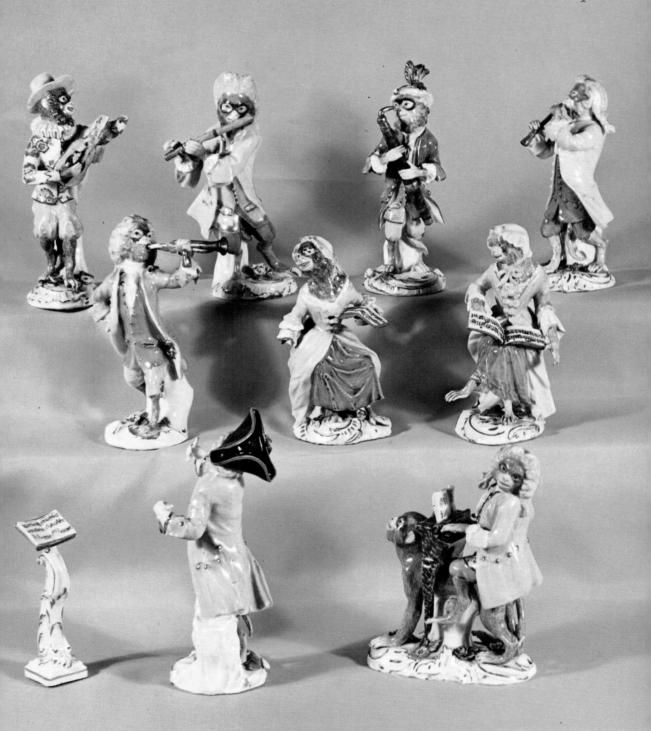

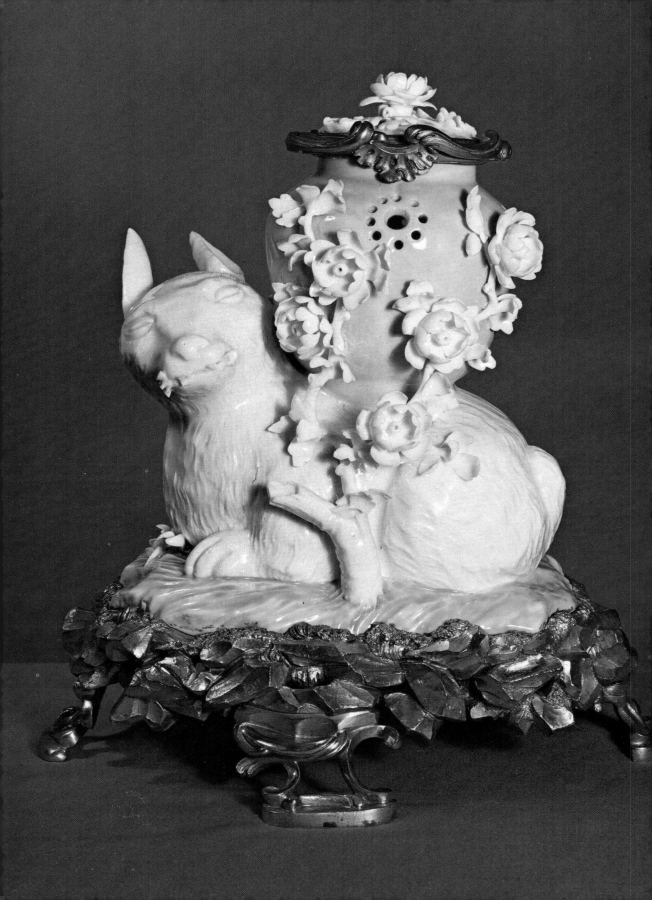

Swansea

In 1813 William Billingsley established a factory at Nantgarw in South Wales for the production of a fine, soft-paste porcelain, but within a year he ran into financial difficulties, necessitating moving his production to the nearby pottery factory of L W Dillwyn at Swansea. For three years Billingsley produced some very fine tablewares before returning to Nantgarw. He remained there until 1819, when he left to join the Coalport factory of John Rose.

When Billingsley left Swansea in 1817, Dillwyn leased the Swansea porcelain works to T and J Bevington, who produced a very poor, glassy body with a brownish translucency, called trident paste (because the mark often used during that period consisted of crossed tridents). It was during this management that a few poor-quality figures of sheep and rams were made. The biscuit figure of a ram (119, p 205) is marked 'Bevington & Co Swansea' and is produced in a manner often wrongly attributed to the Rockingham factory.

Plymouth and Bristol

The two porcelain factories of the West Country and the names of the people associated with them are usually conveniently grouped as one—Plymouth and Bristol of Cookworthy and Champion. The claim to fame of these particular concerns is that they were the first English factories to produce hard-paste porcelain of the Chinese and continental type.

Some time before 1768 William Cookworthy (1705–80), a chemist, located deposits of both china-clay and china-stone (the essential materials for the production of true porcelain) on the property of Lord Camelford near Truro, and in the same year a company of thirteen shareholders was formed as the Plymouth New Invented Patent Porcelain Manufactory. According to Lord Camelford, they experienced difficulties in their production at Plymouth, mostly due to the shortage of skilled labour, and so in 1770 the concern was transferred to Bristol. In 1774 when Cookworthy retired, the remaining years of the patent for making true porcelain in England were transferred to Richard Champion, one of the original partners. In 1775 Champion applied for a fourteen years' extension of the patent but he was opposed by a group of Staffordshire potters, including Josiah Wedgwood, who wished to be able to manufacture such wares themselves. The outcome was that while Champion was granted the sole right to continue to use china-clay and china-stone in the production of 'transparent' porcelain, other potters were now at liberty to use these materials in the production of 'opaque' pottery.

Both Plymouth and Bristol experienced many difficulties: because they used a smaller proportion of the fusible china-stone in their mixture than either the Chinese or the Germans, they were compelled to fire their wares at an even higher temperature. Thus a great deal of smoke-staining is often seen on the glaze, sometimes accompanied by fire-cracking and warping, and many of their early figures are inclined to tilt over, no doubt

28 Pastille burner in the form of a hare in soft-paste porcelain, decorated in enamel colours, and mounted in ormolu (gilt-bronze). FRENCH (Saint-Cloud), about 1750, height 26.7 cm/10½ in. (p 74)
Victoria and Albert Museum, London

owing to the difficulty they had controlling the temperatures of their kilns. The enamel colours that lie very obviously on the surface of the glaze often flake off. The alchemist sign for tin, '2–4', was used at Plymouth as a factory-mark on some useful wares but rarely on figures, and was in underglaze-blue. The Bristol wares were often marked with a simple cross and a number, crossed swords, or the letter 'B', and the marks were usually applied in an enamel colour.

The early days at Plymouth were devoted mainly to the production of tablewares and there are only about twenty different types of figures recorded as having been made, quite a number of which appear to have been produced from moulds previously used at the Longton Hall factory in Staffordshire. Although it is sometimes difficult to separate Plymouth and Bristol figures with any certainty, the alert-looking hare (115, p 203) is considered to have been made at Plymouth. It shows to advantage the crisp detail and painting that can be achieved with hard-paste porcelain.

Among the other animals and birds made at these factories in the material of hard-paste porcelain were well-modelled lions and lionesses, sheep, cows, goats, and dogs, with pheasant and finches appearing to have been the most popular among the birds. These were decorated with very loud and exotic tints, including a strong vermilion—a good pointer to the Plymouth factory.

The elusive repairer-modeller Mr Tebo is thought to have been associated with the Bristol factory from 1772–74. The impressed mark 'T' or 'To' often appears on Bow figures, ornamental wares, the rare figures of Worcester, and on vases and shell-shaped salts of Bristol. There is proof that Mr Tebo attempted to model at times, for in 1775 he was at Etruria in Staffordshire working for Josiah Wedgwood, who wrote in despair: 'Mr Tebo has had a cast of a Hare's Head before him some time, *but it is not a likeness* . . . more like the head of a drown'd puppy.'

After losing the sole right of using china-clay and china-stone, Champion seems to have also lost his enthusiasm for the wares for which he had previously claimed the hardness of Dresden and the elegance of Sèvres. In 1778 a Commission in Bankruptcy was declared against him but was temporarily suspended, and he left Bristol in 1781, after selling the remaining years of his patent to a group of Staffordshire potters who formed the New Hall Company in Hanley. New Hall wares are of a hard-paste porcelain, but have a much softer and wetter-looking glaze than that used at Champion's factory. Hard-paste was produced until about 1814, when it was abandoned in favour of the more popular bone china, which they continued to make until closing in 1835.

Parian souvenir wares

William Henry Goss started to manufacture Parian ware, ivory-porcelain and terracotta (red earthenware) wares in Stoke from 1858. Initially he produced wares such as floral jewellery and scent bottles, but the name Goss is best known today for the mass of souvenir wares for the 'corner cupboard'. The genuine wares of the Goss factory bear the black printed mark of an heraldic bird over the name W H Goss, and they are distinctly superior to the pieces made by many other concerns. The factory was taken over in about 1934 and finally closed in 1944.

Other factories that produced similar wares include Wiltshaw and Robinson of Carlton Works, Stoke, who were in production from 1890 until 1957 (when they became Carlton Ware Ltd) and Arkinstall and Sons, 1904–24, whose pieces are mostly marked with the trade-name 'ARCADIAN' or 'ARCADIAN CHINA'. The easy sale of these souvenir wares, which took many forms apart from the selection of animals illustrated (129, p 211), also attracted the attention of numerous minor German factories. They produced from a hard-paste porcelain many confusing and usually unmarked pieces, which were especially made to order for sale in the area with whose crest they were decorated, the crests being applied by transfer-prints in black and filled in with enamel colours.

Earthenware

In the light of recent research, classes of English pottery dating back to Saxon times have been identified, but throughout these early centuries it was apparently very rare for the country potter serving the needs of his immediate locality to make any wares other than those required for the kitchen or for building purposes. Among the earliest animal forms found in wares of this type are the ewers or aquamaniles, which were often made in the form of stags, rams, or equestrian figures during the thirteenth and fourteenth centuries. These early forms of tableware were used for washing the hands at the table, when the diner used only a knife. Plates made of pottery were unknown at this period (they were of either wood or metal).

Other rare early animal forms are the simple cats and dogs made by the London tin-glazed earthenware potters during the last quarter of the seventeenth century. They were usually formed in the shape of a jug and are often dated; coloured to resemble tabby cats, they had typical markings applied in the high-temperature colours of cobalt and manganese. Examples can be seen in the Victoria and Albert Museum and the Greg Collection in the City Art Gallery, Manchester.

From about the middle of the seventeenth century until today, north Staffordshire has been the recognized centre of the English pottery industry. The area was ideal both geographically and physically, with ample supplies of clay suitable for the type of pottery being produced, unlimited supplies of coal for firing the kilns, and plenty of water. Later, the near-by ports were easily reached by canal for the shipping of their products and the importation of materials necessary for the making of more refined wares. Probably because of the difficulty in obtaining supplies of tin from Cornwall, the Staffordshire potters did not use a tin-glaze on their wares. The earthenwares of Staffordshire and other seventeenth-century centres such as Wrotham in Kent are nearly all modest domestic pieces, and it was not until the early years of the eighteenth century that earthenware figures began to be made for a purely decorative rather than functional purpose. The important salt-glazed stoneware figures made by John Dwight of Fulham during the second half of the seventeenth century are more appropriate to the art of the sculptor.

In the face of increasing competition the Staffordshire potters seem to have suddenly become aware that, if they were to survive, a great improvement in their 'peasant pottery' was essential, for it had changed

little in fifty years. In his search for the secrets concerning the manufacture of porcelain, Dwight had improved upon the coarse grey stonewares of Germany by using calcined flints. Somehow this process soon became known to the potters of Staffordshire and by about 1720 they were making much whiter wares, sometimes by applying a thin surface wash of a clay slip made from the white Devonshire ball-clay (both John Astbury and Thomas Heath have in turn been credited with this method of whitening a previously drab colour salt-glaze). This white stoneware or 'common white' was made in great quantities from about 1740 to the 1760s, and because the wares were produced very cheaply they have not survived to any large extent. Salt-glazed stoneware tablewares became less popular as lead-glazed cream-coloured earthenwares became more readily available from about 1765, but it was from this refined salt-glaze that the Staffordshire potters first started to produce figures that were hawked around the countryside and sold at markets and fairs. Among these figures were models of the familiar household pets and farmyard creatures.

The smug fireside cat (44, p 160) was a particular favourite made in solid agate ware. In order to obtain this agate effect, clays of varying colours (usually white and brown) were 'wedged' together to obtain the natural appearance of striations. The clay was then rolled into thin slabs to be hand-pressed into the inner walls of a simple two-piece mould and the two shells then joined with slip along the central seam. Occasionally the clay was further coloured by artificially staining with cobalt, but this strong oxide tended to give an overall blue tinge to the entire figure; manganese was often used to colour the rat in the mouth of the cat. Such wares obviously could not be made by the slip-cast method, because of the need for keeping the colours apart and clearly defined. The glazing was carried out by the normal high-temperature salt-glaze method. Similar lower-fired earthenware cats with a lead-glaze were also produced at a slightly later date.

A whole range of animals was made in salt-glazed stoneware by the more common method of slip-casting. Use was often made of high-temperature oxide colouring to give a little variation to this type of figure; cobalt was the most common and was used to colour in incised patterns of details or dates, a style of decoration called scratch-blue. The animals associated with the popular sport of hunting naturally commanded attention, and so the fox, stag, hind, hare and rabbit are all represented in this material.

Staffordshire was certainly not alone in the production of salt-glazed stoneware and many models were also made at Nottingham and in Derbyshire. Among the pieces made at all these centres are the beer-mugs in the form of bears. These were usually given a rough-coated look by the addition of 'grog' (ware that has been fired and then crushed up to a coarse sand); it is applied to the wet clay body before firing and the bears are made more attractive by coating with a clay slip rich in iron, which fires to a pleasing rust colour. The bear illustrated (18, p 121) depicts a type used in bear-baiting (a cruel sport of the time) and it is clasping

18 Drinking-vessel in the form of a bear hugging a dog, in salt-glazed stoneware covered with a clay slip rich in iron. ENGLISH (Staffordshire), about 1760; height 33 cm/13 in. (p 120)
Victoria and Albert Museum, London

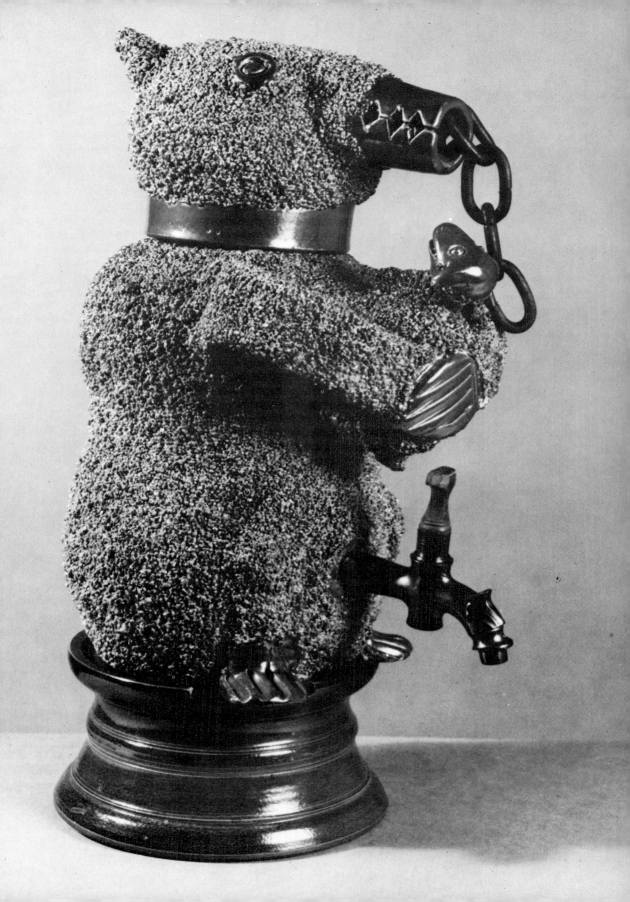

the terrier in a fatal hug. The head is detachable to form a drinking-cup, and in this instance the spigot is almost certainly a nineteenth-century addition. The more common greyhound figures were made chiefly at Brampton and Chesterfield in Derby, during the first quarter of the nineteenth century. The drab colour of the clay was often enriched, sometimes only partially, with a ferruginous slip as just mentioned. In addition to the many jugs and bowls made at Nottingham during the first half of the eighteenth century are some rather wooden-looking hawks, modelled with incised feathers and features and similarly stained to a dark metallic brown.

By the middle of the eighteenth century the Staffordshire salt-glaze potters were becoming aware of the threat to their livelihood from the increasing production of English soft-paste porcelain and so they endeavoured to rival this new body by adding enamel decoration to their stonewares. It is in this field that again the work of William Duesbury is encountered, while he was still an independent decorator. Among the pieces attributed to his workshop are some charming groups of ewes with lambs. They lie on a mound before a tree in a very porcelain-like grouping and the entire surface is painted in enamel colours. The decoration on the pair of swans (7, p 47) leaves us in little doubt about the identity of the painter, for in William Duesbury's account books the entry is found 'swimming swans donn all over'. Staffordshire salt-glazed figures of this type are never marked with the name of the maker and they are only rarely dated; consequently, it is impossible to attribute them to a particular factory.

In addition to salt-glazed stonewares the Staffordshire potters continued to produce the traditional lead-glazed wares, but in a more refined material and workmanlike finish. One of the first English potters to lend his name to a particular type of ware was John Astbury (1686–1743) who has already been mentioned as the man who may well have introduced the use of Devon clay as a whitening agent. These Astbury wares relied solely on the use of various-coloured clays to give them interest. Although dull when first fired, the clays took on a deep richness when covered with a honey-coloured glaze. By at least 1740 the practice of dipping the biscuited ware into a liquid glaze resulted in a far more even and thinner glaze than was possible by dusting the wares with powdered lead galena. The majority of Astbury figures are in human form but among the more ambitious figures are those of mounted dragoons such as illustrated (23, p 94). This might well be classed as an Astbury-Whieldon figure as, apart from being made of various-coloured clays, it is further decorated with the use of high-temperature underglaze colours in a manner associated with Thomas Whieldon of Fenton Low, who was undoubtedly responsible for some of the finest early Staffordshire earthenware figures.

It was Whieldon with whom Josiah Wedgwood was in partnership from 1754 until he started his own pottery of Ivy House Works in 1759. From the middle of the eighteenth century there was a noticeable improvement in the quality of the clays used in Staffordshire for the production of cream-coloured earthenwares. This body is almost identical to that used previously for the production of salt-glazed stoneware but being fired at a lower temperature, it remained porous and a lead-glaze with a slight yellow tint was added and fired at a second kiln-firing. It will be noticed that where a piece of creamware is chipped or broken the body of

the ware is a rather dirty-looking white and the attractive cream colour is confined to the glaze. It was this slightly yellow glaze that Whieldon used to such advantage with his tortoiseshell and variegated coloured glazes. His technique consisted of staining his biscuited wares with particles of the various metallic oxides and then applying and firing the glaze which tended to become very fluid, spreading the colours over the entire surface of the subject. With the tortoiseshell appearance, the only colour used was obtained from manganese, but with the variegated or multi-coloured wares, copper, cobalt, antimony and iron would be used.

It is regrettable that Whieldon never used a factory-mark, but following excavations on the site of potworks at Fenton, certain classes of high-quality wares can be fairly confidently attributed to him. However, one must of course bear in mind that other potters, including William Poulson (died 1746) and Edward and William Warburton, also worked on this same site. Whieldon-type wares were also made at the early Leeds Pottery, but their figures were mostly of plain creamware and date from about 1775.

The Chinese *blanc-de-Chine* figures that had been made in the province of Fukien from about the beginning of the seventeenth century were well known in England and were often used as models by various English ceramic manufacturers. There are many Whieldon examples recorded of the water-buffalo with the perky little boy on his back (30, p 134). The unique smoking-pipe in the form of a coiled snake (110, p 199) is only sparsely decorated in Whieldon-type high-temperature colours and is of a good creamware body. It is very apparent that as the quality of the cream-ware body was improved upon, it no longer became necessary to cover so much of the surface with colours.

In the potteries it was customary to name a son, usually the eldest, after the father and this has caused a good deal of confusion for ceramic re-searchers, probably never more so than in the Wood family of Burslem. Ralph Wood was born in 1715 and died in 1772, and his son Ralph was born in 1748, and died in 1795. This younger Ralph Wood was for a time in partnership with his cousin Enoch Wood, but from 1795 the business was continued by the grandson of the founder of the factory, yet another Ralph Wood, who died in 1801 when he was only twenty years of age. The first Ralph Wood started potting at Burslem in about 1754 where, apart from the normal range of useful wares such as were being made by his contemporaries, he made a variety of figures, but mostly in human form.

The wares of all three Ralph Woods were at times marked with the name impressed into the clay; when the name is incised (scratched) into the clay the pieces are more likely to be recent imitations, and this marking is usually only seen on Wood-type models with enamelled decoration instead of the earlier high-temperature coloured glazes. The name 'R Wood', 'Ra Wood', or 'Ra Wood, Burslem' is most likely to have been applied to wares made by either the father or son, rather than the grandson.

Where Whieldon and some of his contemporaries relied on the glaze to spread the coloured oxides over the surface of their wares, the Woods achieved a much more organized style of decoration by applying their glazes after they had been coloured, in the manner of the French potter Bernard Palissy. In this way, the various parts of their figures were tinted with the appropriate hues, as far as the limited range of colours would permit. How well this was done can best be seen on the figures of the

stag and doe (18, p 81). These simple figures are often of such perfection that they have a beauty of their own, comparable to some of the finest porcelains. The teapot in the form of an elephant, monkey and snake is a very unusual piece (76, p 178), and probably not to everyone's taste, but the control of the glazes has been remarkably successful. Among the more ambitious equestrian figures attributed to the Woods are the very fine groups of St George and the Dragon and Hudibras.

After the death of his father, the younger Ralph Wood did not continue to make wares decorated with high-temperature colours for long. Probably on economic grounds, he changed to dipping the now almost white body into a slightly blued, clear glaze which after firing was decorated in the full range of enamel colours in the porcelain fashion. However, the figures made in this late eighteenth-century period were almost entirely of human form.

Although the general use of high-temperature colours as a means of decoration went out of fashion from about 1780, the continued use of this style by Felix Pratt of Fenton and a few others has resulted in the term Pratt-type. This expression is used to refer to wares with high-relief moulded decoration picked out in rather muddy shades of blue, green and orange on a large variety of jugs, vases and miscellaneous wares. The same term is applied to pieces of normal 'thrown' shapes providing the same range of colours has been used. There are some very finely modelled figures of cocks and hens decorated in this style in about 1790–1800.

During the Whieldon and Wedgwood partnership (1754–9) noticeable advances were made towards perfecting a good earthenware that would be acceptable to the fastidious buyer as an alternative to the more expensive porcelain; this became known as cream-coloured earthenware. The new material was not confined to Staffordshire alone and the wares made at the Leeds factory are at times of very fine quality in their own right, and often show more interesting decoration and form than the rather 'slicker' Wedgwood ones.

The most important of the creamware factories in Yorkshire was the Leeds Pottery, established shortly before 1758. Their earliest wares were for the table and their shapes had much in common with salt-glazed stoneware, redware, and Whieldon-type earthenware. In about 1790 the Leeds Pottery started to manufacture creamware figures. The earliest were of a simple type, again more closely associated with salt-glaze models such as pew-groups, but later they produced some figures of animals and birds, sometimes decorated with splashes of green or yellow underglaze colouring; foxes and farmyard birds seem to have been a speciality of this factory.

The most prized possession of any creamware collector is a Leeds horse: these models, judging by the varying materials in which they were made, were produced over several years. The earliest known examples are in the accepted creamware of early Leeds with the fine pale yellow glaze; others were made in the later creamwares of pearlware where the glaze is deliberately tinted with cobalt to give the illusion that the material is a good white. The horse illustrated (94, p 191) is of a fairly late date. It is made from a very white earthenware, and is decorated in a sponged manner with blue, orange, and black. It has been suggested that this colourful horse may well have been made in about 1835 at the neighbouring pottery at Hunslet, rather than at the Leeds factory of Hartley,

Greens and Co. The majority of these horses are only about 40 centimetres (16 inches) high and are sparingly decorated and the variations in details such as the harness on the larger examples suggest that they were finished by hand rather than completely moulded.

The main aim of Josiah Wedgwood appears to have been a complete breakaway from the materials and styles that had been associated with traditional Staffordshire wares. Therefore, apart from the rare figures of birds, mythical animals, such as sphinxes and griffins, and hedgehogs or porcupines perforated with holes for growing crocuses (127, p 210), his fine stonewares of the eighteenth century were used only for tablewares and reproductions of vases in the popular classical forms. From the early years of the nineteenth century, small animals and fox-head stirrup-cups became much more common.

A whole series of animals such as gazelles, monkeys, panthers and sea-lions was made in earthenware from the models of John Skeaping who had been commissioned by Frank Wedgwood in 1926. Almost as well known as the copies of the famous Portland Vase is the elegant Wedgwood figure of Taurus the Bull (19, below) which was modelled originally by the eminent sculptor Arnold Machin in 1945 and is still produced by the company in a limited number. It is in cream-coloured

19 Taurus the Bull in cream-coloured earthenware, decorated with transfer-prints. ENGLISH (Staffordshire, Wedgwood), modelled by Arnold Machin, 1945; length 40 cm/15¾ in. (pp 18 and 125)
Josiah Wedgwood & Sons Limited, Stoke-on-Trent

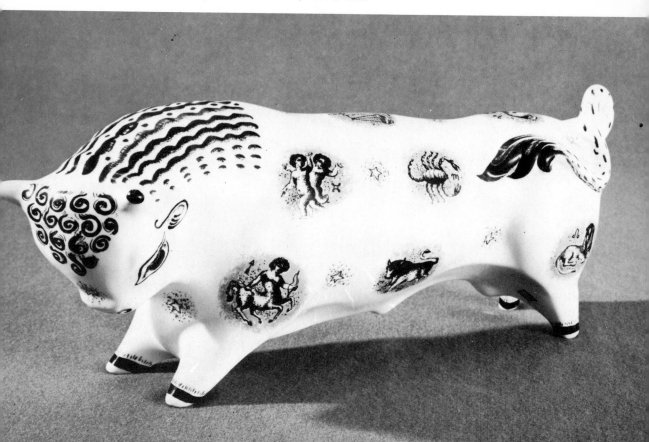

fine earthenware and it is also made in 'black basalt', the fine stoneware first introduced by Josiah Wedgwood in 1767, and of which he remarked, 'The Black is sterling and will last forever' – a prophecy that has proved correct. In both materials, the bull is decorated with the twelve signs of the zodiac (drawn by Machin) applied as lithographic transfers. The mould used to produce this figure comprises five separate pieces and the tail is moulded separately from a two-piece mould.

From the beginning of the nineteenth century, social and economic upheavals throughout the whole of Britain gave birth to a new level of society. People whose entire earnings had previously been spent on the necessities of life were now able to afford little luxuries with which to decorate their homes, and many Staffordshire factories began to produce relatively cheap, colourful, earthenware ornaments, popularly known as chimney ornaments. In addition to the large factories already in existence, such as Wedgwood, Spode and Minton, whole clusters of small 'pot-banks' quickly sprang into operation. In order to produce competitive wares advantage was taken of the cheap labour of women and children. Documentary reports of 1842 tell of the appalling conditions under which the children worked: one little boy, aged nine, related, 'I work by the piece [piecework] and can make forty dozen small figures in a day; I get one penny for ten dozen, that is about two shillings a week.'

It is known that there were a large number of modellers but the identification of their work by name is almost impossible and so, as in the eighteenth century, the name of an individual whose work is sometimes marked is used to refer to a whole group of pieces of a similar type.

John Walton was such a person. He is thought to have started potting in the first decade of the nineteenth century and seemingly continued until about 1835. Walton's wares were far superior to the flat-back figures produced in such numbers from the early years of the reign of Queen Victoria; they are generally marked with the name 'WALTON' impressed on an applied scroll. He endeavoured to model his earthenwares in the spirit of the finer porcelain of the late eighteenth century and was especially keen on the effect of *bocage*, the tree-like formation used as a background. The majority of Walton-type groups depict human forms but he also made figures of a large variety of animals including the lion, unicorn, cows, sheep, and the camel and dromedary (41, p 158). These figures are difficult to date for they were only rarely related to any topical subject.

Another prolific manufacturer of similar figures was Ralph Salt, who worked at Hanley from about 1812–28 and later moved to nearby Shelton where he made both earthenware and porcelain figures. On his death in 1846, the business was continued by his son, Charles, until he also died in 1864. The group of Remus and Romulus being suckled by a wolf (20, p 127) might well be the work of the Salts. The figure of Samson rending the Lion (53, p 165) dates around 1845–50 and is attributed by Reginald Haggar to either John or Rebecca Lloyd of Shelton. The name 'LLOYD/SHELTON' was sometimes impressed in either the back or the base of their figures.

Cream-jugs in the form of a cow with milkmaid (59, p 168) are sometimes a very difficult class for the new collector, for they have been made from the late eighteenth century up to the present day. The earliest examples were coloured in the Whieldon style, with high-temperature oxides; they are also known to have been produced by Obadiah Sherratt.

The nineteenth-century pieces can often be dated by the fact that they are decorated with underglaze red and green, colours derived from chrome that was not used until about 1810–15.

Thomas Lakin and John Ellison Poole started their partnership in 1791, with Thomas Heath as their manager. Apart from the usual range of earthenware and stoneware useful pieces, they are known to have

20 Romulus and Remus being suckled by the wolf, in earthenware painted in enamel colours. ENGLISH (Staffordshire), 1815–50; height 14 cm/5½ in. (p 126)
Crown copyright, Victoria and Albert Museum, London

produced 'figures in great variety'. This partnership only survived until 1795 and in consequence there are only very few figures that can be attributed to them with any degree of certainty.

One very amusing piece is the well-known group of the outside of a travelling menagerie (1, p 1). This somewhat complicated but colourful piece depicts 'POLITOS MENAGERIE OF THE WONDERFUL BIRDS AND BEASTS FROM MOST PARTS OF THE WORLD' or, simply, Polito's Menagerie. It is attributed to the factory of Obadiah Sherratt, who started his production in Burslem in about 1810. He died in about 1840, and the undertaking was continued by the family, but it had certainly ceased by 1860. The Sherratt family are also thought to have produced the large animal groups of bull-baiting, the Roran Lion, and Mr Munro being savaged by a tiger in 1792; in each case the bases are the typical six-legged platform type so often indicative of Sherratt's models. The Staffordshire potters are well known for their economic habit of using the identical moulds to represent different characters or events: this is so with the menagerie group, for after the death of Mr Polito in 1814, the inscription was changed to read 'Wombwell's Circus'.

The Englishman has the reputation abroad of loving animals more than children and this was certainly true when the general public showed so much interest in the arrival in England of a new species of animal – the giraffe. Regent's Park Zoo in London was first opened to the public in 1828, and it was probably with this in mind that the Pasha of Egypt presented George IV with a giraffe in 1827, but despite careful nursing at Windsor Castle, the animal died two years later. Public interest in the welfare of the immigrant had been so great that it justified a caricature by William Heath of the king endeavouring to nurse the sick animal back to health with the aid of a windlass, clothing, and medicine, and thus the giraffe immediately became a popular subject for the Staffordshire potters.

From the beginning of the reign of the young Queen Victoria in 1837, not only members of the Royal Family (96, p 192) but anyone, famous or infamous, became fair game for the Staffordshire potter and might be depicted in the numerous Staffordshire flat-backs. These figures were both bulky and naïve, requiring only a two or three-piece mould for their manufacture. It was at this time that the ever-popular Staffordshire dogs first made their appearance. George Hood, James Dudson, and Sampson Smith are among the many potters recorded as having made such models and the fashion has survived to this day. Many of these figures have been made in this century and one of the most prolific manufacturers, William Kent (Porcelains) Ltd of Burslem, only ceased making such wares from the original moulds in 1962. Rather disturbing to present-day collectors is the knowledge that certain 'wholesale' antique dealers are importing as many as five hundred pairs of 'Staffordshire dogs' each week from Ireland! Deliberate scratching with a file or other sharp tool, meant to indicate signs of age, is frequently seen on recently made Staffordshire-type figures.

All too often the wares of some of the smaller earthenware potteries are either passed over as unimportant or wrongly attributed to one of the many factories of the great centre of Staffordshire. Such is the case with the smaller concerns of Kent and Sussex, operating during the late eighteenth and nineteenth centuries. Documented and dated wares of

the famous Wrotham potters of Kent are well known from the early seventeenth century, but Sussex pottery is more difficult to identify. Pottery from both of these counties was made of a common red-burning clay covered with a rich lead-glaze, which shows to great advantage the pleasing brownish-black speckling caused by the presence of iron in the clay. This feature is well illustrated in the Sussex drinking vessels in the form of pigs (121, p 207). The pig's head detaches to form a cup that will stand (rather precariously) on the snout and ears, while the headless pig sits comfortably on his haunches. Such pigs have proved so popular that they have remained in production for over one hundred and fifty years. Of similar interest and not generally associated with Sussex are whistles in the form of birds. An interesting example in the Hastings Museum, which is rich in Sussex pottery, is a heavily glazed bird with the feathers inlaid with a different coloured clay. Writing of such whistles the late Mr Edmund Austin observed, 'These birds were made with a whistle in the tail. They were often built into old farmhouse chimneys, so that when the wind blew, the bird whistled, which was thought to keep evil spirits away.'

Doulton and Watts was first established in Lambeth, London, in 1815, and it only recently moved. Today Doultons is one of the largest groups of potters in Staffordshire. Their early salt-glazed stonewares do not warrant special mention in this volume but during the 1870s they began to manufacture a class of finely decorated wares that are eagerly sought by today's collector. They made some most interesting figures of groups of mice in salt-glazed stoneware, modelled by George Tinworth, and some rather more grotesque creatures by Mark V Marshall.

The only independent, or studio, potters to make wares similar in style to Doulton were the Martin brothers. These four brothers, Wallace, Charles, Walter, and Edwin, were all born in London between 1843 and 1860. In 1864 Wallace, who showed early promise as a sculptor, attended the Royal Academy School. His close contact with the Lambeth School of Art and the modellers of Doulton's Lambeth factory obviously inspired him to set up a pottery studio in King's Road, Fulham, in 1873, where he and his brothers worked. Both younger brothers, Edwin and Walter, had attended the Lambeth School of Art and gained a certain amount of practical pottery experience as assistants at the Doulton factory. By 1874 the Martin brothers were in business. The major part of the brothers' output was decorative wares, but Wallace soon took to modelling grotesque birds (33, p 154). These birds were obviously intended to act as a container and cup, but one wonders who would relish drinking from such an ominous-looking creature. Nevertheless the figures remained a popular line almost until their studio closed in 1914.

Today the now famous factory of Minton is associated with beautiful tablewares but they too have made some figures of animals in earthenware and unglazed bone china (biscuit). The factory was started originally by Thomas Minton in 1793, who had already earned a reputation as a free-lance designer and for being a fine engraver of the copper-plates used for transfer-printing designs onto ceramics. The early wares of Minton are difficult to identify for he only rarely used a mark and often worked as a 'sub-contractor' for other potters. In about 1820 his son Herbert became a partner, and from this time the excellence of their productions gained a world-wide reputation and the patronage of royalty. From 1836 until

1841 Herbert Minton was in partnership with John Boyle, but they ran into the same troubles that are encountered today, for Boyle notes 'the crisis seems to have come which will settle the point whether the employers or the employed are to be masters'.

There is still confusion today over the terms maiolica, and majolica: the first should be used to refer to the tin-glazed earthenwares of Italy, the latter to the coloured glazes used so successfully on examples like the splendid figure of a peacock (12, p 59). The story of this amazing bird was recently told in an advertisement of the Minton factory. The bird is life-size and is considered to be one of the most skilful examples of ceramic art ever to be produced in Britain. It was originally modelled in about 1850 by Paul Comolera, a well-known artist and sculptor from Limoges. There were five birds produced from the moulds, all decorated by hand with soft coloured glazes by the Frenchman. In 1878 the peacock illustrated was *en route* for an exhibition in Australia when the ship carrying it was wrecked off the Australian coast, but the crate was later salvaged and found to be still intact. This same bird can be seen today in the famous public house in Rowley, Derbyshire. The name of the pub is of course The Peacock!

The humble little figure of a rabbit (116, p 203) was made some time between 1905 and 1915 by the Staffordshire factory of Bernard Moore at Wolfe Street, Stoke. The wares of Moore are best known for their elaborate glaze effects made possible by the increased knowledge of chemistry and science, enabling potters to produce glazes that formerly were to be seen only on the wares of the Far Eastern potter. Moore's wares are generally marked with either the written 'BM' monogram or the full name in either writing or print.

14 Ireland

It was in 1852 that John Bloomfield discovered deposits of feldspar on his estate on Upper Lough Erne in Ireland and he apparently realized that this material might well be used as an important ingredient in the manufacture of porcelain. Later, he met Robert Williams Armstrong and W H Kerr of the Royal Porcelain Works of Worcester; Kerr was himself an Irishman and was thus very keen to do all he could to help establish a factory in that country. By 1856, Bloomfield was advertising porcelain clay and feldspar as being available for export to English manufacturers.

The most probable date for the building of the actual factory at Belleek is thought to be 1857. Armstrong was the art director and the necessary finance was put up by his friend David McBirney, a Dublin merchant. The firm traded under the name of McBirney & Co. The site chosen was ideal in every way: it was near the necessary clay deposits, ample supplies of water were available for driving all the machinery, towns on the lough were easily reached by boat, Belfast was linked by canal, and an adjacent railway connected with the port of Londonderry and with another to Dundalk and Dublin. The firing of the kilns was carried out by using local peat, and only a small amount of coal and ball clay had to be imported. It was only later that the local feldspar and china-clay had to be replaced: the former from Narvik in Norway, the latter from Cornwall.

The records of the factory tell in detail of the various bodies they made. The popular hard-paste porcelain was composed of 67 parts feldspar (china-stone) to 55 parts china-clay; this gave a much harder body than the Parian wares being made in England at about that time. The rate of shrinkage was unusually high – roughly a quarter compared with the average sixth. Belleek porcelain is best identified from the mother of pearl iridescence of its glaze, and any overglaze colours or gilding was usually very sparingly applied. The factory produced an enormous range of wares, including Parian-type statuary both of well-known historical or public figures and of allegorical types such as Venus and Clytie. In addition they made a wide range of figures of animals and birds, including a large wall-bracket in the form of two birds at their nest, and paperweights with full relief figures of a fly or a frog – both extremely rare.

It is said that it was Mrs Armstrong who was responsible for suggesting so many of the marine subjects of shells, seaweeds, sea-urchins and corals. Many similarly-designed wares were modelled by William Gallimore, who had previously worked at the Staffordshire factory of Goss. The vase in the form of a flying-fish (86, p 184) is very similar to Goss's work.

Several different factory-marks were used, but most included the name Belleek. One exception was the use of an Irish harp, which was either impressed or painted in black enamel. Their other marks include an Irish wolfhound, a harp and a tower, with the words: Belleek Co Fermanagh, Ireland. Any marks that include the word Ireland indicate a date not earlier than 1891.

15 Contemporary studio potters

England

The work of modern studio potters now covers such a vast field that it has been necessary to confine the illustrations to the work of a selected few whose work is widely known or extremely unusual.

Denise and Henry Wren founded the Oxshott Pottery, Surrey, in 1919. Born in Western Australia, Mrs Wren first studied in this country as a young girl at the Kingston-upon-Thames School of Art under Archibald Cox. She was particularly influenced at the time by the skills and techniques of the local potters engaged in the making of chimney-pots and churchwardens' pipes. In 1911 she established her own pottery at Kingston but later she and her husband designed and built Potter's Croft, Oxshott, where together with her daughter and other potters she is still making exciting new forms in early pottery traditions aided by new and improved firing techniques, many of which she herself has introduced.

In 1967, at the Commonwealth Institute Art Gallery, London, Mrs Wren showed a total of forty-six objects, all of salt-glazed stoneware fired with coke in a reducing atmosphere at 1280–1320 °C. The deeply-grooved decoration is incorporated with the throwing, turning and hand-building. Black cobalt, manganese, ochres, ilmenite, rutile and oxides of iron are rubbed in, and also sometimes wood ash. She certainly favours elephants for in the 1967 exhibition there were four examples. The old bull elephant illustrated (77, p 178) was designed and made by her in 1969. It is of grogged clay, coiled and modelled, and fired in smothered bonfire after biscuiting at 1000 °C, resulting in a very appropriate grey to lustrous black colouring. She has been exhibiting, often in foreign parts, since 1912, and from 1922–37 organized the Artist Craftsman Exhibitions held in Westminster, London.

Rosemary D Wren (daughter of Denise K Wren) was brought up at the Oxshott Pottery founded by her parents and since 1950 she has had her own workshop. Miss Wren's introduction to animals was in her work

opposite

29 Dish with reptiles and fish in lead-glazed earthenware, decorated in coloured glazes. FRENCH, modelled by Bernard Palissy (or followers), 1550–1600; length 53 cm/21 in. (p 78)
Victoria and Albert Museum, London

overleaf

30 Chinese boy on a buffalo in lead-glazed earthenware, decorated in high-temperature colours. ENGLISH (Staffordshire, Whieldon), about 1765; height 19 cm/7$\frac{1}{2}$ in. Compare with illustration 125, p 209. (p 123)
The Gubbay Collection (Clandon Park, National Trust)

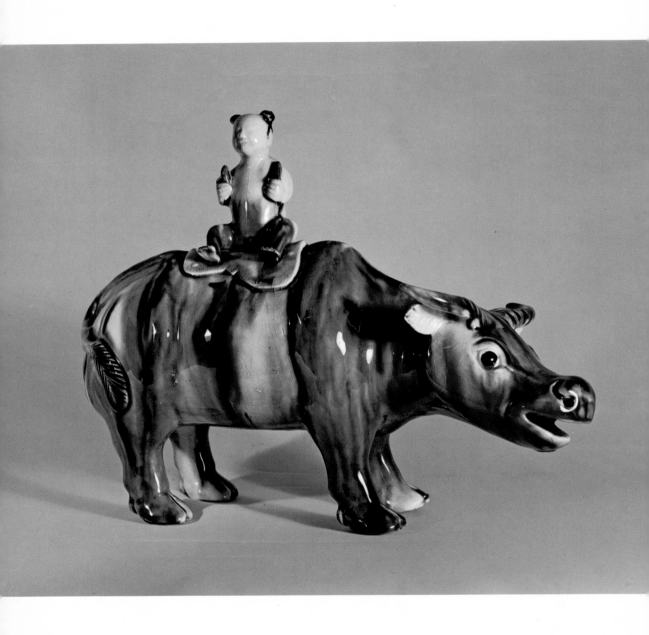

on farms and at Chessington Zoo, Surrey. After three years at the Guild-ford School of Art, she went on to the Royal College of Art, Kensington. Her early work as an independent potter was concerned with the more traditional 'thrown' wares in salt-glaze, but partly due to the influence of Francine Delpierre, the French potter, and Alberto Diato, the Italian, with whom she worked during vacations, Miss Wren became aware of many new techniques and possibilities that could be achieved by various forms of hand-modelling, and since about 1968 she has concentrated mainly on hollow clay structures derived from the forms of animals and birds. There has hardly been a recent exhibition of potter's art worth mentioning in which her work did not feature.

The pair of birds (21, p 138) in stoneware illustrate her early output. These bird forms are hollow-built by hand and covered with an iron wash, rust-red to burnt-brown, with vitrified slip brushed and spattered. The Hoolock gibbon (103, p 195) is a hollow, hand-built form in black and white stoneware; it is made up of thinly flattened coils of heavily grogged clay. The precise shape is obtained by beating the forms as they begin to dry, and finishing them to a smooth surface with sandpaper when completely dry. The cat (49, p 162) is a worthy example of Rosemary Wren's work in *raku*. The technique of smoked *raku* involves putting the biscuited and glazed pieces into the kiln at 850 °C, drawing them out red-hot as soon as the glaze has melted, and plunging them into a bed of sawdust. The clay turns black with carbon penetration and the oxides are reduced to metal. Dowsing in water then fixes the colours by quick cooling, though the metallic lustre may change to clear turquoise over a period of months or years, as it sometimes combines with oxygen in the atmosphere. The body used is two-thirds siliceous ball-clay (white) with one-third of coarse fire-clay grog.

Since the beginning of 1972 Miss Wren has started to work in a fine porcelain body; a fellow potter, David Leach, developed this new high-fired body that has a fine bluish tint obtained by a reducing atmosphere. This new material is shown in the delightful bantam cock and hen (38, p 157).

Miss Wren is not only an excellent potter, but obviously an outstanding teacher, for when Peter M Crotty arrived at Oxshott in 1969 he had had no previous experience in working in clay and had no intention of be-coming involved in the art (or for that matter in any other form of manual occupation). However, it must be very difficult to remain in the company of such an inspiring potter without becoming at least interested, and in a very short time, 'small strange *raku* creatures developed rapidly in methods of construction and minuteness of decoration, where their basic

overleaf
31 Sea-lion in hard-paste porcelain, painted in enamel colours. DANISH (Royal Copenhagen Porcelain), originally modelled by Theodor Madsen in 1900; height 29.2 cm/11½ in. (p 86)
Copyright The Royal Copenhagen Porcelain Manufactory Limited

opposite
32 Elephant, rhinoceros, lion, and buffalo, in bone china, covered in 22 carat gold. ENGLISH (Staffordshire, Coalport), modelled by John Kaposvary, 1972; height of rhinoceros 15.2 cm/6 in. (p 112)
Courtesy Coalport, a member of the Wedgwood group

21 Two birds in stoneware, with an iron-wash and vitrified slip brushed and spattered. ENGLISH (Oxshott, Surrey), modelled by Rosemary D Wren, 1955; height of larger bird 22.9 cm/9 in. (p 137)
Collection of Mr and Mrs David Attenborough

glazes have been elaborated to give a range of more than twenty colours, used like those of the painter's palette'. Mr Crotty's approach to clay is entirely divorced from Miss Wren's and he does not necessarily start to model with any clearly defined result in view; rather, he attacks the clay with hand and tool, allowing unconscious influences to help achieve the result. His work is well illustrated in the delightful group of various cats and bird (48, p 162).

The amusing model of a dog (75, p 177) is of unglazed stoneware and was made by Terry Bell-Hughes, who works with his wife Beverley in the Garden Workshop at Potter's Croft, Oxshott. He is not part of the Oxshott Pottery although there does seem to be a distinct similarity between his work and that of the well-known Wrens. This dog has been made by hand from pinched, rolled and torn pieces of clay and is of unglazed stoneware of a pale sand colour.

Iris Sonnis has made her name as a creator of ceramic animal forms in a very short time. She studied sculpture at the Central School of Arts and Crafts, London, and originally designed animals for casting in bronze. On finding metal casts too expensive, she started firing models in a pottery kiln and has since developed a technique of using clay and fibre glass. There have been many exhibitions of her work, which now features in private collections in England, the continent, USA and Israel.

The donkeys (22, p 140) are in unglazed earthenware; the pair of playful cats (**15**, p 70) are in white and terracotta clay and can be pulled apart; the very inquisitive-looking cat (47, p 161) is in a terracotta stoneware; and the highly original ant-eater (128, p 210) is of white earthenware. All of these examples illustrate a very stylized but most successful approach to some enchanting ceramic sculpture.

David Woodcock took his diploma in art and design at the Loughborough College of Art from 1963–66 after which he instructed in pottery in the Fine Art Department of Newcastle-upon-Tyne University, and since 1971 he has been lecturing in ceramics at the Trent Polytechnic. The boxes surmounted with models of beetles (99, p 193) are hand-thrown and turned in red stoneware clay, made up of two parts red earthenware and one part grey stoneware. The models of the beetles are produced in varying proportions of red and grey clay to obtain the subtle browns of their markings. After the pieces have been biscuited, the black or cream matt glaze is applied and fired at about 1220 °C.

Mr Woodcock's work has been shown both in Britain and on the continent, and while all his pieces might not appeal to the squeamish, they are highly original. They find a very ready market with collectors, who now realize that the work of studio potters will become more worthy as antiques of the future than some of the oddities that are being gathered today by those desperate to make a collection of some sort.

J J Kändler, the famous Meissen modeller, once said that there was nothing that could not be made in porcelain, and modern artists are proving that he was right: none more so than Patrick O'Hara of Brookside Studio, Tewkesbury, Gloucester, who combines the beauty of wild flowers with that of butterflies and insects. He spent more than ten years as an agricultural adviser before changing his career and finding that he had a latent talent for creative work in the field of hard-paste porcelain.

It is only four years since he embarked on this new career, yet already collectors are paying very high prices for his work, accurate to the extent that it has merited praise from world-famous botanists and entomologists. His creations call for as many as eight separate kiln-firings at temperatures ranging from 800 °C for the firing of the enamel colours to 1300 °C for initial biscuit firing. His subjects are provided by the woods and fields, and his butterflies and insects are modelled on a collection he made when young. All his pieces are individual, in preference to limited editions of identical slip-moulded materials.

When modelling a butterfly the clay is continually rolled out (much like the preparation of pastry) until it is less than one millimetre thick; the outline of the insect is then transferred from detailed drawings on to the clay, taking into account that the clay will shrink approximately one eighth during the first firing. The clay is then 'skived' down to paper thickness prior to the delicate veins on the wings being applied in slip—similar to the famous *pâte-sur-pâte* of Marc Louis Solon.

22 Donkey with foal in unglazed earthenware. ENGLISH, modelled by Iris
Sonnis, 1967; height 30.5 cm/12 in. (p 139)
Courtesy Iris Sonnis

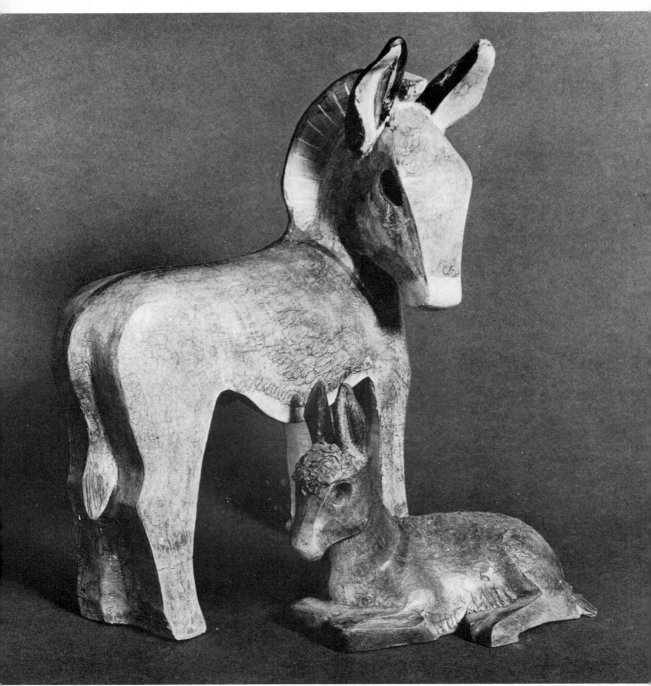

The example illustrated (25, p 104) is one of O'Hara's earlier pieces; a recent exhibition included twenty more examples of his creations, which then numbered 120, each an individual original work mounted on an appropriate matching base of exotic materials such as Brazilian onyx, Persian onyx, Panama rosewood, African teak, or English walnut.

Scandinavia

One of the best known of all Swedish ceramic modellers is Tyra Lundgren who, having trained as a sculptress and a painter, since 1925 has worked at both the Arabia porcelain factory at Helsingfors in Finland and the Rörstrand ceramic factory near Lidköping in Sweden. Having studied in France and Italy she started to work independently in 1941 in Gustavsberg, and in 1950 began to produce wares in her own workshop in Stockholm. The fish (85, p 183) is of stoneware and decorated with rather sombre coloured-glaze.

The very sleek stoneware cat (46, p 161) with dark greyish-green glaze was modelled by Gunnar Nylund. This outstanding modeller was at the Bing & Grøndahl factory in Copenhagen, Denmark, from 1926–28 and 1937–38, but most of his creative years have been spent at the Rörstrand factory in Sweden, where from 1931 he was artistic director and primarily responsible for the introduction of stoneware. In about 1958 Gunnar Nylund returned to Denmark and has since worked at the Nymolle Keramiska factory and the Schous factory. He has been most versatile in his work, and is probably best associated with the large figures of lions, but is equally at home designing tablewares in porcelain. His major independent works include ceramic murals for the Västgöta Fraternity at Uppsala University, and a portal decoration for a large Swedish hotel.

The 'contoured' lion (57, p 167) is the work of a lesser known modeller, Michael Schilkin, who is of Russian origin. He has worked at the Arabia factory in Helsingfors, Finland, since 1936 and has always been at his best when working with heavy coarse clays in either full reliefs, as in the lion, or high relief wall decorations. The Arabia factory, which started in 1874, is one of the most successful and progressive concerns in Scandinavia today.

It is very rare that a modeller combines the clays of porcelain with that of stoneware but such is the case with the *Husmask*, or larva of a caddis fly, modelled by Gösta Grähs in about 1966 (98, p 193).

16 United States of America

It was not until about the middle of the nineteenth century that a wide range of ceramics was made in the United States of America. In almost every instance these pieces were very similar to the contemporary wares being made in the pottery and porcelain centres of England.

The best known American centre was at Bennington, Vermont, where an independent factory was established in 1847 by Christopher W Fenton who made both Rockingham-type earthenwares and Parian wares. From 1853 to 1858, this factory was known as the United States Pottery Company. The lion (56, p 167) based on the marble figure in Florence (54, p 166) has the typical mottled flint enamel glaze, patented by Fenton in 1849; it is very similar to that used on the pottery made at the Rockingham factory in Yorkshire, England, during the early part of the nineteenth century. Both the lion and the figure of a doe (66, p 172) are rather exceptional as most of Fenton's output was devoted to the production of more useful pieces such as jugs, flower-vases and teapots. Very similar wares with a heavily mottled glaze were also made at East Liverpool, Ohio. In order to produce an English-type Parian ware, Fenton is said to have obtained the services of John Harrison, who had previously worked at the Copeland factory in Stoke, England. The dogs illustrated (72 and 73, p 176) are typical of these rather simple figures, which were sometimes further decorated with enamel colours in the biscuit.

The Union Porcelain Works of Greenpoint, New York, was acquired in about 1861 by an American architect, Thomas Smith, and from that time they made a wide range of decorative pieces. The vase (105, p 197) was designed by Karl Müller, whose work was shown at the Philadelphia Exhibition of 1876; he modelled a similar vase that has a turtle at the base, and some pieces that were rather less generally acceptable, such as a teaset with a goat as the handle of the creamer and rabbits as supports for other pieces.

It is during more recent years that the USA has come to the fore with some remarkable, independent potters, people whose work is now included in some of the major American museums.

Carl Walters, who died in 1955, worked at Woodstock, New York, and made some very fine earthenware figures. The cat (23, p 143) is of glazed clay and amusingly entitled Cat in Tall Grass. The figure of a duck (35, p 155), also by Walters, is of earthenware with underglaze colours of mulberry, brick-red, and yellow on a cream ground.

23 Cat in glazed pottery, called Cat in Tall Grass. AMERICAN (Woodstock, New York), modelled by Carl Walters, 20th century; height 39.9 cm/15½ in. (p 142)
Courtesy The Metropolitan Museum of Art, New York

Edward Marshall Boehm was born near Baltimore in Maryland and did not take up ceramic sculpture until he was nearly forty years of age, although his previous working years spent in animal husbandry had given him a close love and understanding of animals and nature. For many years Boehm had practised sculpture as a hobby only, and it was not until 1949 that he set up a studio in the pottery centre of Trenton, New Jersey, and turned his outstanding ability as a modeller to commercial advantage.

The American market for such porcelain figures was already well catered for by the Dorothy Doughty series of American Birds made and exported to the USA by the Worcester Royal Porcelain Company. It was not until the Metropolitan Museum of Art in New York exhibited two Boehm figures in their galleries that the skill of this artist was fully appreciated and internationally recognized. The two exhibits were the fine model of a *percheron* horse (97, p 192) and the Hereford bull (62, p 170), both in hard-paste porcelain. These figures, like the Doughty birds, have been produced in a limited edition, thus creating a collector's item immediately on publication. The robin (36, p 155) was first produced in 1964 in a limited edition of five hundred copies.

Boehm and his apprentices model only from life, and he breeds the necessary species depicted in his creations. The original models are made from a mixture of ball-clay and glycerine (plasticine) and the model has to be scaled up by about 13 per cent, the amount that the figure will shrink during firing. The plasticine model is cut up and appropriate moulds made (as described on p 24), and a plaster version is then produced which is used as a standard figure by the craftsmen who assemble the various pieces. The rather high number of thirty-five casts is given for the life of a Boehm mould; usually with the slip-cast method of production the mould would have started to lose the fine detail of the original model before this number had been reached. Boehm figures are now on exhibition in The White House, nearly all the major American museums, Buckingham Palace in London, the Elysée Palace in Paris, and many foreign museums.

A further American ceramic studio that has produced a large number of outstanding animal figures is Cybis Porcelains of Trenton, New Jersey. The firm was started soon after 1939, when Boleslaw and Marja Cybis became American citizens rather than return to their home in Poland following the Nazi invasion. Cybis was already an artist of some repute and, at the time of the outbreak of the 1939 war, he was engaged on two *al fresco* murals for the Polish Pavilion in the 1939–40 World's Fair in New York. He successfully converted his talents in painting to work in porcelain and his wares are now known throughout the world. The beautiful figure of a bull (64, p 171) is a recent model, produced in a limited edition of one hundred pieces, one of which is in the collection of the President of Mexico, Gustavo Diaz Ordaz. Examples of the graceful

24 Group of snakes and birds in low-fired earthenware decorated in underglaze colours, called Two Very Very Nice Snakes Taking Some Birds for a Walk among the Rocks. AMERICAN (Hamlin, New York), modelled by Bill Stewart, 1971; length 280 cm/109 in. (p 146)

Museum of Contemporary Crafts, New York; photograph Ferdinand Boesch

figure of a unicorn (82, p 181) are now housed in at least eight major museums and houses throughout America, including The White House. To pair with the unicorn there is no lion, but a beautiful figure of Pegasus, the animal immortalized by the ancient Greeks.

New Jersey has certainly attracted a great many artists concerned with the love of creating beautiful forms from porcelain. Illustration 39 (p 157) is a Burgues ruby-throated hummingbird in hard-paste porcelain and was made by the Brielle China and Galleries.

Finally for three 'crazy' American animals that one cannot but adore, if only for their ugliness. These amusing examples were in an exhibition at the Museum of Contemporary Crafts of the American Crafts Council entitled CLAYWORKS: 20 AMERICANS. Bill Stewart, who works in Hamlin, New York, showed four pieces entitled the Happy Apple Duck House, 9 Boxes, One Footed Elephant and Rhino Lamps with Snake, and Two Very, Very Nice Snakes Taking Some Birds for a Walk among the Rocks (24, p 145); the latter is of low-fired clay, decorated with underglaze colours, and is nearly 3 metres (9 feet) long! The well-shod dog (74, p 177) was exhibited in 1971 by Jack Earl, who works at Genoa, Ohio. Earl received a BA from Bluffton College in Ohio in 1956 and then taught until 1963, when he took up teaching at the Toledo Museum of Art, School of Design. The life-size warthog (122, p 207) in glazed earthenware was modelled by David Gilhooly, who was born in Auburn, California, but now teaches at the University of Saskatchewan, Canada. All seven pieces of his work shown in the New York Exhibition were from the Allan Stone Collection and they featured titles such as Frog Mounties – Scourge of the Outlaw, Napoleon Frog, Rape of the Sabine Frogs, and First Frog on the Moon.

The illustrations
in animal groups

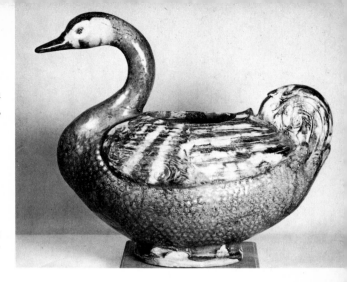

25 Jar in the form of a goose, in pottery with coloured glazes. CHINESE (T'ang dynasty), AD 680–750; length 35.2 cm/14 in. (p 40)
Courtesy The Asian Art Museum of San Francisco, Avery Brundage Collection

26 Cockatoo in hard-paste porcelain, painted in enamel colours. GERMAN (Meissen), modelled by J J Kändler, 1734; height 35 cm/13¾ in. (p 61)
Courtesy Rijksmuseum, Amsterdam

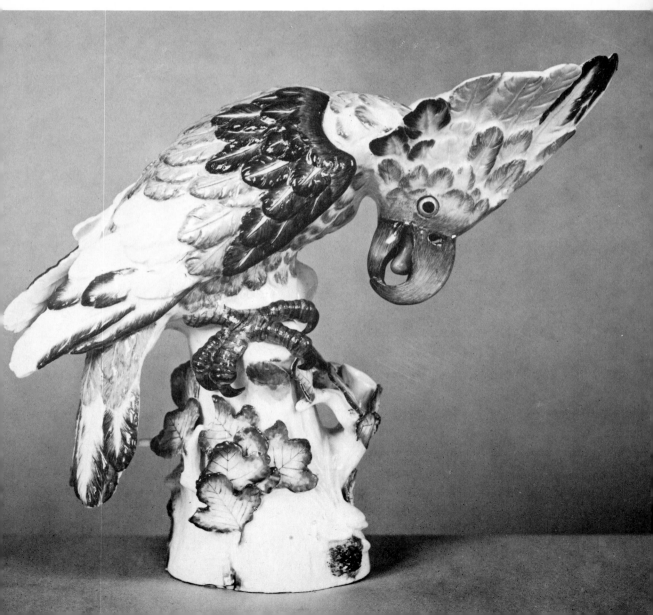

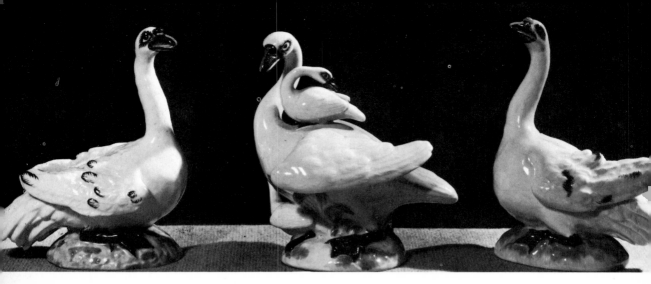

27 Group of swans in hard-paste porcelain (from the Swan Service), painted in enamel colours. GERMAN (Meissen), modelled by J J Kändler, 1737–41; height 22 cm/8½ in. (p 63)
Courtesy The Antique Porcelain Company Limited, London

28 Pair of candlesticks depicting The Vain Jackdaw and The Cock and Jewel (from Aesop's fables), in soft-paste porcelain decorated in enamel colours and gilt. ENGLISH (Chelsea), about 1765; height 26 cm/10¼ in. (p 97)
Crown Copyright, Victoria and Albert Museum, London

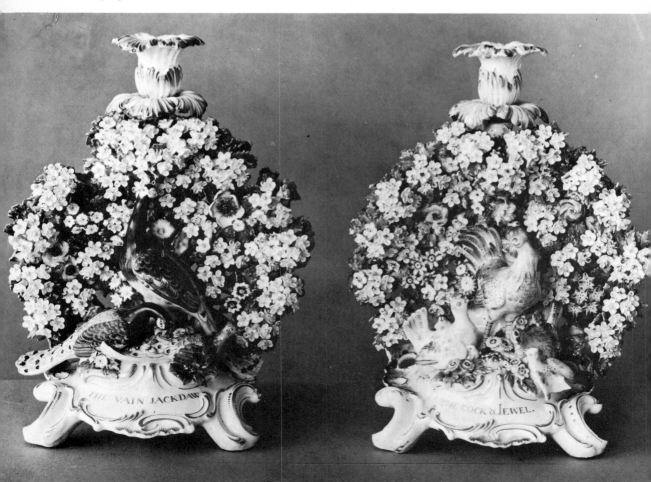

29 · Partridge in glazed soft-paste porcelain, marked with a raised anchor on an applied medallion. ENGLISH (Chelsea), 1749–52; height 15.2 cm/6 in. (p 95)
Courtesy Dudley Delavigne Collection

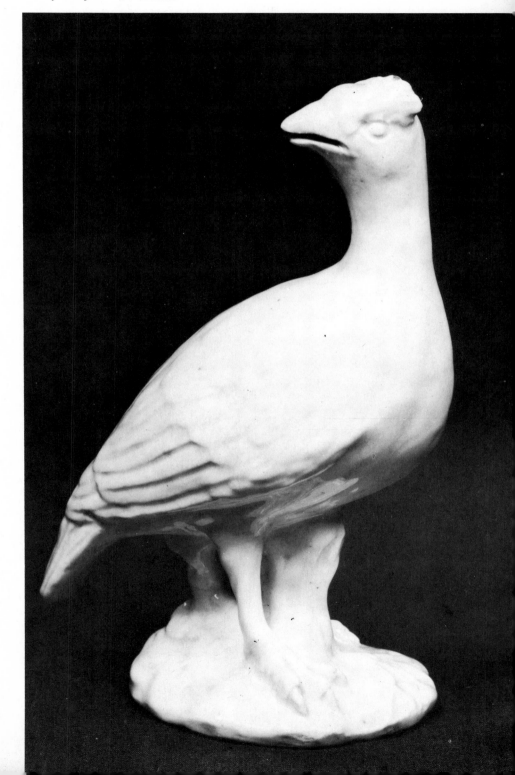

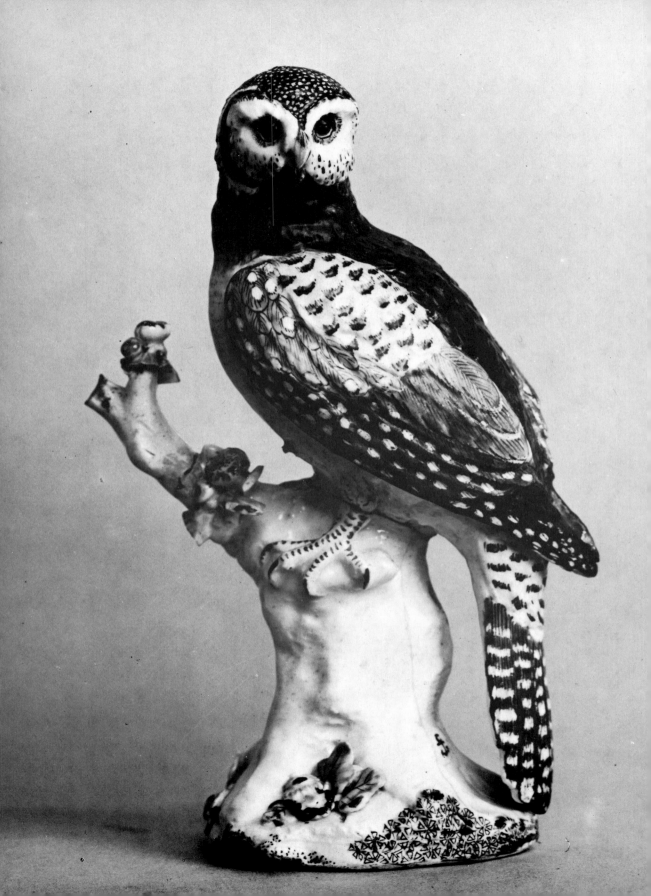

30 Little hawk owl in soft-paste porcelain, painted in enamel colours, and marked with a raised anchor in red enamel on an oval medallion. ENGLISH (Chelsea), about 1750; height 17.1 cm/6¾ in. Based on the engraving in illustration 31. (p 95)
Crown copyright, Victoria and Albert Museum, London

31 Engraving of the little hawk owl that inspired illustration 30. From George Edwards's *Natural History of Uncommon Birds*, on which the Chelsea modellers based their porcelain reproductions.
Crown copyright, Victoria and Albert Museum, London

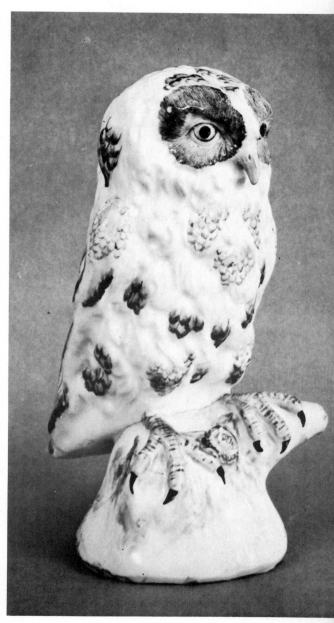

32 Owl in soft-paste porcelain, painted in enamel colours. ENGLISH (Bow), about 1755; height 19 cm/7½ in. (p 100)
Courtesy Dudley Delavigne Collection

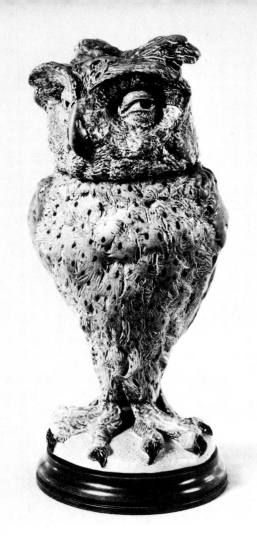

33 Drinking-vessel in the form of an owl, in salt-glazed stoneware decorated with an iron slip, and marked 'R W Martin & Bros London & Southall, 3–1899'. ENGLISH (Southall), 1899; height 26.7 cm/10½ in. (p 129)
Victoria and Albert Museum, London

34 Pair of incense-burners in the form of quail in stoneware, decorated with mottled glaze of dark bronze, silver, bright brown, and grey, with gilt on inside. JAPANESE (Yamashiro, Kyōto), 18th or 19th century; height 12.6 cm/5 in. (p 44)
Freer Gallery of Art, The Smithsonian Institution, Washington DC

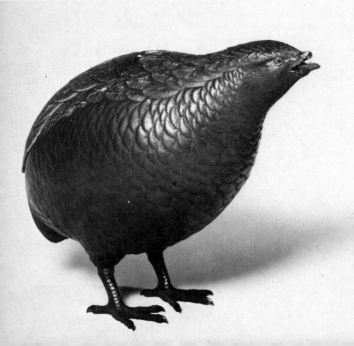
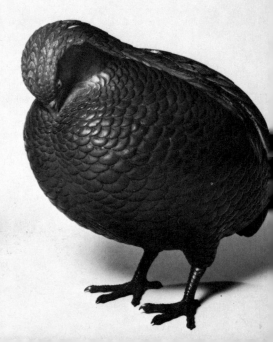

35 Duck in earthenware, with underglaze colours of mulberry, brick-red, and yellow, on a cream ground. AMERICAN (Woodstock, New York), modelled by Carl Walters, early twentieth century; length 28 cm/11 in. (p 142)

Courtesy The Metropolitan Museum of Art, New York

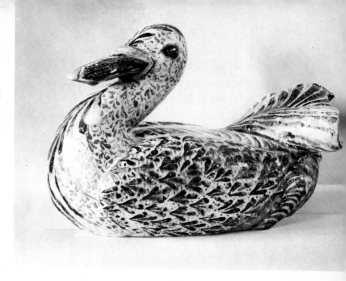

36 Robin in hard-paste porcelain, decorated in matt enamel colours. AMERICAN (Trenton, New Jersey), modelled by Edward Marshall Boehm, 1964; height of daffodil 37 cm/13 in. (p 144)

Courtesy Edward Marshall Boehm

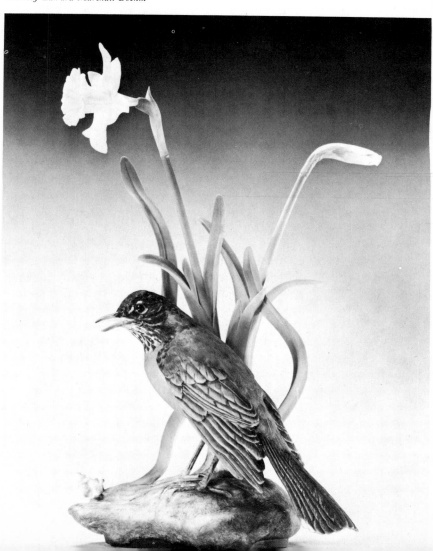

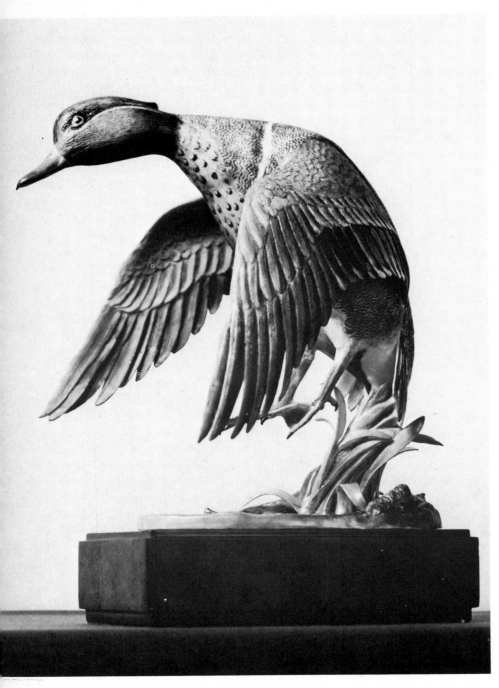

37 Green-winged teal in bone china, painted in enamel colours. ENGLISH
(Worcester), modelled by Ronald Van Ruyckevelt, 1970; height 30.5 cm/12 in.
(p 111)
Courtesy The Royal Worcester Porcelain Company Limited

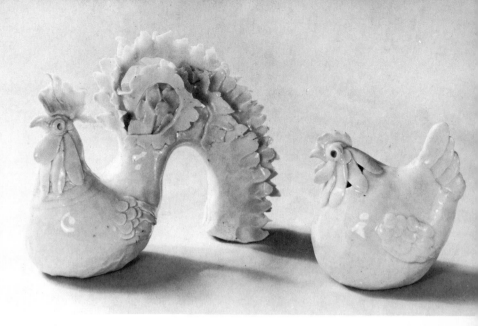

38　Bantam cock and hen in hard-paste porcelain. ENGLISH (Oxshott, Surrey), modelled by Rosemary D Wren, 1973; greatest height 16.5 cm/6½ in. (p 137)
Courtesy Rosemary D Wren

39　Ruby-throated hummingbird in hard-paste porcelain, painted in enamel colours. AMERICAN (Brielle China and Galleries), 1973; height 20.3 cm/8 in. (p 144)
Courtesy Brielle China and Galleries, New Jersey

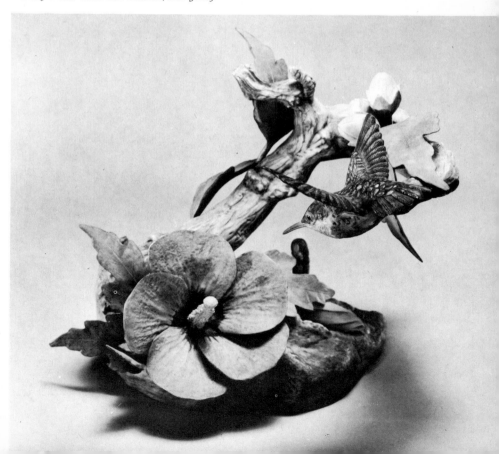

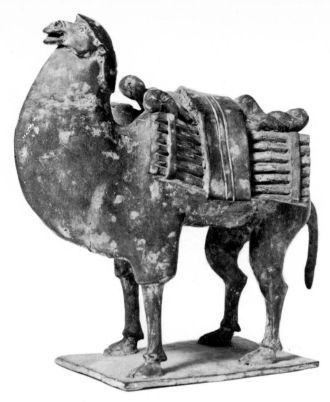

40 Bactrian camel in earthenware, painted in coloured slips. CHINESE (Northern Wei dynasty), AD 500–535; height 24.7 cm/9¾ in. (p 36)
Courtesy The Asian Art Museum of San Francisco, Avery Brundage Collection

41 Camel and dromedary in earthenware, painted in enamel colours. ENGLISH (Staffordshire), about 1830; height 15.8 cm/6¼ in. (p 126)
Courtesy Charles Mundy

42 Stirrup-spout vessel in the form of a cat, in black burned pottery with incised decoration. PERUVIAN (Chavin or Cupisnique culture), about 800 BC; height 23.1 cm/9 in. (p 46)
Courtesy Museum of Primitive Art, New York

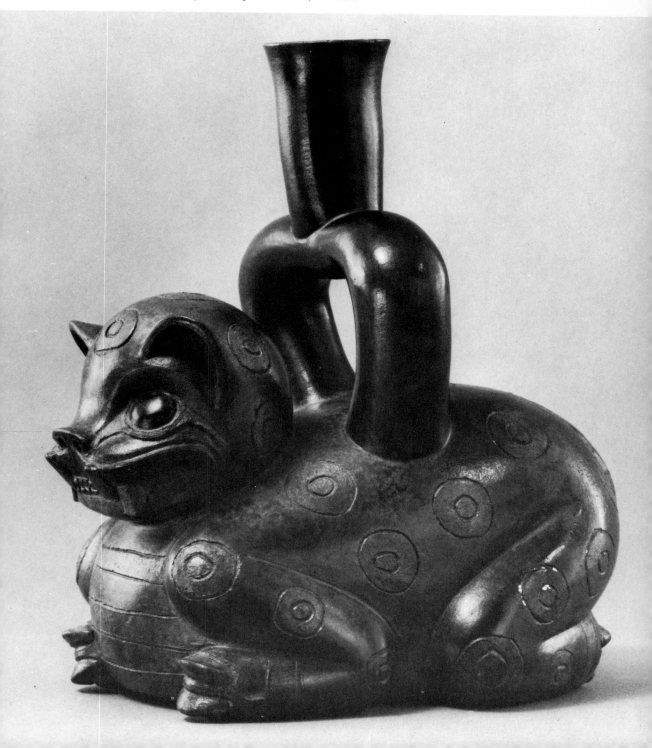

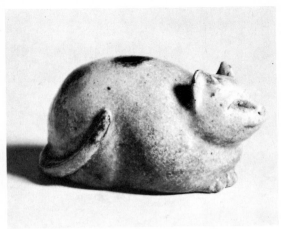

45 Cat in earthenware, with coloured glaze.
JAPANESE (Yamashiro, Kyōto), 18th or 19th
century; length 5.5 cm/2¼ in. (p 44)
*Freer Gallery of Art, The Smithsonian Institution,
Washington DC*

43 Water-dropper in the form of a cat, in white
earthenware with underglaze-blue and black.
PERSIAN (Meshed), 1600–50; height 15 cm/6 in.
(p 33)
Crown copyright, Victoria and Albert Museum, London

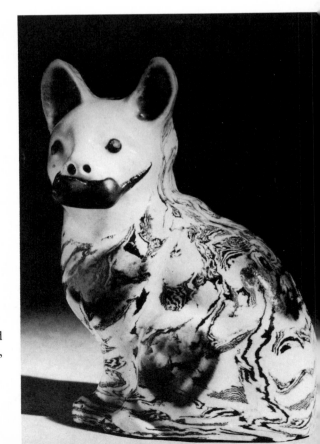

44 Cat with rat in its mouth, in salt-glazed
stoneware (agate ware). ENGLISH (Staffordshire),
about 1745; height 9.7 cm/3¾ in. (p 120)
Courtesy The Cecil Higgins Art Gallery, Bedford

46 Cat in stoneware with a dark greyish-green glaze. SWEDISH (Rörstrand), modelled by Gunnar Nylund, 1942; height 33 cm/13 in. (p 141)
Courtesy Nationalmuseum, Stockholm

47 Siamese cat in white and terracotta stoneware. ENGLISH, modelled by Iris Sonnis, 1970-73; length 25.9 cm/10 in. (p 139)
Courtesy Iris Sonnis

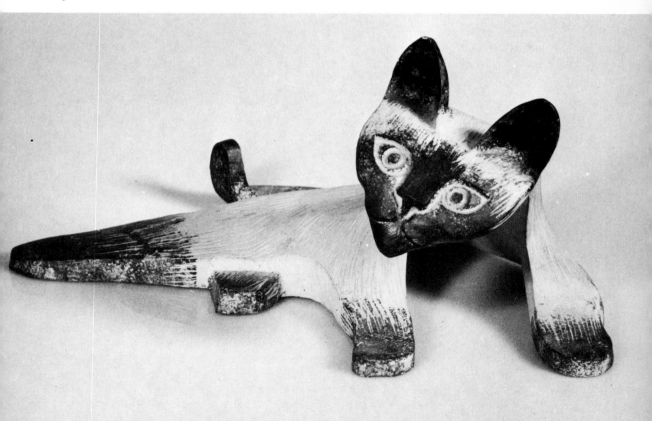

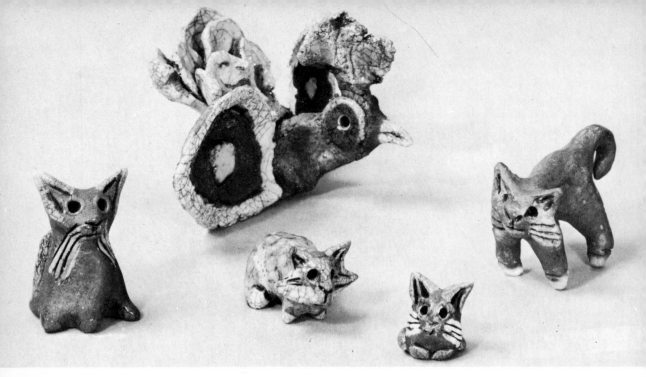

48 Group of cats with bird in *raku* and stoneware: from left to right, En-
quiring Cat, Butterfly Bird, Hearth Cat, Carpet Cat, Purr Cat (stoneware).
ENGLISH (Oxshott, Surrey), modelled by Peter M Crotty, 1971–72; length of
bird 8.8 cm/3½ in. (p 138)
Courtesy Peter M Crotty

49 Cat in *raku* ware. ENGLISH (Oxshott, Surrey), modelled by Rosemary D
Wren about 1973; length 40.8 cm/16 in. (p 137)
Courtesy Rosemary D Wren

opposite

50 Stirrup-spout vessel with tiger in relief, in red earthenware with red and
white painted decoration. PERUVIAN (Mocchica culture), first to tenth century;
height 25.4 cm/10 in. (p 51)
Courtesy Museum of the American Indian, Heye Foundation, New York

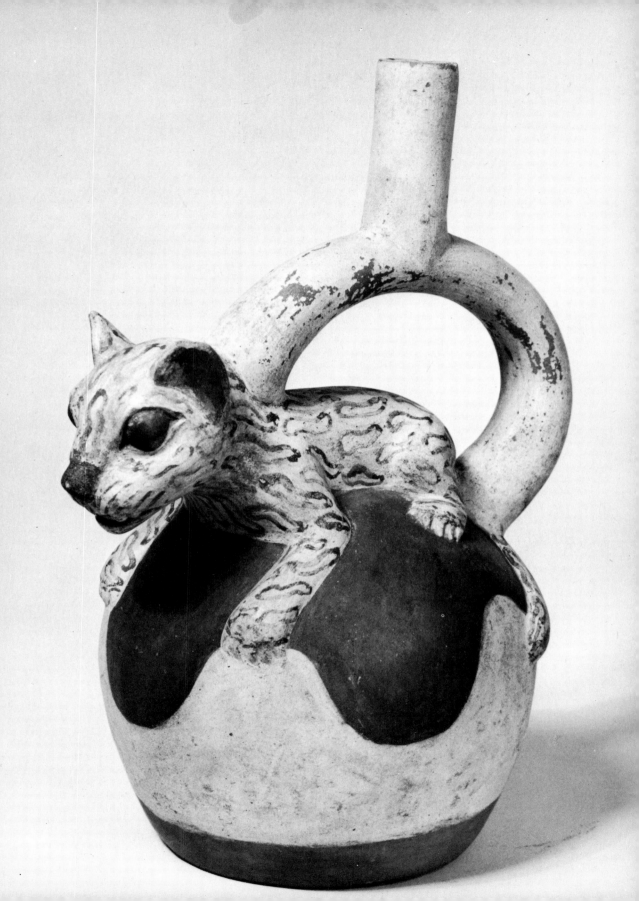

51 Tame leopard and child in soft-paste porcelain. ENGLISH (Bow), about 1765; height 14 cm/5½ in. (p 100)

Formerly in Leslie Slot Collection

52 Pair of guardian lions (or dogs of Fo) in hard-paste porcelain, decorated with turquoise glaze on the biscuit. CHINESE (K'ang Hsi period), 1662–1722; height 19 cm/7½ in. (p 41)

Crown Copyright, Victoria and Albert Museum, London

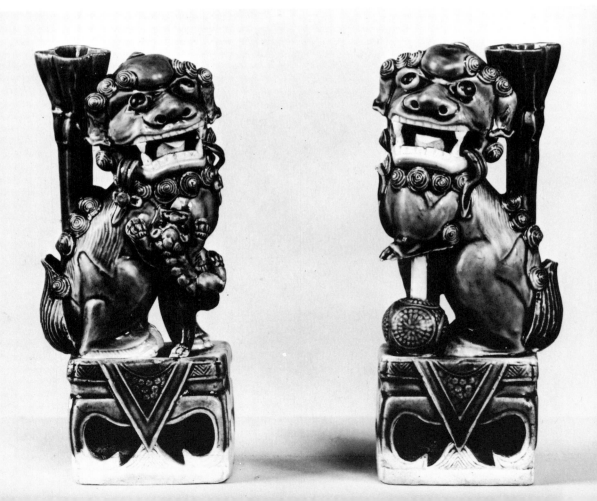

53 Samson rending the lion, in pottery painted in enamel colours. ENGLISH (Staffordshire), attributed to either John or Rebecca Lloyd of Shelton, about 1845–50; height 29.2 cm/11½ in. (p 126)

Collection of Dorothy and Reginald Haggar

54 Lion in Roman marble, from the Loggia dei Lanzi, Florence; early classical.
Compare with illustrations 55 and 56.
Mansell Collection

55 Lion in soft-paste glazed porcelain. ENGLISH (Chelsea), 1750–55; length
29.2 cm/11½ in. Based on the Italian lion in illustration 54. (p 96)
Courtesy Dudley Delavigne Collection

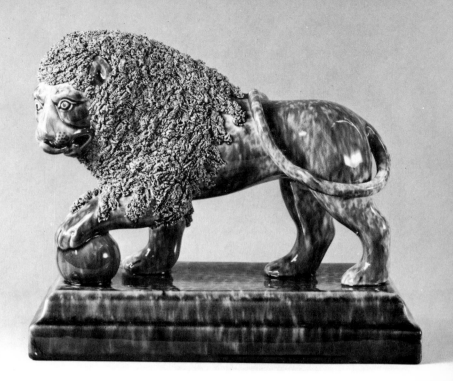

56 Lion in flint enamel-glazed earthenware. AMERICAN (Bennington, Vermont), attributed to Daniel Greatbach, 1853–58; length 27.7 cm/11 in. Based on the Italian lion in illustration 54. (p 142)
Courtesy The Metropolitan Museum of Art, New York

57 Lion in stoneware with mottled *sang-de-boeuf* glaze. FINNISH (Arabia, Helsingfors), modelled by Michael Schilkin, 1941; length 44 cm/17½ in. (p 141)
Courtesy Nationalmuseum, Stockholm

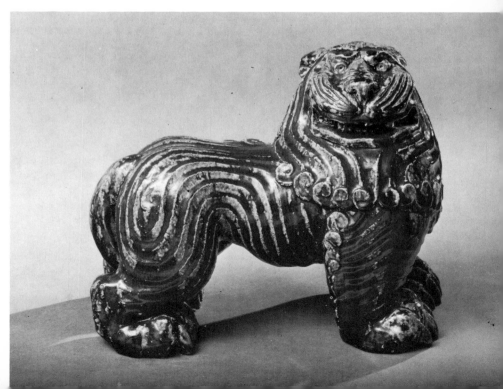

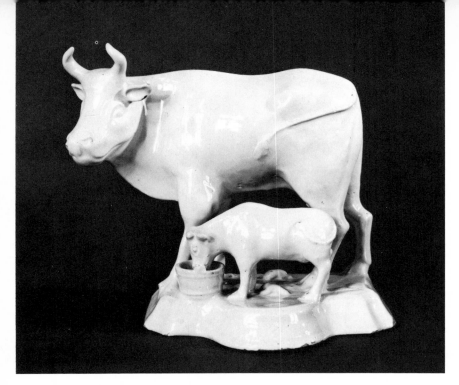

58 Cow and calf in tin-glazed earthenware (Delftware). DUTCH (Delft), 1700–25; height 15 cm/6 in. (p 54)
Courtesy Rijksmuseum, Amsterdam

59 Creamer in the form of a cow and milkmaid, in lead-glazed earthenware. ENGLISH (Staffordshire), late eighteenth century; length 18.4 cm/7¼ in. (p 126)
Courtesy The Cecil Higgins Art Gallery, Bedford

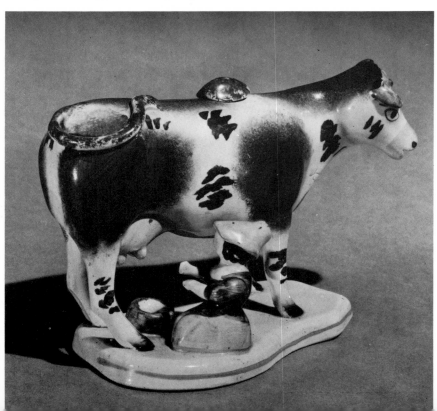

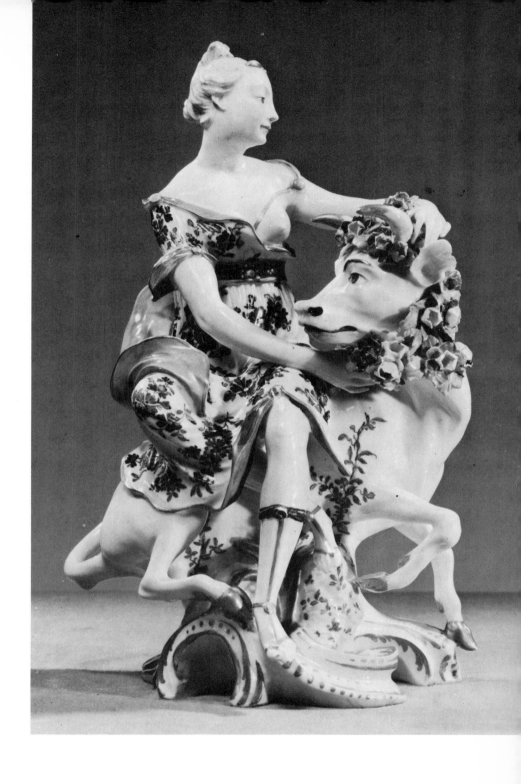

60　Europa and the Bull in soft-paste porcelain with colourless glaze. ENGLISH (Derby), about 1765; height 28.6 cm/11¼ in. (p 105)

Crown copyright, Victoria and Albert Museum, London

61 Cow in hard-paste porcelain, painted in enamel colours. GERMAN (Fürsten-berg), early nineteenth century; length 15.9 cm/6¼ in. (p 66)
Crown copyright, Victoria and Albert Museum, London

62 Hereford bull in hard-paste porcelain painted in enamel colours. AMERICAN (Trenton, New Jersey), modelled by Edward Marshall Boehm, mid 20th century; length 26 cm/10¼ in. (p 144)
Courtesy The Metropolitan Museum of Art, New York

63 Brahman bull in bone china, painted in enamel colours. ENGLISH (Worcester), modelled by Doris Linder, 1967; length 27.9 cm/11 in. (p 111)
Courtesy The Royal Worcester Porcelain Company Limited

64 Bull in hard-paste porcelain. AMERICAN (Cybis Porcelains), about 1967; length 30.4 cm/12 in. (p 144)
Courtesy Cybis, Trenton, New Jersey

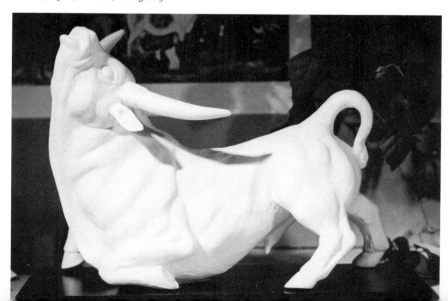

65 Tureen in the form of a stag in hard-paste porcelain, painted in enamel colours. GERMAN (Meissen), modelled by J J Kändler, 1774; height 41.3 cm/16¼ in. (p 64)
Copyright Bayerisches Nationalmuseum, Munich

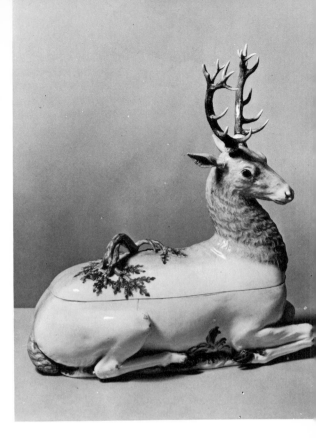

66 Doe in earthenware with a brown and green lead-glaze. AMERICAN (Bennington, Vermont), nineteenth century; height 21.5 cm/8½ in. (p 142)
Courtesy The Metropolitan Museum of Art, New York

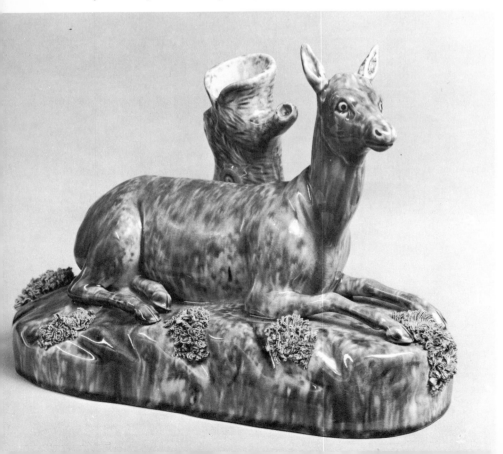

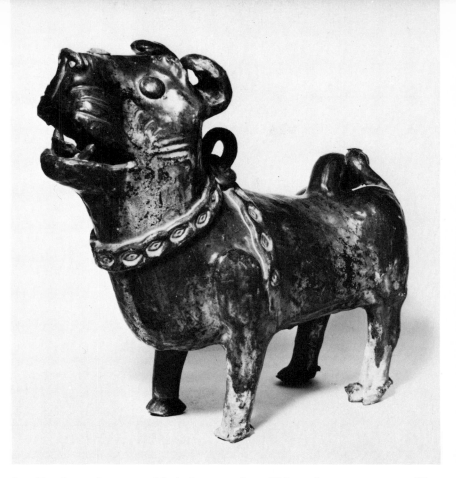

67 Dog in earthenware with dark-green glaze, Ch'ang-sha type. CHINESE (Han dynasty) 206 BC to AD 220; height 35.6 cm/14 in. (p 34)
Courtesy The Asian Art Museum of San Francisco, Avery Brundage Collection

68 Greyhound in white soft-paste porcelain, marked with a crown and trident painted in underglaze-blue. ENGLISH (Chelsea), about 1749; length 14.6 cm/5¾ in. (p 89)
Victoria and Albert Museum, London

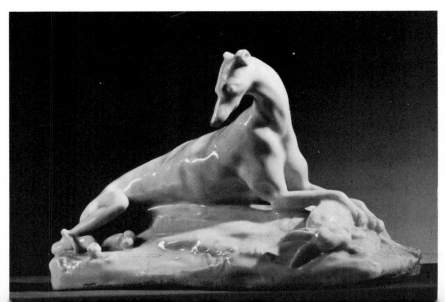

69 Dog in tin-glazed earthenware. GERMAN (Nuremberg), attributed to G Kordenbusch, about 1750; height 19 cm/7½ in. (p 73)

70 Bolognese hound in hard-paste porcelain, painted in enamel colours, and marked with crossed swords in underglaze-blue. GERMAN (Meissen), modelled by J J Kändler, 1769; height 15.4 cm/6 in. (p 64)

Copyright Bayerisches Nationalmuseum, Munich

71 Three pugs in soft-paste porcelain, decorated with manganese and under-glaze-blue. ENGLISH (Lowestoft), about 1775; height of middle dog 8.9 cm/3½ in. (p 105)

Collection of Dr Bernard Watney (left); Victoria and Albert Museum, London (centre and right)

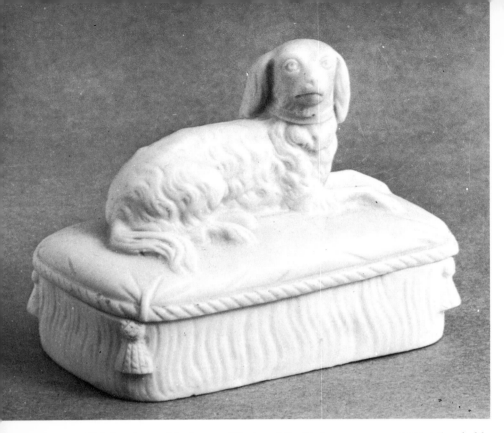

72 Trinket box with dog on lid, in white Parian ware. AMERICAN (probably
Bennington, Vermont), mid nineteenth century; height 7.3 cm/2¾ in. (p 142)
Courtesy The Metropolitan Museum of Art, New York

73 Pair of dogs in white unglazed Parian ware. AMERICAN (probably Benning-
ton, Vermont), mid nineteenth century, height 21.6 cm/8½ in. (p 142)
Courtesy The Metropolitan Museum of Art, New York

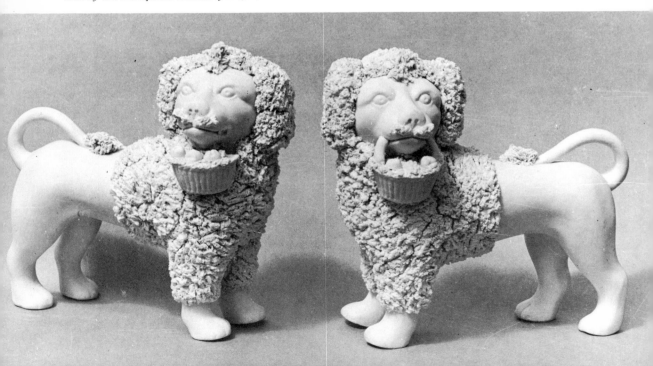

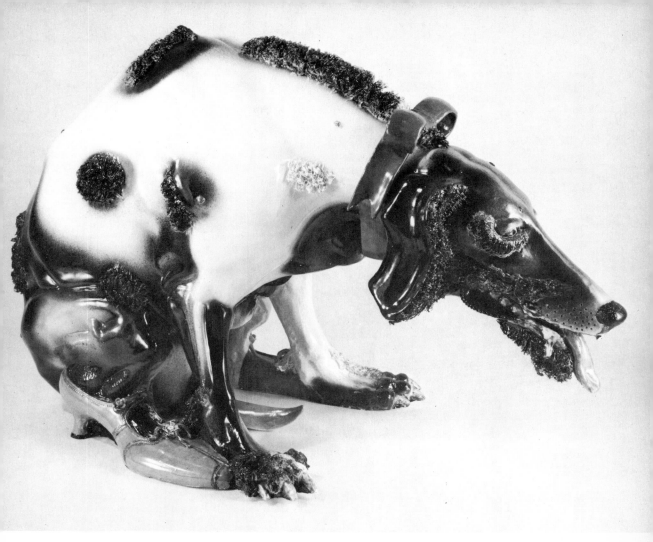

74 Dog in porcelain. AMERICAN (Genoa, Ohio),
modelled by Jack Earl, 1971; height 45.6 cm/18 in.
(p 146)
Museum of Contemporary Crafts, New York;
photographed Ferdinand Boesch

75 Dog in unglazed stoneware. ENGLISH (Ox-
shott, Surrey), modelled by Terry Bell-Hughes,
1973; height 25.4 cm/10 in. (p 138)
Courtesy Terry Bell-Hughes

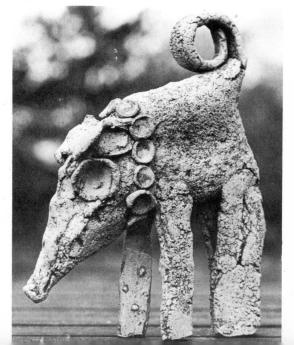

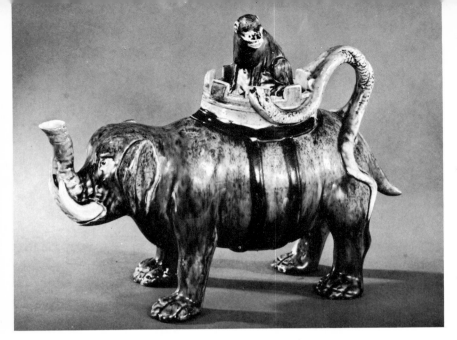

76 Teapot in the form of an elephant with a monkey and snake on its back, in earthenware decorated with high-temperature coloured glazes. ENGLISH (Staffordshire, Ralph Wood), about 1770; length 27.9 cm/11 in. (p 124)
Collection of Joan and Kenneth Chorley, USA

77 Elephant in earthenware, with grey to lustrous black colouring. ENGLISH (Oxshott, Surrey), modelled by Denise K Wren, 1969; length 34 cm/13 in. (p 132)
Courtesy Denise K Wren

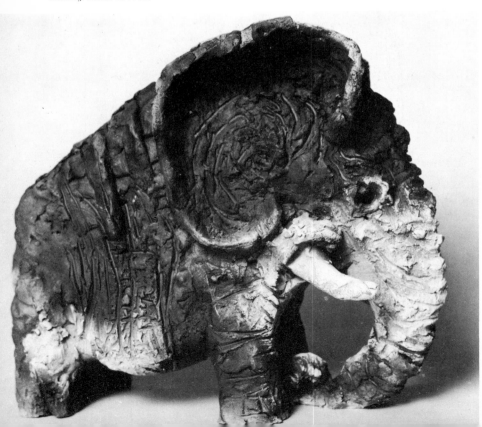

79 Animal with two heads in painted pottery.
MEXICAN (Tarascan, state of Nayarit), AD 300–1250;
length 44.5 cm/17½ in. (p 46)
*Courtesy Museum of the American Indian, Heye Foundation,
New York*

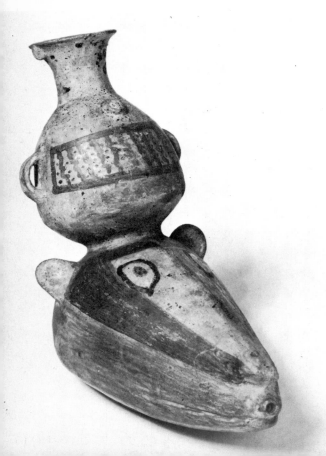

80 *Paccha* or drinking vessel in the form of an
animal's head surmounted with an *arybal* (vase), in
buff earthenware painted in red and black.
PERUVIAN (Inca, Cuzco), about 1450–1532;
height 19 cm/7½ in. (p 51)
*Courtesy Museum of the American Indian, Heye Foundation,
New York*

81 Seahorse (from a centrepiece featuring Neptune and Aphrodite) in hard-paste porcelain, painted in enamel colours and gilt. GERMAN (Nymphenburg), modelled by Dominikus Auliczek about 1770; length 24 cm/9½ in. (p 67)
Copyright Bayerisches Nationalmuseum, Munich

82 Unicorn in hard-paste porcelain. AMERICAN (Cybis Porcelains), 1969; height 33 cm/13 in. (p 144)
Courtesy Cybis, Trenton, New Jersey

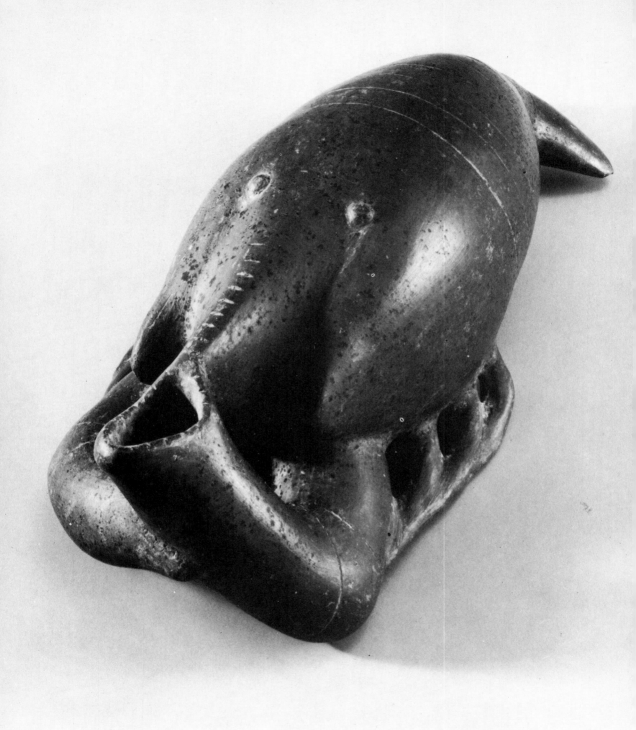

83 Vessel in the form of a crayfish in red earthenware. MEXICAN (Colima culture), Formative period, about 1500 BC to AD 300; length 34.3 cm/13½ in. (p 45)
Courtesy Museum of Primitive Art, New York

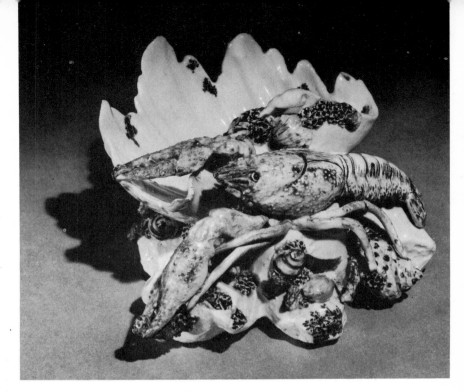

84 Salt in the form of a shell and crayfish, in soft-paste porcelain. ENGLISH (Chelsea), 1745–49; height 7 cm/2¾ in. (p 89)
Courtesy The Cecil Higgins Art Gallery, Bedford

85 Fish in stoneware with brown and greyish-brown glaze. SWEDISH (Gustavsberg), modelled by Tyra Lundgren about 1942; length 36 cm/14¼ in. (p 141)
Courtesy Nationalmuseum, Stockholm

86 Flower vase in the form of a flying fish, in Parian ware, marked with a hound, tower, and harp, and with 'Belleek' printed in black. IRISH (Belleek, Co Fermanagh), about 1875; height 18.4 cm/7¼ in. (p 131)
Victoria and Albert Museum, London

opposite
87 Horse in unglazed grey earthenware with traces of red pigment. CHINESE (Six dynasties), AD 221–617; height 23.2 cm/9¼ in. (p 35)
Crown copyright, Victoria and Albert Museum, London

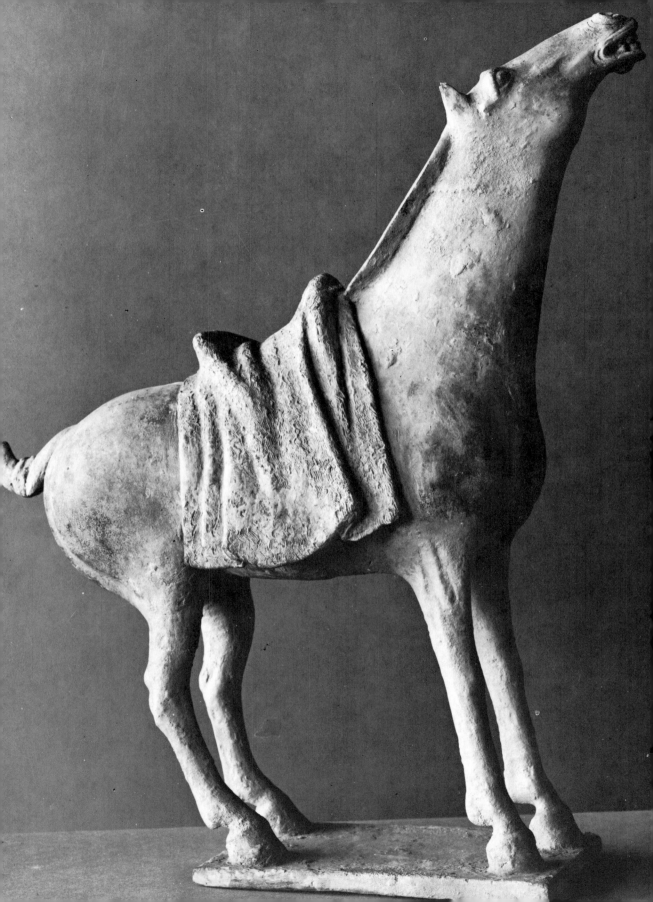

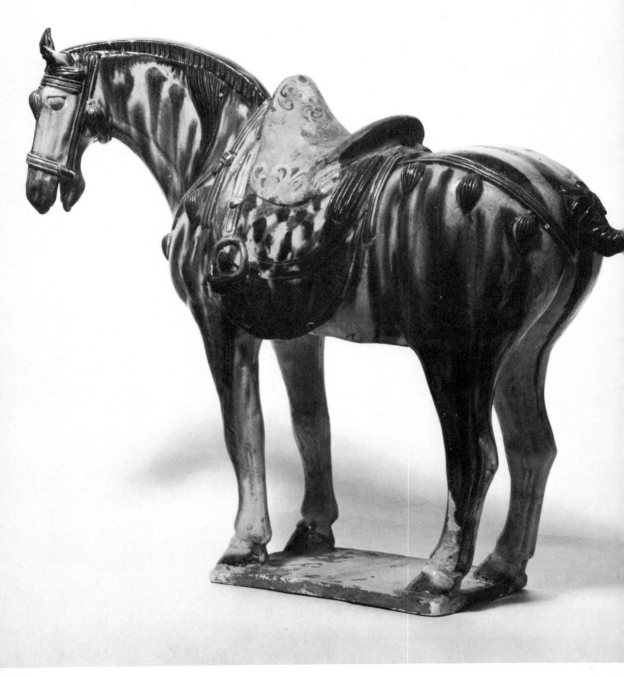

88 Horse in earthenware, decorated with blue, amber, and brown glazes.
CHINESE (T'ang dynasty) AD 680–750; height 36.3 cm/14¼ in. (p 39)
Courtesy The Asian Art Museum of San Francisco, The Avery Brundage Collection

89 Europa on a horse in hard-paste porcelain, painted in enamel colours and gilt. GERMAN (Meissen), modelled by J J Kändler about 1746; height 21.3 cm/8½ in. (p 64)

Museum of Art, Rhode Island School of Design, Providence, Lucy T Aldrich Collection

90 Horse with blackamoor groom in hard-paste porcelain, painted in enamel
colours and gilt. GERMAN (Meissen), modelled by J J Kändler, 1745–50; height
24.2 cm/9½ in. Compare with illustration 91. (p 63)
Courtesy Mrs Peter Holt-Wilson

91 Horse with blackamoor groom in soft-paste porcelain, painted in enamel colours and gilt. ENGLISH (Longton Hall), about 1755; height 20.1 cm/8 in. Based on the Meissen original in illustration 90. (p 108)

Crown copyright, Victoria and Albert Museum, London

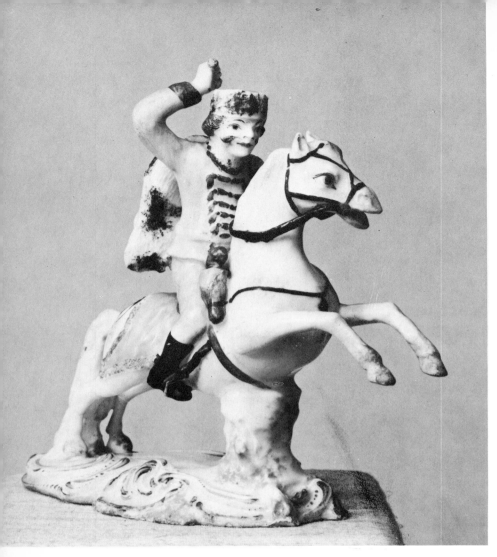

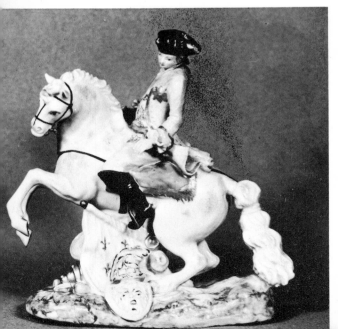

92 Mounted hussar in soft-paste porcelain, painted in enamel colours. ENGLISH (Longton Hall), 1756-60; height 12.2 cm/4¾ in. (p 108)
Crown copyright, Victoria and Albert Museum, London

93 The Duke of Brunswick on his charger, in soft-paste porcelain, painted in enamel colours. ENGLISH (Longton Hall), about 1760; height 21.6 cm/8½ in. (p 108)
Courtesy The British Museum, London

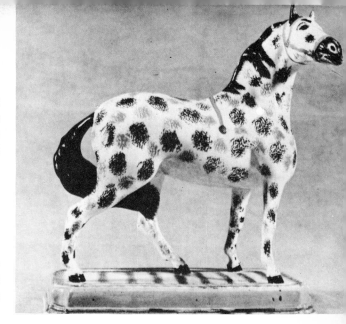

94 Horse in cream-coloured earthenware, painted in blue, orange, and black enamel. ENGLISH (probably made at Hunslet from Leeds pottery moulds), about 1835; height 40.5 cm/16 in. (p 124)
Courtesy Leeds Art Gallery

95 Ewer in the form of a horse, in red earthenware decorated with clay-slip and glazes. TURKISH (Chanak Kalé, Dardanelles), nineteenth century; height 22.3 cm/8¾ in. (p 33)
Victoria and Albert Museum, London

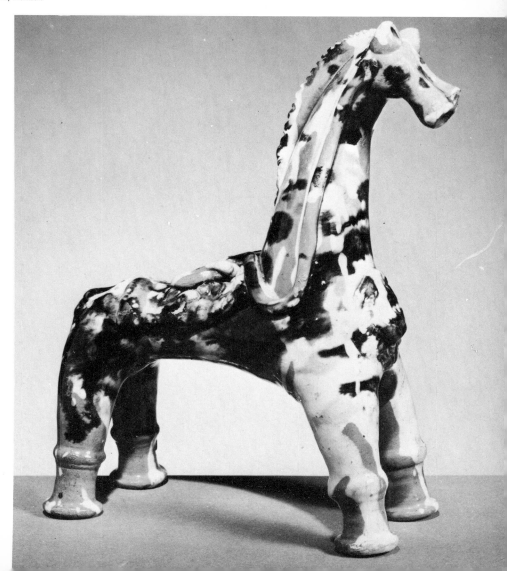

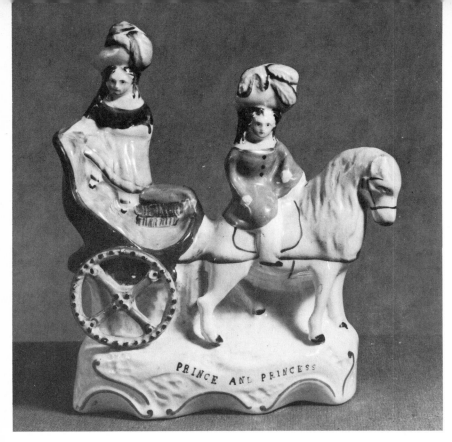

96 Pony and carriage with the Prince of Wales and Princess Royal, in earthenware painted in enamel colours. ENGLISH (Staffordshire), 1845–50; height 19.7 cm/7¾ in. (p 128)
Courtesy Rijksmuseum, Amsterdam

97 *Percheron* horse in hard-paste porcelain, painted in enamel colours. AMERICAN (Trenton, New Jersey), modelled by Edward Marshall Boehm, mid twentieth century; height 23.2 cm/9 in. (p 144)
Courtesy The Metropolitan Museum of Art, New York

98 Larva of a caddis fly *(Husmask)* in white and brown porcelain and stone-
ware. SWEDISH, modelled by Gösta Grähs about 1966; length 20 cm/7¾ in. (p 141)
Courtesy Nationalmuseum, Stockholm

99 Four boxes surmounted by various beetles, in red and grey stoneware clay.
ENGLISH, modelled by David Woodcock, 1972; height 10.2 cm/4 in. (p 139)
Courtesy David Woodcock

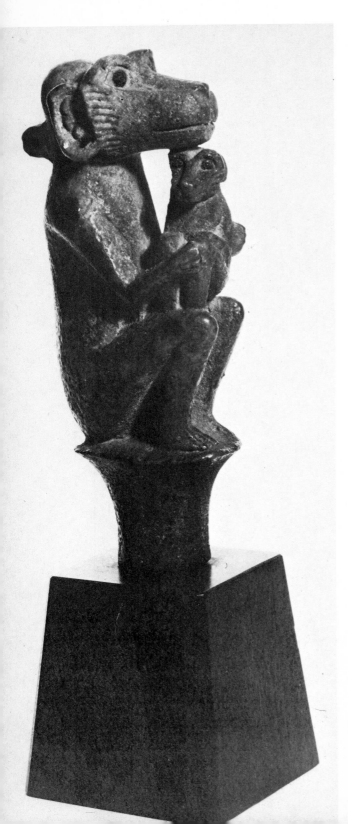

100　Terminal of a staff in the form of a monkey holding its young, in earthenware. EGYPTIAN (Late period), after 750 BC; height 12 cm/4¾ in. (p 32)
Courtesy The British Museum, London

101　Monkey in hard-paste porcelain, painted in enamel colours. GERMAN (Meissen), attributed to J G Kirchner, about 1727; height 47.7 cm/18¾ in. (p 58)
Dr Ernst Schneider Collection, Schloss Lustheim, Germany

102 Monkey in hard-paste porcelain, painted in enamel colours. GERMAN (Meissen), attributed to J G Kirchner, about 1730; height 48.2 cm/19 in. (p 61)
Courtesy Museum of Fine Arts, Boston

103 Hoolock gibbon in black and white stoneware. ENGLISH (Oxshott, Surrey), modelled by Rosemary D Wren, 1967; length 91.2 cm/36 in. (p 137)
Collection of Mr and Mrs David Attenborough

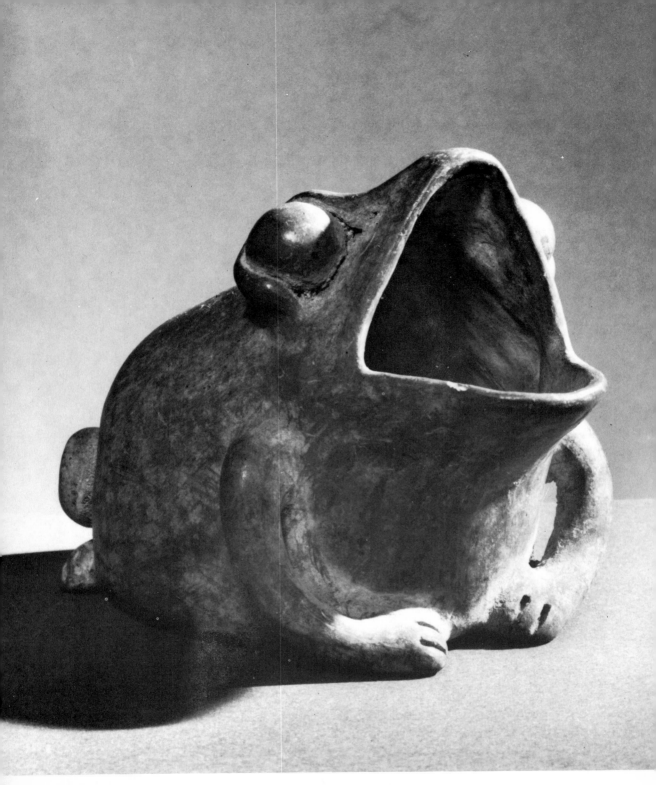

104 Frog in earthenware. MEXICAN (Colima culture), Formative period, about
1500 BC to AD 300; height 17.5 cm/7 in. (p 45)
Courtesy Museum of Primitive Art, New York

105　Vase in the form of a plant with frog, in hard-paste porcelain, marked with 'UPW' and 's' in gold. AMERICAN (Union Porcelain, New York), designed by Karl Müller, about 1884; height 14.6 cm/5¾ in. (p 142)

Courtesy of Brooklyn Museum, New York, gift of Franklin Chase

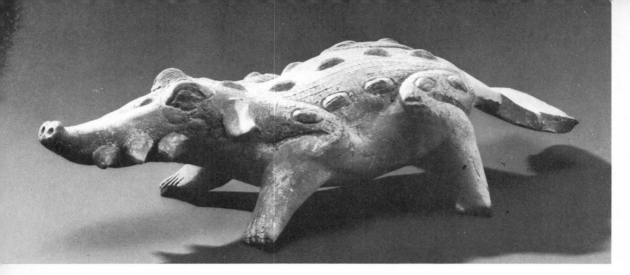

106 Alligator in painted earthenware. MEXICAN (Maya culture), Classic period, about AD 300–980; length 18.8 cm/7½ in. (p 45)
Courtesy Museum of Primitive Art, New York

107 Foot-rasp in the form of a crocodile in red burnished earthenware. EGYPTIAN (Assiut), mid nineteenth century; length 19 cm/7½ in. (p 32)
Victoria and Albert Museum, London

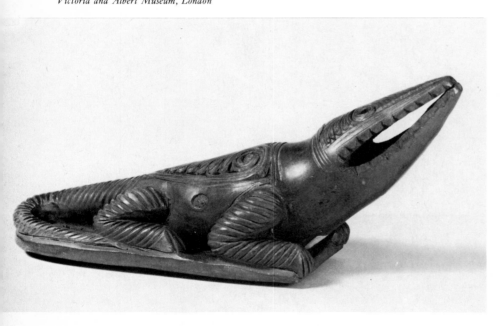

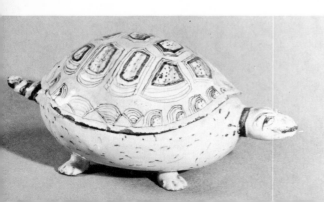

108 Tortoise in tin-glazed earthenware, painted in yellow and purple enamel colours, and marked in purple with a hayfork, and 'P7' and 'v'. GERMAN (Abtsbessingen), mid eighteenth century; length 17 cm/6¾ in. (p 73)
Victoria and Albert Museum, London

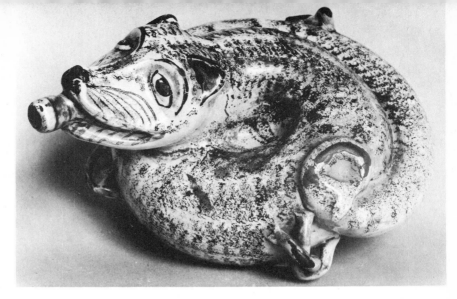

109 Serpent in tin-glazed earthenware. NORTH GERMAN, eighteenth century; diameter 18 cm/7 in. (p 73)
Copyright Germanisches Nationalmuseum, Nuremberg

110 Smoking-pipe in the form of a coiled snake, in cream coloured earthenware, decorated in high-temperature Whieldon-type colours. ENGLISH (Staffordshire), about 1755; length 19.2 cm/7½ in. (p 123)
Victoria and Albert Museum, London

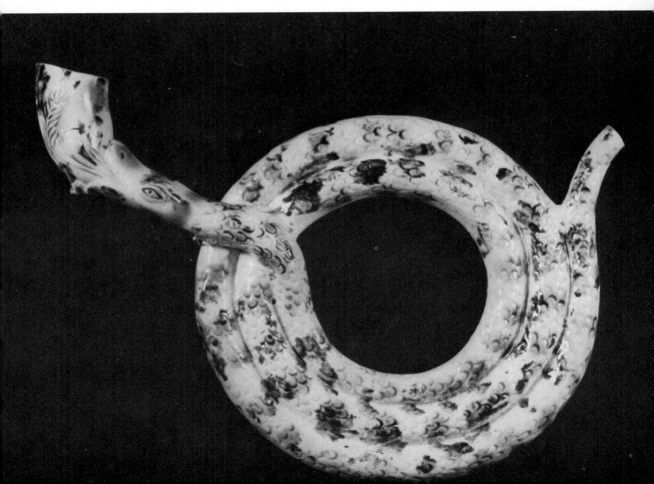

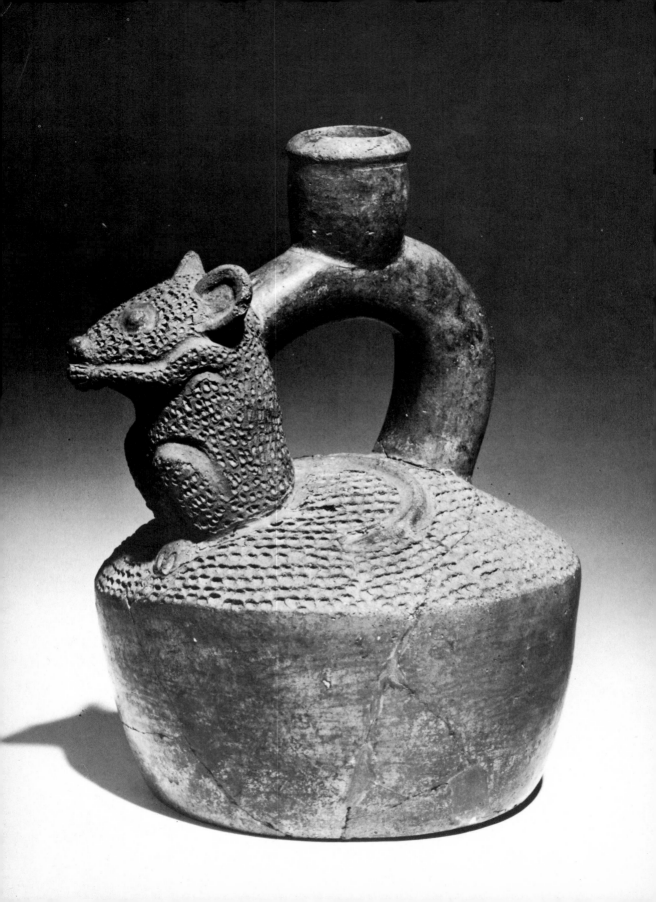

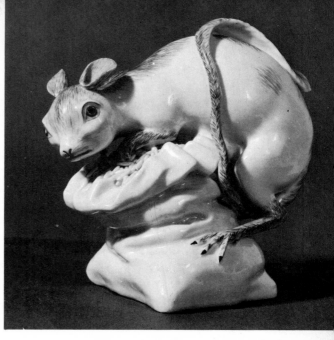

111 Jar with mouse on top, in black earthenware.
PERUVIAN (Cupisnique culture), 750–250 BC;
height 21.7 cm/8½ in. (p 51)
*Courtesy Museum of the American Indian, Heye Foundation,
New York*

112 African springmouse in hard-paste porcelain, painted in enamel colours,
and marked with crossed swords in underglaze-blue. GERMAN (Meissen),
modelled by J J Kändler about 1734; height 17.1 cm/6¾ in. (p 63)
Courtesy The Antique Porcelain Company Limited, London

113 Water-pot in the form of a squirrel, in hard-paste porcelain, painted in
enamel colours on the biscuit. CHINESE (K'ang Hsi period), 1662–1722; height
8.6 cm/3½ in. (p 41)
Victoria and Albert Museum, London

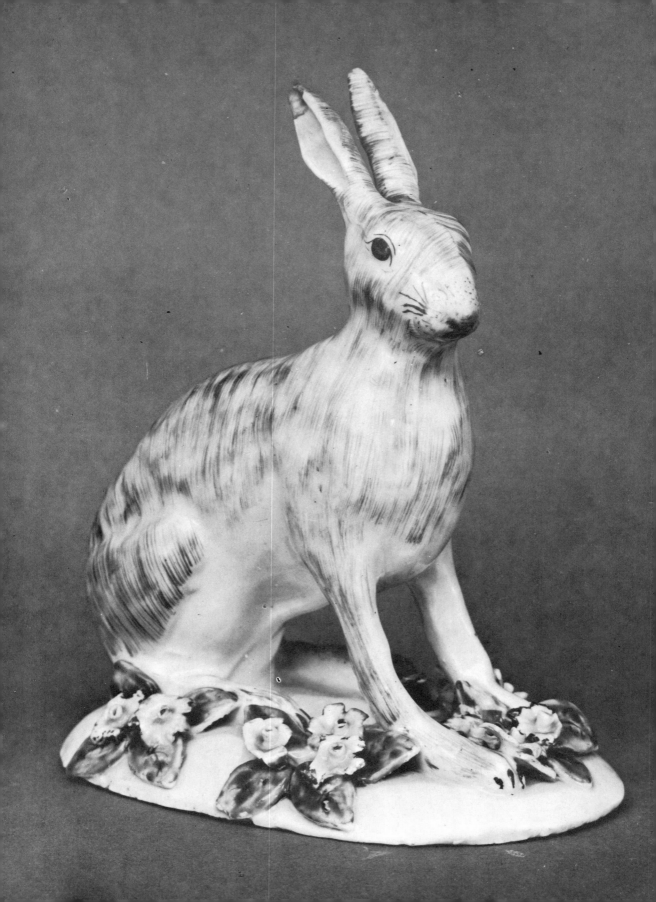

114 Hare in stoneware with semi-opaque white glaze. CHINESE (Kuangtung province), eighteenth century; height 13.3 cm/5¼ in. (p 42)
Victoria and Albert Museum, London

opposite
115 Hare in hard-paste porcelain, painted in enamel colours. ENGLISH (Plymouth), 1768–70; height 16.5 cm/6½ in. (p 118)
Crown copyright, Victoria and Albert Museum, London

116 Rabbit in earthenware with red *flambé* glaze, marked with 'BM' monogram in black. ENGLISH (Stoke, Bernard Moore), 1905–15; height 7.6 cm/3 in. (p 130)
Pietro Raffo Collection

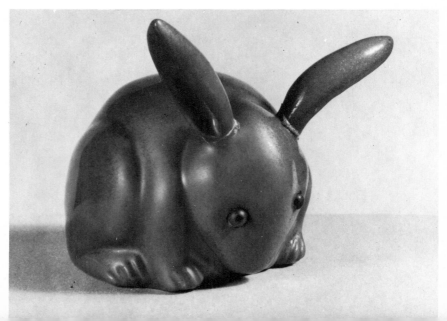

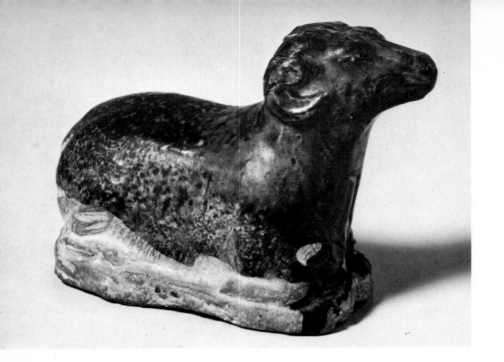

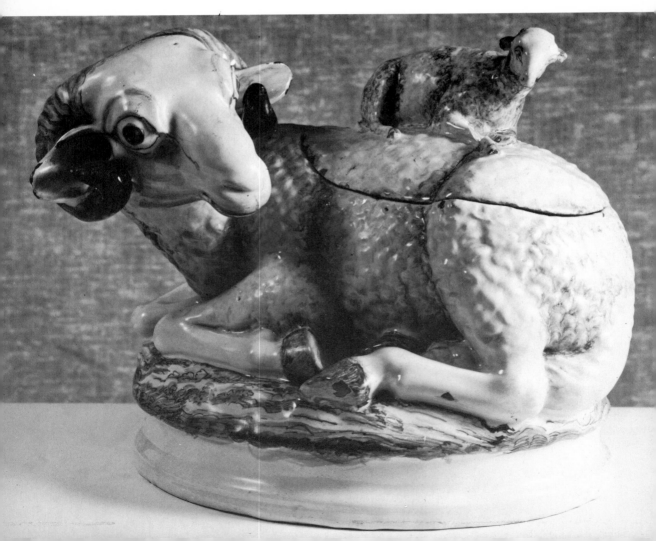

opposite
117 Ram in earthenware with brown and brownish-yellow glaze. CHINESE (Six dynasties), AD 221–617; length 10.6 cm/4¼ in. (p 36)
Freer Gallery of Art, The Smithsonian Institution, Washington DC

opposite
118 Tureen in the form of a ram, in tin-glazed earthenware decorated in high-temperature colours. SPANISH (Alcora), 1750–70; length 24.2 cm/9½ in. (p 84)
Crown copyright, Victoria and Albert Museum, London

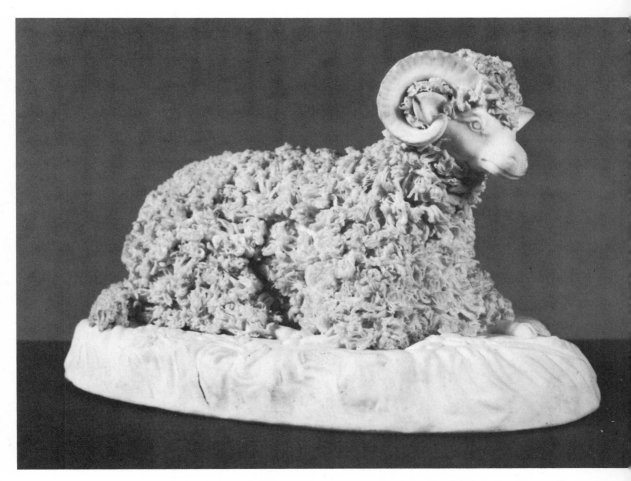

119 Ram in unglazed soft-paste porcelain, marked with 'Bevington & Co Swansea' impressed. ENGLISH (Swansea), 1817–24; length 11 cm/4¼ in. (p 117)
Victoria and Albert Museum, London

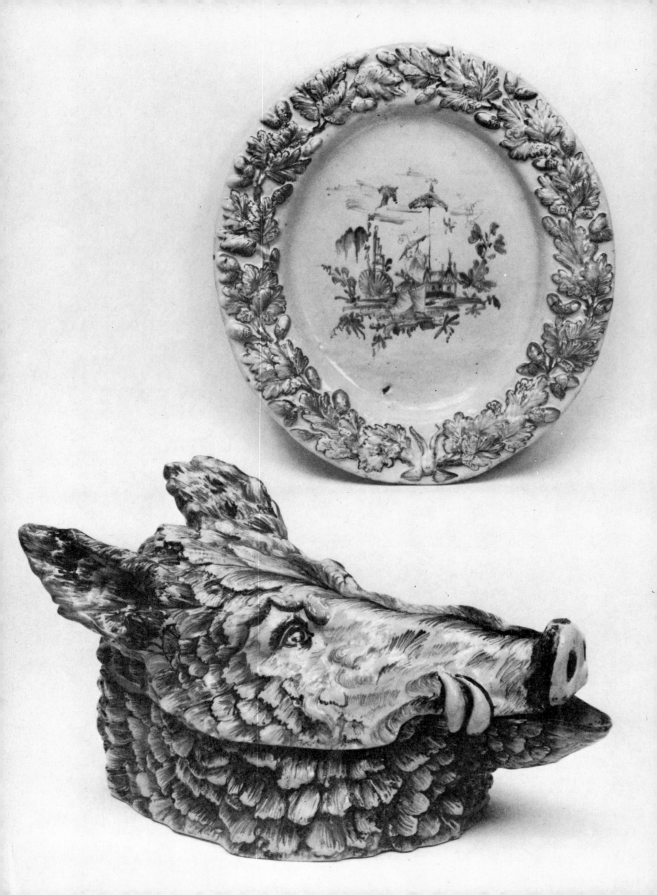

120 Tureen in the form of a boar's head, with dish, in tin-glazed earthenware painted in enamel colours. DANISH (Holstein), about 1770; length 47.9 cm/18¾ in. (p 86)

Courtesy The Campbell Museum, Camden, New Jersey

121 Three drinking vessels in the form of pigs, in lead-glazed red earthenware. ENGLISH (Sussex), nineteenth century; length 40.3 cm/15¾ in. (p 129)

Courtesy Colonial Williamsburg, Virginia

122 Warthog in glazed earthenware. AMERICAN, modelled by David Gilhooly about 1971; length 136.8 cm/54 in. (p 146)

Museum of Contemporary Crafts, New York; photograph Ferdinand Boesch

123 Hippopotamus in earthenware, with copper alkaline glaze. EGYPTIAN
(Middle Kingdom), about 1900 BC; length 7.4 cm/3 in. (p 31)
Courtesy The British Museum, London

124 *Aryballos* or toilet-pot in the form of a hedgehog, in earthenware. EGYPT-
IAN (Late period), after 750 BC; height 5.1 cm/2 in. (p 31)
Courtesy The British Museum, London

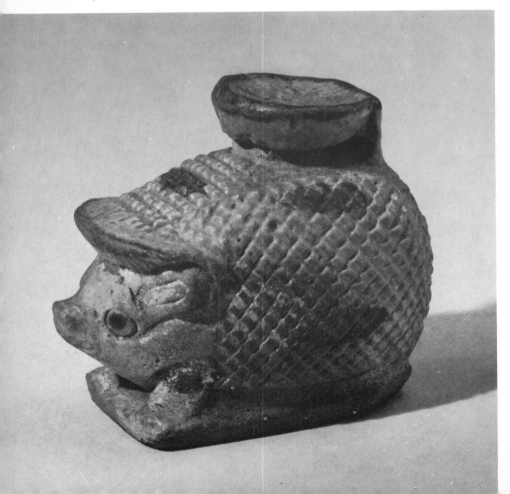

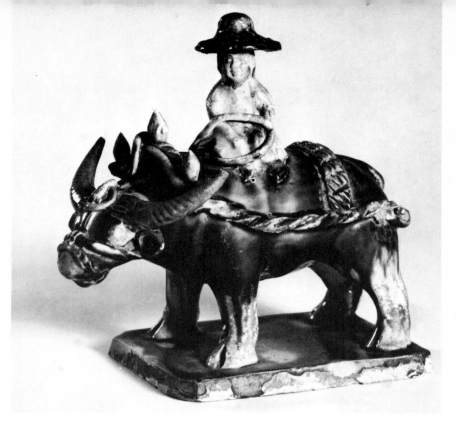

125 Water-buffalo and rider in earthenware decorated with coloured glazes. CHINESE (T'ang dynasty), AD 618–906; length 16.3 cm/6½ in. Compare with illustration **30**, p 134. (p 40)

Freer Gallery of Art, The Smithsonian Institution, Washington DC

126 Fox in white soft-paste porcelain. ENGLISH (Bow), 1750–55; height 14 cm/5½ in. (p 99)

Courtesy Dudley Delavigne Collection

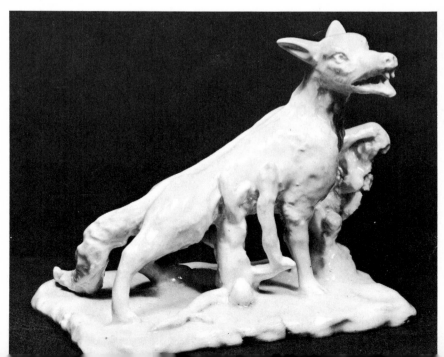

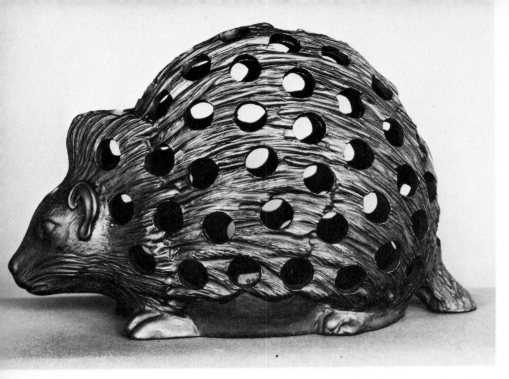

127 Bulb pot in the form of a porcupine in black basalt. ENGLISH (Staffordshire, Wedgwood), late eighteenth century; length 25.7 cm/10 in. (p 125)
Crown copyright, Victoria and Albert Museum, London

128 Ant-eater in white earthenware. ENGLISH, modelled by Iris Sonnis about 1970; length 27.9 cm/11 in. (p 139)
Courtesy Iris Sonnis

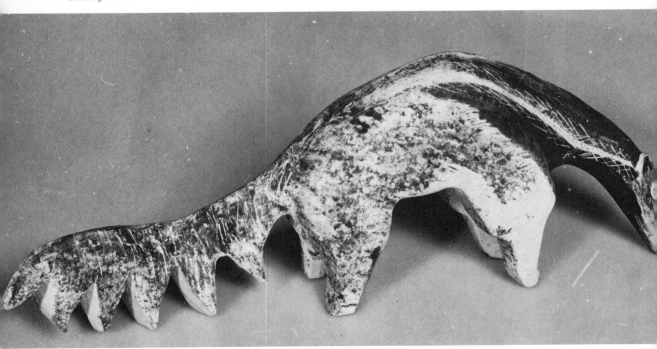

129 Group of unglazed Parian souvenir wares, with coloured crests representing various towns or places.
Top row: frog (Crowborough), ENGLISH (Stoke, Wiltshaw & Robinson), early twentieth century; duck (Walton-on-the-Naze) and owl (Uppingham School), both ENGLISH (Stoke, Arkinstall & Sons), early twentieth century.
Middle row: Bill Syke's dog (Great Malvern), ENGLISH (Stoke, Wiltshaw & Robinson) early twentieth century; tortoise (Ryde, Isle of Wight), foreign, probably GERMAN, about 1920; elephant (Dumfries), unmarked, probably GERMAN.
Bottom row: lion (Hertford), ENGLISH (Stoke, Arkinstall & Sons), early twentieth century; horse (Burgas Newberie), ENGLISH (Stoke, W H Goss), early twentieth century; camel (Great Yarmouth), unmarked.
Height of horse 10.5 cm/4¼ in. (p 119)
Collection of Monica Hannaford

130　Group of Beatrix Potter characters, in hand-painted pottery, from a set of
39. From left to right, (back) Timmy Willie, Samuel Whiskers, Mrs Tittle-
mouse, Squirrel Nutkin, Little Pig Robinson; (front) Jemima Puddleduck,
Foxy Whiskered Gentleman, Jeremy Fisher, Peter Rabbit, Mrs Tiggywinkle.
ENGLISH (Staffordshire, John Beswick), about 1973; heights about 10 cm/4 in.
(p 112)

Courtesy Royal Doulton Tableware Limited, Stoke-on-Trent

GLOSSARY OF TERMS IN GENERAL USE

Agate ware: earthenware made by blending various coloured clays in order to imitate agate stone; a similar effect can be obtained with surface clay slip. This ware can be found either with a salt-glaze or a lead-glaze, or occasionally in the biscuit.

Alkaline glaze: glaze of soda-glass or potash and sand, generally used on Near Eastern pottery, which included the same elements.

Amalgam: metal alloyed with mercury to form a paste that can be applied to ceramic glazes. When fired the mercury vaporizes, leaving a very thin deposit of metal (here gold) fused to the glaze.

Aquamanile: water jug, often in the form of an animal, dating back to Roman times and used for washing the hands at table.

Basaltes: the name given by Josiah Wedgwood to the hard black stoneware he perfected in 1767.

Biscuit: ceramic body fired only once, without the addition of glaze.

Blanc-de-Chine: eighteenth-century French term for the hard-paste Chinese porcelain made at Tê Hua in the Fukien province.

Bocage: screen of pottery or porcelain leaves and flowers, used to form a background to a figure or group.

Body: alternative name to describe the composite material used for the production of a particular type of ceramic.

Bone-ash: calcined animal bones, rich in lime and phosphoric acid, used as an ingredient in many forms of artificial porcelains.

Brede hedgehogs: pottery models of hedgehogs made at Brede in Sussex.

Camaïeu, en: decoration painted in various tones of a single colour (monochrome).

China-clay: white refractory clay formed over a very long period from decomposed granite (known originally in China as kaolin).

China-stone: fusible stone which, when fired at about 1350 °C together with china-clay, forms the hard, white, translucent material of hard-paste porcelain; it is known as *petuntse*.

Clobbering: the adding of further decoration to previously decorated work, often done to enhance the value.

Crazing: minute surface cracks in the glaze caused by the glaze shrinking at a different rate to the body during cooling. The larger and more obvious 'crackle' seen on some Chinese wares was caused deliberately to give a look of antiquity.

Creamware: cream-coloured earthenware covered with a pale yellowish lead-glaze. Perfected by Josiah Wedgwood in about 1760, it was soon imitated by many other English and continental potters. Also known as Queen's ware after Wedgwood made a service in the material for Queen Charlotte.

Delftware: tin-glazed earthenware made at Delft in Holland; however, the term was often used to describe English wares that in many cases pre-date the Dutch ones.

Deutsche Blumen: naturalistically painted German flowers used on Meissen porcelain from about 1740 and imitated on the wares of several English factories.

Dresden china: the name often wrongly given to porcelain made at Meissen. (In the nineteenth century there were several minor establishments in the city of Dresden producing poor quality porcelain.)

Earthenware: low-fired pottery that is not vitrified; it is normally glazed in order to render it waterproof.

Enamel colours: opaque or translucent pigments of a vitreous nature used to decorate ceramics; they are fused to the surface of the glaze or the ceramic body at a temperature not exceeding 800 °C.

Enamel on biscuit: process originating in China of firing enamel colours direct to the once-fired ceramic body, rather than to an applied glaze.

Faience: the term for French tin-glazed earthenware, made using a technique similar to that of Faenza in Italy.

Famille jaune: french term for the Chinese decoration in use from the reign of the Emperor K'ang Hsi (1662–1722) where the ground colour is predominantly yellow.

Famille noire: form of Chinese porcelain decoration popular from the reign of the Emperor K'ang Hsi in which the ground colour is black and invariably washed over with a green enamel that has the effect of giving a better black.

Famille rose: Chinese porcelain that includes in the decoration the various tones of pink to a deep crimson derived from chloride of gold. This colour was popular from the late years of the Emperor K'ang Hsi, and was used by German enamellers from about 1680.

Famille verte: the palette of Chinese colours used from the reign of the Emperor K'ang Hsi, in which various green tones predominate.

Fayence: the German equivalent of faience.

Feldspathic glaze: glaze rich in feldspar (alumino silicates) that is used on hard-paste porcelain and fired at the same time as the body.

Ferruginous: describing a body or glaze that is rich in iron; this results in a buff to brownish-red colour or, when fired under special conditions, to a 'celadon'.

Fire-crack: fault in the nature of a split or crack in a ceramic body caused by expansion or contraction of wares made up of clay of various thicknesses. Press-moulded wares are more likely to have this fault than those made by slip-casting.

Fleurs des Indes: the French term for *Indianische Blumen*, a misnomer given to a form of flower painting derived from Far Eastern porcelains that were brought to Europe in the vessels of the various East India companies.

Frit: powdered form of the ingredients of glass, used in soft-paste porcelain as an alternative to china-stone in hard-paste.

Galena: lead sulphide used for early glazes on low-fired earthenwares (slip-wares). Various impurities usually give such a glaze a rich yellow tone.

Gilding: the application of various forms of gold to the surface of ceramic wares. Early gilding consisted of ground gold-leaf or gold powder with honey as a medium, which was applied in liquid form and then fired to the glazed ware. From the late eighteenth century the honey gilding was replaced by an amalgam of mercury and then similarly fired. After the firing, the gilding was burnished to give a high sheen.

Glaze: covering of vitreous substance over a body to give a glossy coating that is impervious to liquids. The glaze on hard-paste porcelain is usually feldspathic; the glassy glaze applied to other porcelain bodies is a thin layer of glass made from frit.

Grand feu: the high-temperature kiln used for firing the body and glaze of true porcelain or tin-glazed earthenware decorated with the limited range of high-temperature colours such as cobalt, copper, manganese, antimony and iron.

Grog: previously fired pottery that is pulverized down to minute sand-like particles and then used to produce a tougher type of earthenware when added to low-fired clays.

Hard-paste porcelain: the type of porcelain first introduced by the Chinese potter in about AD 850 and made from china-clay and china-stone, two varying forms of decomposed granite.

High-temperature colours: colours applied to a body with the glaze and at high temperatures. Originally, the only ones that could be used as underglaze colours on hard-paste porcelain were cobalt (giving blue) and copper (giving a dull red). These two colours, together with antimony, manganese, and iron, were used to decorate tin-glazed wares and were applied to the powdery glaze prior to the glost firing. A further range of colours became available in the early years of the nineteenth century from the use of chrome.

Honey gilding: see gilding.

Indianische Blumen: East Indies flowers. See *fleurs des Indes*.

Intaglio: form of decoration created by incising or carving below the surface. The reverse of relief decoration as seen on a cameo.

Jasper ware: hard, fine-grained stoneware, sometimes slightly translucent, introduced by Josiah Wedgwood in about 1774. It is best known in the popular blue and white form but it could be tinted to a variety of colours with the use of metallic oxides.

Kaolin: China clay. It was first found by the Chinese but has since been discovered at many places throughout the world.

Leather-hard: the term used to describe the state of a clay body during the drying process, when any necessary turning on a lathe or incising is carried out.

Lead-glaze: transparent glaze containing lead oxide. Such glazes were originally applied in a dry powdered form, but later the ingredients were suspended in water into which the ware was dipped.

Lustre decoration: metallic colours fused to the glaze of wares in a reduction kiln: copper results in copper-coloured tones; silver fires to a brassy yellow; and chloride of gold looks like copper when applied to a dark brown body and appears pink when on a white clay surface. Platinum was used to give the effect of silver, since it did not oxidize to a black as real silver metal would.

Luting: the use of liquid clay either to assemble the various parts of a moulded figure or vessel or to apply separately any moulded decoration to the surface of a vessel. The latter technique can also be termed 'sprigging'.

Maiolica: the term applied to Italian tin-glazed earthenwares. Thought to be derived from Majorca, the island concerned with the importation of Hispano-Moresque wares.

Moulding: the shaping of clay with the use of prepared moulds. The clay is used in a plastic state and hand-pressed into the hollow moulds which were usually of fired clay or plaster of Paris.

Muffle kiln: the low-firing kiln (about 800 °C) used for applying enamel colours to ceramics.

Oxidizing kiln: kiln into which air is freely admitted, the kiln atmosphere creating colours different from the wares or decoration.

Parian ware: white ceramic body introduced in Staffordshire in about 1840, used primarily for the production of scaled-down reproductions of full-size statuary. The body is usually left 'in the biscuit' but when used for decorative or tablewares, glaze was usually applied. The name derives from the Greek island of Paros, a source of fine marble.

Petit Feu: term for coloured enamels fired to ceramic bodies at low temperatures.

Petuntse: see china-stone.

Repairer: the trade-name of the craftsman responsible for assembling the various moulded or cast sections of a ceramic vessel or figure with the aid of slip.

Reducing kiln: kiln where a smoky atmosphere is deliberately caused in order to achieve certain effects and colours on the ceramics being fired.

Salt-glaze: glaze used on stoneware, made by throwing salt into the kiln at the peak firing temperature.

Slip: clay watered down to a creamy consistency, used as an adhesive for assembling casts together.

Slip-casting: the forming of clay wares or figures by pouring slip into hollow plaster-of-Paris moulds. The plaster absorbs the water and in so doing builds up a layer of clay onto the inside wall of the mould, any surplus slip being poured off. Complicated figures or wares necessitate many separate moulds.

Soft-paste porcelain: artificial porcelain made from various white-firing clays and the ingredients of glass, bone-ash, or steatite, etc.

Sprigging: the application of separately moulded decoration to the surface of wares; it is often of a contrasting coloured clay.

Stoneware: high fired pottery that contains sufficient natural fluxes for it to vitrify between 1200 and 1400 °C; it is completely impervious to liquids.

Throwing: the process of forming a hollow circular shape from clay by hand with the use of a fast-turning potter's wheel.

Tin-glaze: lead-glaze (translucent) made white and opaque by the addition of tin oxide.

Transfer-printing: the transferring of a design engraved on a copper-plate or wood-block by means of a thin tissue paper or slab of gelatine onto the surface of the body, or onto the glaze of a ceramic or enamel ware. High-temperature colours such as cobalt are applied to the once-fired body of the ware prior to the application of the glaze; low-temperature enamel colours are fused onto the previously applied and fired glaze.

Wasters: faulty wares, usually discarded during manufacture and often good evidence of types of manufacture carried out at old potteries.

ACKNOWLEDGEMENTS

the following photographs were specially taken for this book:
4, 5, 7, 11, 17, 18, 19, 20, 23, 24, 26, 27, 29, 30, 18, 33, 68, 86, 95, 96, 107, 110, 113, 114, 119, by C Cannings;
15, 47, 128, by Imitor Limited.

COLOUR ILLUSTRATIONS

BLACK AND WHITE ILLUSTRATIONS

(The first 24 illustrations are included in with the text; all the others are grouped together according to animal kind in chronological order)

FURTHER READING

General
CHARLESTON, R J (editor), *World Ceramics*, London 1968.
CUSHION, J P, *Pocket Book of English Ceramic Marks*, London 1959.
 Pocket Book of German Ceramic Marks, London 1961.
 Pocket Book of French and Italian Ceramic Marks, London 1965.
 Continental China Collecting for Amateurs, London and New York 1970.
 Pottery and Porcelain (*The Connoisseur*'s Illustrated Guides Series), London 1972.
HONEY, W B, *European Ceramic Art* (2 vols), London 1952.
LAUFER, B, *Beginnings of Porcelain in China*, Chicago 1917.
Li Tre Libri dell' Arte del Vasaio, mid 16th century treatise by Cavaliere Cipriano Piccolpasso.
SAVAGE, G, *Porcelain through the Ages*, London 1954, New York (revised edition) 1963.
 Pottery through the Ages, London 1959, New York 1963.
 and NEWMAN, H, *An Illustrated Dictionary of Ceramics*, London 1974.

The Middle East
LANE, A, *Later Islamic Pottery*, London 1957.
WALLIS, H, *The MacGregor Collection*, London 1898.

China
Chinese Art in the Everson Museum (Cloud Wampler and other collections), Syracuse New York (Exhibition), New York 1968.
GRAY, B, *Early Chinese Pottery and Porcelain*, London 1953.
HONEY, W B, *Ceramic Art of China and other Countries of the Far East*, London 1945.

Japan
CLEVELAND, R S, *Two Hundred Years of Japanese Porcelain* (for an exhibition at the City Art Museum of St Louis), St Louis 1970.
JENYNS, S, *Japanese Porcelain*, London 1963, New York 1965.
KOYAMA, F (editor), *Japanese Ceramics from Ancient to Modern Times*, Oakland, California 1961.

Greece
LANE, A, *Greek Pottery*, London 1948.

Holland
HUDIG, W, *Delfter Fayence*, Berlin 1929.
DE JONGE, C H, *Delft Ceramics*, London and New York 1970.

Germany
ALBIKER, C, *Die Meissner Porzellantiere im 18 Jahrhundert*, Berlin 1935.
DUCRET, S, *German Porcelain and Faience*, London 1962.
HONEY, W B, *Dresden China* (new edition), London 1954.
PAULS-EISENBEISS, DR E, *German Porcelain of the Eighteenth Century* (2 vols), London 1972.
SAVAGE, G, *Eighteenth Century German Porcelain*, London 1958.

France

HONEY, W B, *French Porcelain*, London 1950.

LANE, A, *French Faience*, London 1948,
 revised edition, CHARLESTON, R J (editor), New York 1971.

SAVAGE, G, *French Porcelain of the Eighteenth Century*, London 1960.
 The Campbell Museum Collection, Camden NJ 1972.

Spain

FROTHINGHAM, ALICE W, *Lustreware of Spain*, New York 1955.

RIANO, J F, *Spanish Arts*, London 1879.

Denmark

HAYDEN, A, *Royal Copenhagen Porcelain*, London 1911.

HERNMARCK, C, *Fajans och Porslin*, Stockholm 1959.
 Three Centuries of Swedish Pottery: Rörstrand (for an exhibition at the
 Victoria and Albert Museum, London), London 1959.

England

FALKNER, F, *The Wood Family of Burslem*, London 1912.

GODDEN, G, *The Illustrated Guide to Lowestoft Porcelain*, London and New York
 1969.

HAGGAR, R, *Staffordshire Chimney Ornaments*, London 1955.

HASLEM, J, *The Old Derby China Factory*, London 1876.

HONEY, W B, *Old English Porcelain* (2nd edition), London 1948.
 Wedgwood Ware, London 1948.

LANE, A, *English Porcelain Figures of the Eighteenth Century*, London 1961.

MOUNTFORD, A, *Illustrated Guide to Staffordshire Salt-glazed Stoneware*,
 London 1971.

RACKHAM, B, *Medieval English Pottery*, London 1948.

SANDON, H, *Royal Worcester Porcelain from 1862 to the Present Day*, London
 1973.

SAVAGE, G, *The American Birds of Dorothy Doughty*, Worcester 1962.

SHAW, S, *History of the Staffordshire Potteries*, Hanley 1829.

WATNEY, B, *Longton Hall Porcelain*, London 1957.

Ireland

MCCRUM, S, *The Belleek Pottery*, London 1972 (HMSO).

Studio pottery

DIGBY, G W, *The Work of the Modern Potter in England*, London 1952.

HONEY, W B, *The Art of the Potter*, London 1946.

ROSE, M, *Artist Potters in England* (2nd edition), London 1970.

WREN, DENISE and ROSEMARY, *Pottery Making*, London 1952.

United States of America

BARBER, E A, *The Pottery and Porcelain of the United States* (3rd edition), New
 York 1909.

BARRET, R C, *Bennington Pottery and Porcelain*, New York 1958.

HAWES, L E, *The Dedham Pottery*, Boston 1969.

HENZKE, LUCILLE, *American Art Pottery*, New York 1970.

SCHWARTZ, M and WOLFE, R, *A History of American Art Porcelain*, New York
 1967.

INDEX